BAS JAN ADER

BAS JAN ADER

DEATH IS
ELSEWHERE

Alexander Dumbadze

University of Chicago Press *Chicago and London*

The University of Chicago Press, Chicago 60637
The University of Chicago Press, Ltd., London
© 2013 by The University of Chicago
All rights reserved. Published 2013.
Paperback edition 2015
Printed in the United States of America

24 23 22 21 20 19 18 17 16 15 3 4 5 6 7

ISBN-13: 978-0-226-03853-7 (cloth)
ISBN-13: 978-0-226-26985-6 (paper)
ISBN-13: 978-0-226-03867-4 (e-book)
10.7208/chicago/9780226038674.001.0001

Library of Congress Cataloging-in-Publication Data

Dumbadze, Alexander Blair, 1973–
Bas Jan Ader : death is elsewhere / Alexander Dumbadze
pages. cm.
Includes index.
ISBN 978-0-226-03853-7 (cloth : alk. paper)
ISBN 978-0-226-03867-4 (e-book)
1. Ader, Bas Jan, 1942–1975. 2. Artists—Biography. I. Title
NX512.A34D86 2013
709.2—dc23
[B]
2012045007

♾ This paper meets the requirements of ANSI/NISO Z39.48-1992
(Permanence of Paper).

FOR SIMONE

FALLING

1

One day in April 1970, Bas Jan Ader began to prepare, with the help of his wife, Mary Sue, and his friend the artist William Leavitt, a piece that would be called *Fall 1, Los Angeles*.[1] Some black-and-white film footage from the making of the work survives. It shows Ader, tall and slender, his hair somewhat long, walking out of the house that he and his wife had bought several years earlier in Claremont, a picturesque college town some thirty miles east of downtown Los Angeles. Typical for the area, the wood-frame structure, which no longer stands, sat fairly far back from a main thoroughfare. It faced the distant city; to the north loomed the San Gabriel Mountains, and directly south were flat vistas similar to the landscape Ader knew from his childhood in Holland. The film records Ader ambling down the front steps, then turning to his right to climb a ladder that leans against the front porch roof. He ascends cautiously, one hand occupied with the chair he is carrying. Once on the roof he appears a bit wobbly, but as soon as he gains his footing, he moves from the lower porch to the gable of the main roof, sliding along like a tightrope walker until he finds a suitable spot for his chair.

The final, edited version of *Fall 1, Los Angeles* (fig. 1), running just twenty-four seconds (six of them devoted to the title), comes across as a visual aphorism. It opens with Ader, dressed in a long-sleeve shirt and bell-bottom pants, the loose fabric flapping like pennants in the breeze, sitting erect atop the house on the simple, straight-back chair, his hands resting on his thighs. The initial moments feel like an eternity as he gradually tilts to his right, his hands extended toward the shingled roof. Once horizontal, he begins to tumble. Through two full rotations he builds momentum, but not enough for him to clear the almost flat roof of the veranda. He makes one more roll, then, before friction stops him completely, scoots toward the edge and hurls himself over. This last heave causes his right shoe to fly off and twists him around entirely; he picks up speed on his way toward the ground. A mattress hidden in the bushes softened Ader's impact, and a few brief

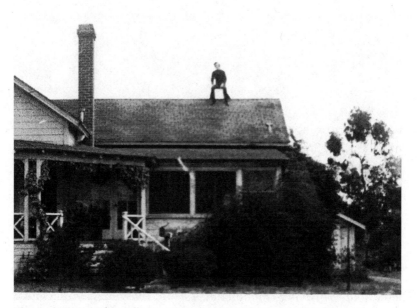

Figure 1. Bas Jan Ader, *Fall 1, Los Angeles*, 1970. © The Estate of Bas Jan Ader.

shots from the outtakes show Leavitt running into the frame to check on his friend, who, despite rumors to the contrary, was unharmed.[2]

Ader discussed *Fall 1, Los Angeles* in an interview with Willoughby Sharp that appeared in the winter 1971 issue of *Avalanche*. Sharp had been in Los Angeles the previous autumn to take the measure of what was then a misunderstood and widely underappreciated art scene. Helene Winer, curator of the Pomona College Art Gallery, the most progressive exhibition space in the Los Angeles metropolitan area, drove Sharp around, introducing him to artists she found interesting.[3] Sharp had been in Los Angeles before, in 1969, when the gallerist Eugenia Butler brought him down from San Francisco. It was during this trip that he met Leavitt, at one of the many parties Butler hosted. Sharp took an interest in Leavitt's work, and in the course of a studio visit, Leavitt showed him a book that included stills from *Fall 1, Los Angeles*. Sharp was intrigued by what he saw, and while the two were having drinks Leavitt telephoned Ader to see if he would be willing to have one of his works reproduced in *Avalanche*. Excited by the possible attention, Ader quickly accepted.[4]

Sharp never met Ader, but they talked over the phone, with Sharp asking simple questions in the hope of eliciting profound responses.

He was taken by Ader's seriousness and commitment to his art, which made Sharp want to conduct a more formal interview, something Ader was reluctant to do.[5] Nevertheless, he did speak about his art. What Sharp brought to print is one of Ader's few public statements on the subject, and its singularity makes it all the more significant. It neither jibes with comments made by conceptual artists who were influenced by the advances of analytic philosophy, nor shares common ground with Los Angeles–based artists like Laddie John Dill, who came to prominence in the wake of the Finish Fetish and Light and Space movements. Ader's thoughts seem out of sync with those of many of his contemporaries, for what he said, or at least what Sharp transcribed, was, "I do not make body sculptures, body art, or body works. When I fell off the roof of my house, or into a canal, it was because gravity made itself master over me."[6]

Fall 1, Los Angeles was not exhibited until the summer of 1971, well after Ader's conversation with Sharp and just a few months after his comments appeared in print. In some ways, Ader's enigmatic statement supplements this and other *Fall* works to come. His remark implies that he fell not because he wanted to but because gravity — a force that had somehow attained subjectivity — compelled it. Events could not have unfolded differently; nothing he could have done, no decision or even indecision on his part, would have altered the course of events — even though in the film there are two instances in which he punctures the illusion of his submission. The first comes at the start of the piece: his slow, controlled extension out of the chair and onto the roof. The second is his slight shuffle toward the edge of the veranda roof (fig. 2). Ader clearly initiates both actions, although the logic of the work and of his declaration to Sharp ascribes that agency to gravity. These are volitional gestures, expressions of will, a decision to initiate as well as to interrupt an event he asserts is predetermined. Of course, Ader's rolling himself forward can be seen as innocuous, but in light of his declaration, it opposes the conceit of *Fall 1, Los Angeles* and establishes a tension between his will and a determinist power.

Toward the end of 1980, five years after Ader's death, the young Dutch art historian Paul Andriesse interviewed Leavitt. Andriesse was compiling information for the Ader catalogue raisonné. The conversation was probably recorded, but what survives are Andriesse's notes, either taken during the interview or made in the following days. The

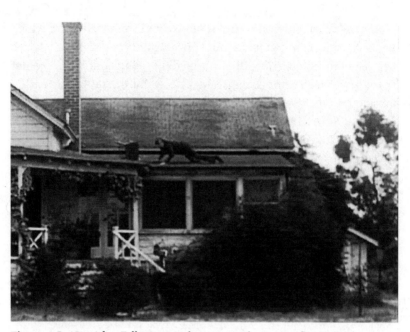

Figure 2. Bas Jan Ader, *Fall 1, Los Angeles*, 1970. © The Estate of Bas Jan Ader.

notes are generally decipherable to anyone with previous knowledge of Ader's career. Andriesse was meticulous in his accounting, trying to ascertain as much detail as possible. There is a remark about *Reader's Digest*, talk about Ader's 1967 graduate thesis exhibition and how Ader's father was brave and intelligent, and discussion of *Piece G*, a collaborative work made by Ader and Leavitt at Mount San Antonio College in 1969. Leavitt also mentions that Ader's interest in falling was tied to the philosophical problem of free will and determinism.[7]

That Leavitt was so candid regarding Ader is remarkable. Over the years, he became less willing to speak about his friend. In a letter he wrote to Andriesse in the spring of 1988, he explains apologetically that he will not be able to contribute an essay to Andriesse's forthcoming catalog on Ader because his writing has been impeded by a welter of conflicting emotions.[8] Eventually, though, he did send Andriesse a short compendium of quotations from Ader, as well as several of his own reminiscences. The eight notes, some just a line, others a full paragraph, speak to the time before their friendship began to dissolve, toward the end of 1972.[9] Two of Leavitt's reflections recount

how Ader was deeply invested in philosophy as he searched for concrete truths. Leavitt also describes how Ader sought to rid his practice of artifice, aspiring to art that would reveal an authenticity he thought existed in mathematics. Leavitt did not share Ader's motivations. He found them strange, if not overdetermined, but consistent with Ader's interest in imperfection, failure, and the Sisyphean nature of his work. It was the content of the work that most concerned him, not the connotations of its presentation.[10] In the spring of 1970, art was a way for Ader to think philosophically. It was not so much that Ader wanted to depict the issues as that he wanted to actualize them; authenticity, for the work of art, lay not in representing philosophical concepts but in embodying them.

If a central theme runs throughout Ader's brief but fecund career, it is this pursuit of concrete truths and the elimination of artifice.[11] His initial interest in the question of the will is curious given the art historical context, since few of his contemporaries considered existential questions. Far more common were engagements with formalism, phenomenology, the nature of art as such, the critique of representation, and the relation of art to politics. Nevertheless, Ader's investigation into the status of the will — or for that matter, into freedom — initiated within his practice inquiries far more universal in scope and radical in their constitution: he searched for ways for art and life to communicate without recourse to mediation. At stake was a reorientation of art: the way it functioned, the way it looked, the way it interacted with its public. Ader was never short of ambition, and the potential impossibility of his efforts was not lost on him. To a certain extent, he accomplished his goal, but only at the expense of his life. His death — so sudden, so dramatic, without art historical precedent — necessitates talking about his life alongside his art. This is a historiographic operation that coincides with the particular conditions of Ader's art, which increasingly foregrounded his life and placed it in a dialectical relation with his practice. To think historically about Ader's life and art is not to compose a biography or to suggest that artistic meaning rests in biography. Rather, it is to see these entities as equally open to interpretation, and to look to their coexistence to explain Ader's relevance today. In his mysterious passing and the unavoidable emphasis on his myth, anachronism and aura become one. It is here that Ader remains alive while his death is elsewhere.

2

Ader did not speak much about falling and its significance. One assumes that in conversations with friends, colleagues, and others who might have inquired the topic came up, but in print—whether interviews or his own writing—there is little beyond his statement to Sharp.[12] Ader's silence, if it can be called that, does not indicate a lack of reflection; his ruminations were in the works themselves. Over a two-year period, beginning in 1970 with *Fall 1, Los Angeles*, Ader made around fourteen works (nearly half of his entire production) that in one way or another had falling as the central theme. Most were either photographic or filmic, but one, *Light Vulnerable Objects Threatened by Eight Cement Bricks* (1970), was an installation *cum* performance, while another, *The Boy Who Fell Over Niagara Falls* (1972), was simply a performance. These works do not cohere as a singular position, nor do they advance an argument that progresses from *Fall 1, Los Angeles* to *The Boy Who Fell Over Niagara Falls*. Ader had higher ambitions for these explorations. On December 19, 1970, he wrote to his dealers, Adriaan van Ravesteijn and Geert van Beijeren, at the Art & Project Gallery in Amsterdam, that he was working on a series of introspective works in which he silently declares on film everything there is to know about falling. He admits that the works will be difficult to make, but he is convinced that in their final state they will be extraordinarily moving.[13]

Ader's preoccupation with the physical act of falling goes back at least to his days at the Otis Art Institute, which he attended from 1963 to 1965. He had arrived in Los Angeles in the first part of 1963, and his good friend Ger van Elk, whom he knew from the Institut voor Kunstnijverheidsondwijs in Amsterdam, had encouraged him to continue his studies in the United States. Familiar with the American education system after a year abroad as a high school student in the Washington, DC, area, Ader spent a few months preparing and eventually passed several equivalency exams that paved the way for his matriculation at Otis. At the time, he was living in Hollywood with Van Elk, who had come to the United States a year or so earlier to further his education and to be closer to his father, an animator at the Hanna-Barbera Studio. [14] It was at Otis that Ader met Mary Sue Andersen, a graduate student from Arizona who was the daughter of the school's director. Ader, as the story goes, approached Andersen one day dur-

ing a break between classes. She was with a group of friends huddled around a coffee stand not far from campus. Supremely self-confident, Ader introduced himself by lifting up his shirt, exposing his bare stomach, and exclaiming that he had one of the five most beautiful belly buttons in the world.[15] Andersen was taken by his charm, and not long afterward they moved in together.[16]

While at Otis, Ader began to study photography. This marked a shift from his previous work, which had consisted mainly of muddy, gestural paintings in the figural abstraction vein. These pieces had won him a fair amount of success. During his year in the DC area, at the age of nineteen, he had had the opportunity to show at both the Upstairs Gallery and the Galerie Realité.[17] Ader was obviously precocious, and his already sizable ego was swelled further by the praise he received not only in the local press but in a Voice of America interview and several articles that appeared in Dutch newspapers.[18] Now, as Ader grappled with an unfamiliar medium, trying to master its intricacies and potential, he took numerous pictures. Some are simple snapshots of Andersen curled up in a chair or reading quietly; others show her parents caught in moments of contemplation. From the few contact sheets that remain, it seems that Ader was interested in capturing unposed moments, as is further evident in several shots of older women distractedly eating lunch. These are curious photos, shot from a low angle, perhaps taken on the sly with the camera resting on a table. Interspersed among the character studies are pictures of the architectural oddities that dot Los Angeles, and of signs promoting everything from fishing bait to the miraculous powers of Jesus Christ. But if Ader had a subject he returned to on a regular basis, it was the Bradbury Building in downtown Los Angeles, which at the time was falling into a state of ruin. Almost weekly, Ader and Andersen would sneak into the historic structure, and Ader would photograph its overlapping staircases, intricate ironwork, monumental elevators, and the glass roof that makes the massive building seem light and airy.

Ader was widely liked by his peers at Otis and was known for his sense of humor, a blend of deadpan drollness and daring physicality reminiscent of Buster Keaton. His comic timing was excellent, and he would disrupt class with gestures that were performative in spirit.[19] At times he feigned ignorance of English—despite being fluent—and affected a thick Dutch accent, acting as if he could not comprehend the

lecture or assignment. His classmates struggled to stifle their laughter as Ader's subversive humor revealed their professors' indifference toward the students. On one occasion, Ader instigated what was perhaps his first fall. It was during an American literature class, and Ader, dressed (as he almost always was) all in blue, sat off in a corner, away from the other students. The instructor, famously boring, spent much of the class reading passages from the book assigned for that day. He spoke in a monotone, smoking cigarettes and cracking asides that delighted only him. As the students drifted toward sleep, Ader crept slowly toward the edge of his seat. Inch by inch he shifted his body until he fell to the ground with a tremendous clatter that toppled the chairs around him.[20] In a gesture such as this, the slapstick element, and the pretense that everything was normal was especially important.

Soon after graduation, in June 1965, Ader and Andersen were married in Las Vegas. A close friend of Andersen's, Jan Oestern, acted as their witness, and it was she who filmed the young couple as they approached the chapel. A brief fragment of film shows Ader on crutches smiling toward the camera. Nothing, of course, was wrong with his legs; he simply thought it funny to fake an injury and to approach a solemn event with an apparatus that literally and metaphorically kept him from falling. The spontaneous and private wedding came as a shock to Ader's mother, who had hoped, when the day came, to perform the ceremony herself.[21] She knew how serious Ader and Andersen were and approved of their relationship, deeming Andersen to be a positive influence on her son.[22] There were plans to have a second ceremony in Holland, but this never transpired despite numerous visits after their marriage.

Not long after the wedding, Ader enrolled in the master of fine arts program at Claremont Graduate School. Little information exists about his course of study, nor is there much documentation of the art he made over the two-year period. Several installation shots from his thesis exhibition in the spring of 1967 show that he created mixed-media work that incorporated elements of painting, sculpture, and drawing. These pieces, far removed from both the emotive work he had done in Washington and his more detached photographs from Otis, barely allude to the more conceptually oriented art to come, although the exhibition poster is suggestive (fig. 3). A pop sensibility emerges, with a pictorial strategy akin to John Welsey's but with a softer, more humane

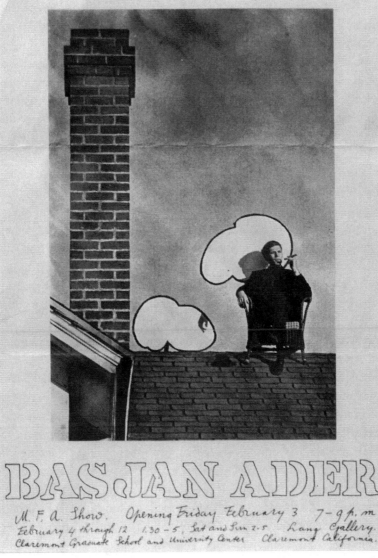

Figure 3. Bas Jan Ader, *Implosion—The Artist Contemplating the Forces of Nature,* 1967. © The Estate of Bas Jan Ader.

figuration. These were flat, obdurate compositions, literal depictions of brick walls, made with red paint and thick black lines. A fairly large painting shows Ader, his head tilted slightly to the right, riding his bicycle straight toward the viewer.[23] Another work is more sculptural: a bicycle, missing its wheels, lies atop a painted, cloudlike brick wall spread out on the floor.

Hung on the wall in a neat grid is a series of drawings that are more complicated compositionally than the other works in the show, juxtaposing multiple images and incorporating textual elements in a manner reminiscent of early Jasper Johns. Some, in particular those depicting women, have hints of Tom Wesselman's paintings from the mid-1960s, albeit with figures that have eyes and a sense of identity. Others are more haphazard in their organization, as seen in the inconsistent shading and the abandonment of perspective. In their original context, the drawings illustrated two fairly long poems: *What Makes Me so Pure, Almost Holy? And More* and *What Does It Mean? Cheep Cheep* (fig. 4). The combination of word and image had been printed in an edition of one hundred as an artist book, which in retrospect is an anomaly in Ader's practice. It is not the book format that seems strange; only a few years later he self-published, in the style of Ed Ruscha, a small volume containing film stills from *Fall 1, Los Angeles* and *Fall 2, Amsterdam*. What is odd is the profusion of writing: sustained, thought out, and, in comparison to his notebook from later years, extensive. The poems were written in Ader's distinctive hand, and he utilized this freedom from the limits of typesetting to place words on paper in an artful manner. The pages of text are as formally complex as the drawings and it could be said that each illustrates the other equally. In terms of structure, the poems are more like prose than lyric: their content a bit opaque, fantastical in many ways, but grounded, one presumes, in aspects of Ader's childhood. Images abound of Ader playing with his friend Bea, of a passing truck with geraniums for wheels, of a school trip marred by the death of a bicyclist, as well as comparisons between life in Los Angeles and in Holland, both loved by Ader but wonderfully different.

The book pays little attention to falling; its themes are Ader's memories, his longing for home, and his celebration of America. Yet the idea of falling arises in the exhibition as a unifying principle that must have been clear to Ader even if not wholly visible in the works. In a

short text written for his thesis committee, he lucidly explains, albeit in outline format, the goals and ambitions of his show: "In this project the notions of fall and rise were to be explored. . . . Something dealing with this notion is present in each piece, and most titles reflect this."[24] He does not go into detail, merely mentioning the titles of some works: *Humpty Dumpty — Fall Guy, Sue Falls — Table Your Feelings*, and *Niagara Falls*. But other issues were important as well. Ader describes a relation between part and whole in which individual works matter less than how "an environment made up out of separate, but cross breeding pieces" forms a larger, interconnected meaning.[25] He also elucidates the tension between the real and the illusory. It is to this dualism that Ader seems to have given his most sustained thought, both conceptually and visually, as with the piece in which the bicycle rests atop the painted canvas. This work becomes for Ader a situation wherein the actual and the representational blur, a gesture, possibly, to the avant-garde aspiration of fusing art and life.

Whatever the issues Ader believed he was exploring in his thesis exhibition, he put them to rest, at least visually, once he commenced graduate study in philosophy at Claremont College. He may have been dissatisfied with the conceptual rigor of his work, or it could be that he saw this time of study as the next step in his education. During his two years at Claremont, Ader made perhaps two works, and neither was concerned with falling, but rather with the social status of the artist. In the staged photograph *The Artist as Consumer of Extreme Comfort* (1968/2003), Ader sits in a Barcalounger, his gaze trained wistfully toward a fireplace, an open book on his lap, his dog lying at his side.[26] The work is playful, and striking in that Ader is central to its composition. It is not, however, a self-portrait, and it reveals little about him. The piece has more in common with his college pranks and unresolved graduate work. Ader must have felt the absence of an intellectual core in this work, since his subsequent art, particularly that which engaged with the problem of falling, became more philosophically focused.

Ader wrote hardly anything concerning his ideas about falling in his notebook, a sparse collection of thoughts, asides, wordplay, and directives for future works that he started, presumably, a year after receiving his MFA and continued at least until the summer of 1971.[27] The notebook contains hints as to paths he might have followed with certain projects, as well as ideas he deemed inadequate. There Ader wrote

Instead of making mudpies out of ~~made out of elephant skin.~~

made out of
elephant
skin.

I wore wooden shoes
and trained the Crocodile i found in the
kitchen sink to win bicycle ~~races~~

of
gas

then a BIG TRUCK with gerani-
ums for wheels came by carry-
ing a cannon and six thousand (6000) steel
shovels.

the same night I saw the seven (7) beau
ties gang (7) up on the sleeping ~~way~~ and put
his head in a bucket of coffee.

Later I cleaned my nose with the
vacuum cleaner while tragically
and known to only few, the little fish
that could already swim when it was only
four (4) days old, drowned in mid air.

Figure 4. Bas Jan Ader, *What Makes Me so Pure, Almost Holy? And More* and *What Does it Mean? Cheep Cheep*, 1967. © The Estate of Bas Jan Ader.

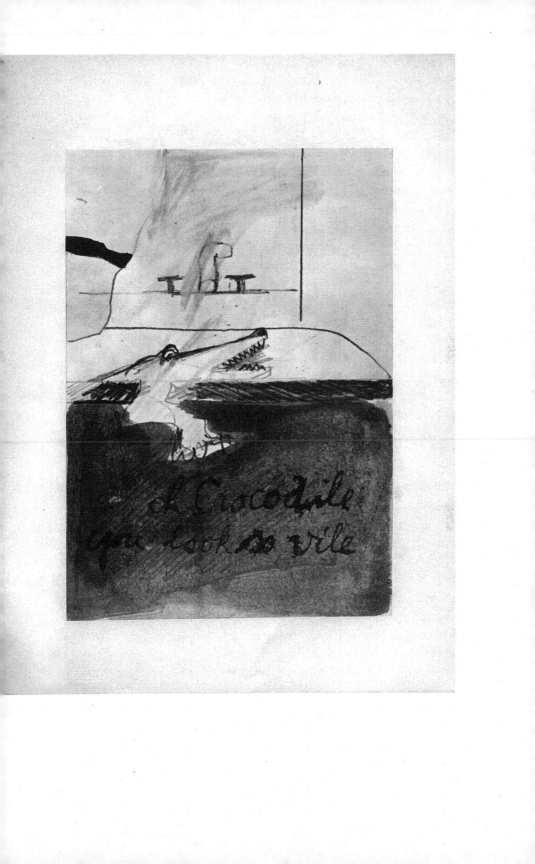

such fragments as "Prolegomena for 16 falls fraught with extreme personal danger," "The Fall of Far Out Modern Sculpture," "The Fall of Jericho quite literally painted with letters falling(en) off a wall," "device to prevent the falling of people (objects)," "fall in Vermont big red leaves fall on me," "I move about & things fall on me (bricks) while I save a cup of tea from spilling," "the earth will fall beyond where it will be tomorrow," and "all is falling." Additionally, he reminds himself to "do film 'nude descending staircase,'" an obvious allusion to Marcel Duchamp. There is also an undated scrap of paper bearing a quote from John Milton's *Paradise Lost*: "The Lord speaks: 'I made him just and right, sufficient to have stood, though free to fall.'"[28] These fragments are teasingly ambiguous, almost as open-ended as *Fall 1, Los Angeles*. The phrases Ader recorded had obvious appeal, but he rarely titled his work so wittily. If anything, his notes hints as to how he brought his art into the world, not koans for understanding his creations.

Perhaps most intriguing are several newspaper clippings he collected around 1972 and 1973, after he completed the majority of his fall pieces.[29] It does not seem that he scoured the *Los Angeles Times* on a regular basis, nor do the clippings, most of them photographs, respond to or anticipate particular works. Instead, the content of the images, often with telling captions, offers a glimpse into Ader's feelings and thoughts on falling. One shows a Brooklyn man who had threatened to jump from the window of a building; a priest and a police officer convinced him not to, but as he backed away from the edge he slipped and fell — fortunately into the safe embrace of a police net below. Another captures a distraught husband in Recife, Brazil, pleading with his wife not to leap to her death with their one-year-old child; in the photo, he reaches to grab his daughter from his wife, who, after hours of coaxing, would ultimately choose not to jump. In these dramatic scenes the end seems inevitable, but in each tragedy is averted. The two photographs show moments when two individuals confronted the most fundamental decision — to live or to die — with both eventually opting for life.

Another pair of clippings, however, strikes a different note. An illustration from a Jehovah's Witness magazine shows a burly man, muscles straining, struggling to row his small boat out of the overwhelming currents pulling him toward the lip of a massive waterfall. The fatalistic belief of the Jehovah's Witnesses suggests the outcome of

the implied narrative, and Ader may have seen it as expressive of his own worldview. The tragedy depicted is metaphorical, in contrast to the other clipping, which also involves a waterfall of sorts: it depicts a rescue team trying to save someone who has been swept over the Cedar River Dam in Iowa. The scene is chaotic, the boat nearly capsized. Moments later, one of the rescuers shown would fall overboard and himself drown. It is obviously chilling to know that the image captures life on the verge of death, to recognize that, in the attempt to do good, to save a person threatened with death, another life would be lost.

Before Ader began to cull these images he did an interview with the journalist Betty van Garrel, which appeared in the *Haagse Post* in the first weeks of 1972.[30] Van Garrel focused on Ader's interest in falling, the tragic, and on how the death of his father at the hands of the Nazis affected his enigmatic art. In retrospect, Ader regretted consenting to the interview. He found it to be filled with inaccuracies and insensitive toward his current and completed works. In a letter to Van Ravesteijn and Van Beijeren, he describes the article as an absolute farce and even wonders if Van Garrel's intention was to be malicious.[31] Two years later, in a letter to the curator of the Groninger Museum, Poul ter Hofstede, he declared that he "shall never again give interviews to the popular press."[32] Despite Ader's protests, the powerful and compelling statements Van Garrel attributed to him ring true, especially when he says, "I have always been fascinated by the tragic. That is also contained in the act of falling; the fall is failure."[33]

As the phrases dotting his notebook attest, Ader derived pleasure from various kinds of wordplay. He was attracted to the similarity of the words "fall" and "fail," in sound and in spelling. Leavitt mentions the fall-fail relation in his discussion with Andriesse in 1980, and in the writing on Ader since his death, the conjunction of the physical act of descent and a quality of abjection has consistently guided interpretation of the work.[34] In almost all accounts, with a couple notable exceptions, Ader's connection with failure has been posited as a sign of his passivity—of a sense or conviction that his shortcoming was foreordained, beyond his control, and that, if anything, he was a victim.[35] This presumption of passivity colors the allusions to failure despite the evidence of the *Fall* works, in which, almost always, some gesture or subtle movement represents a choice made, an exercise of

individual will, even if there are doubts throughout all of the pieces as to the efficacy of the will.

On June 1, 1970, a couple of months after completing *Fall 1, Los Angeles*, Ader opened a one-week solo exhibition at Chouinard Art School in Los Angeles. The show consisted of a single installation, *Light Vulnerable Objects Threatened by Eight Cement Bricks* (fig. 5). Positioned throughout the room were several eggs, two pillows, a radio, flowering plants, an arrangement of paper bags, a store-bought sheet cake reading "Happy Birthday," a poster (or perhaps a photograph) of a dark-haired woman, and a string of lightbulbs. Above these objects were eight cinder blocks suspended by rope. Formally, the regularity of the cinder blocks — most hanging slightly askew — contrasted nicely with the everyday objects, which had no special significance beyond their shared fragility. At some point, after the opening, Ader went through the room and, one by one, cut the ropes, allowing the blocks to crush whatever was below. The poster received little damage, which could not be said for the cake or the lightbulbs. The plant survived somewhat; the flowers on the edge remained standing, while those in the middle were flattened. The image of the block resting among the yellow flowers is quite poetic, so too the idea of Ader walking through the room destroying random things. It was part of the performance to exercise his will, and with eight decisive actions Ader set in motion the events in which fate would run its course.

3

The corner of Kerkstraat and Reguliersgracht in central Amsterdam, where the Herengracht, the Keizersgracht, and Prinsengracht form a half circle that radiates outward, is like much of this picturesque part of the city: sixteenth- and seventeenth-century houses packed closely together, made almost exclusively of brick that is either left in its natural red or painted a blackish gray. These inviting structures are strangely conventional, never deviating much in order or in kind. Many have extremely large windows, seemingly out of proportion to the rest of the building, but offsetting the effect of the endless gray skies that dominate a city whose only points of elevation are the bridges spanning the canals. Some of the buildings lean forward, their tops reaching beyond their foundations. This architectural quirk en-

abled merchants using pulleys mounted near the tops of the structures to lift goods more easily to storage areas on the upper floors. It also makes the houses seem to bow gently to passing pedestrians, cyclists, and slow-moving barges.

It was the summer of 1970, and on the eastern side of the Reguliersgracht Mary Sue Ader manned a 16-millimeter camera. The camera, fixed in position, was trained on a spot across the canal, with one edge of the pictorial frame capturing the point where the Kerkstraat intersects with the Reguliersgracht. Leavitt and Van Elk were there as well, with at least one of them standing on the opposite side of the Reguliersgracht. They both took photographs as events unfolded, and one of their pictures is exceptionally beautiful, its color composition standing in stark contrast to the black-and-white footage that would become *Fall 2, Amsterdam*. The photo shows Ader, on a bicycle, plunging toward the canal. It is slightly blurred, suggesting a rapid descent. Ader holds a bouquet of flowers in his right hand, his eyes focused on the murky water several feet below. The picture is more dramatic than the film, as is another color image that simply shows the flowers Ader once held floating listlessly in the water. Both suggest something spectacular, even romantic — the melancholic inevitability of the moment permeating every aspect of the photographs.

The finished film is nineteen seconds long, six of which are given to the title (fig. 6). Ader emerges from Kerkstraat and turns right on the Reguliersgracht. He pedals slowly, wobbling just a bit, as one does when traveling in a languid, casual manner. There is no one else visible, no barges moored to the side of the canal. A small car is parked at water's edge; its trunk protrudes into the shot. Compositionally, the piece seems to share qualities with structuralist film: a fixed image, no zooming or panning, no application of effects. The wall of the canal bisects the picture, providing a sort of horizon line. A fair amount of unused footage has survived, shots that suggest the piece was initially more about an Amsterdam street scene than a stirring event. People are walking, a duck floats in the canal, and some individuals cross the bridge as a taxi drives down the Reguliersgracht. Ader had to time his action precisely, and as he enters the frame in the completed version of

Figure 5 (*following pages*). Bas Jan Ader, *Light Vulnerable Objects Threatened by Eight Cement Bricks*, 1970. © The Estate of Bas Jan Ader.

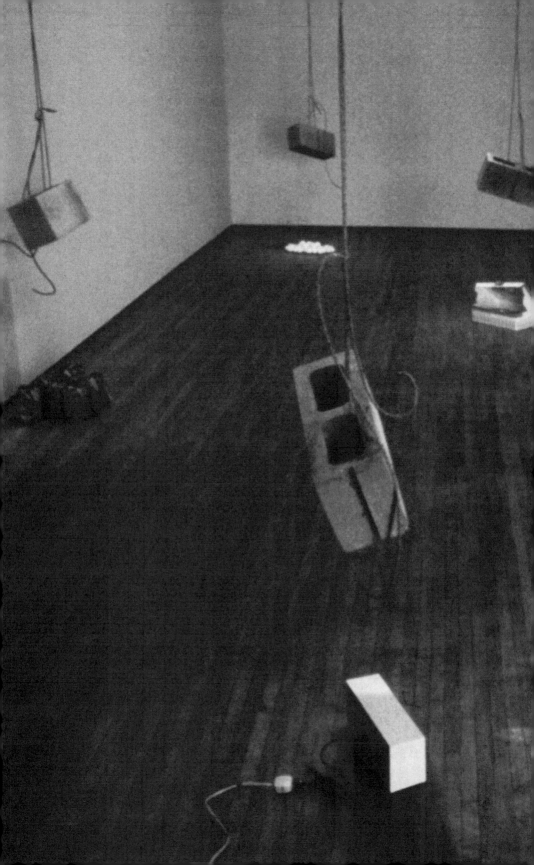

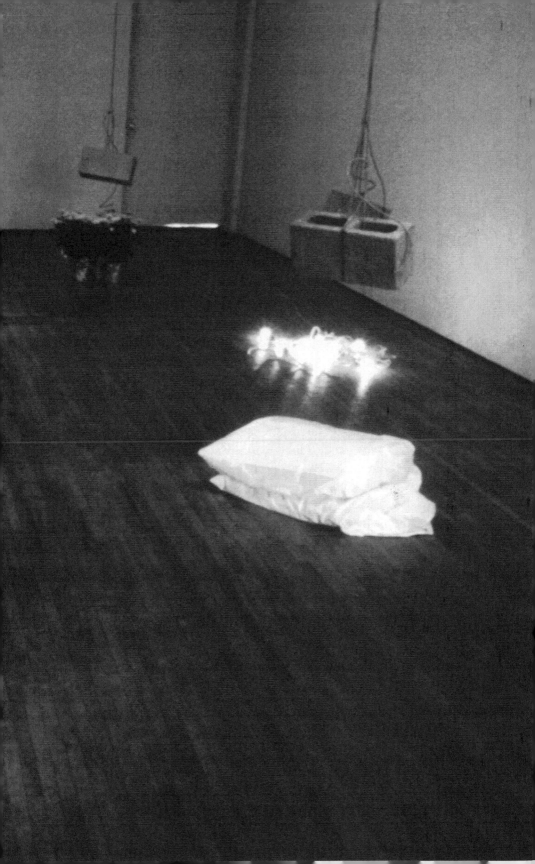

Figure 6. Bas Jan Ader, *Fall 2, Amsterdam*, 1970. © The Estate of Bas Jan Ader.

the film there is little hint of what will happen. He passes a couple of trees, which obscure him from view, then heads toward the canal, maintaining a steady pace. He approaches the edge and turns ever so slightly to his right; for an instant he seems to straddle a fine line between falling and not. It is hard to prove, and repeated viewings only create more ambiguity, but it appears that when Ader is at the point of no return, he leans his bicycle into the fall in order to propel himself downward. Regardless of active intent or unintended passivity, Ader hits the water almost face-first, his torso taking the brunt of the impact as his bicycle disappears from view. The film quickly fades to black, leaving the fate of Ader and the ramifications of his actions shrouded in suspense.

Fall 1, Los Angeles and *Fall 2, Amsterdam* were shown on the same reel in the summer of 1971, when they were included in the film section of the major international exhibition *Sonsbeek buiten de perken*.[36] Although conceived as separate pieces, the material conjunction makes them a kind of diptych, within which one is free to read associations, connections, and even a progression of ideas. Both commence in medias res, with no prologue or explanation of why Ader is sitting on a roof or bicycling by the canal. The events are presented as ordinary occurrences that abruptly become highly unusual experiences. And

however oblique the origins of the action in the two pieces, their conclusions are equally ambiguous, since there is no aftermath, no opportunity to see whether Ader has been harmed. He makes it impossible to know what exists beyond the confines of the film, and he forecloses speculation by means of hermetic compositions that enforce the fictional contest between the will and determinism. In each piece, and within the framework of submissiveness, Ader performs noticeable acts that counter his otherwise studied passivity. What is not clear, though, is the benefit he gains from his freedom, since neither film depicts the importance of choice. If anything, the films distinguish themselves from one another in terms of their mood. *Fall 1, Los Angeles* comes across as unintentionally heroic because of the absurdity of its situation and the forcefulness with which Ader appears to hit the ground, whereas *Fall 2, Amsterdam* stands out for its pathos, a sentiment grounded in the conditions of ordinary life: he cycles — like almost everyone in Amsterdam — and then suddenly turns toward the water, the force of the impact causing him to flinch meekly.

Sonsbeek was the first exhibition Ader participated in that included major American artists like Carl Andre, Donald Judd, Robert Morris, and Robert Smithson. Staged primarily in the Dutch city of Arnhem, much of the ambitious program took place outdoors, with a number of works occupying a large eighteenth-century formal garden. Critics of the show commented on its thematic and practical disorganization. Presenting an array of singular artistic positions, it had little conceptual unity. Nor had the curator, Wim Beeren, completed the installation by the time of the opening.[37] Ader had received an invitation in early April to exhibit as part of a separate film program held in an inflatable tent close to Sonsbeek Park.[38] A number of interesting artists were slated for this section, and it was an achievement for him to be presented in such company. In a letter written in impeccable English, Ader accepted the invitation, but with several caveats: he hoped that the curator would find a less "avant-garde" way of showing his and others' works, and, "in view of the fact that I have lived in the U.S. for the last 10 years and the list of Dutch artists already appears to be inflated with too many names, most of whose work appears to be of questionable international merit, I wish to be included among the U.S. contributors."[39]

The latter request was denied, but it does reveal the degree to which

Ader identified with his adopted homeland and its art scene. His implicit critique of the show was well founded, as some of the best works in *Sonsbeek* were by Americans, especially those who exhibited far from the exhibition's primary venue. *Sonsbeek*'s dispersed nature facilitated the creation of several earth works by such artists as Robert Smithson, whose *Broken Circle/Spiral Hill* (1971) was made in a quarry on the outskirts of Emmen in northwest Holland, about fifty miles south of Ader's childhood home in the furthest reaches of the Groningen province.

Ader was born in the town of Winschoten on April 19, 1942. His father, Bastiaan Jan Ader, for whom Ader was named, was the minister for the parish of Nieuw-Beerta, situated close to the German border. The church from which the elder Ader led his Dutch Reform congregation was like many in the region: a brick structure, built on the slightest of rises, with a rectangular plan that welcomed astringent Calvinists into an open space devoid of images but awash in sunlight. At the time, the Aders lived across from the church in one of the few houses of the village. It was quite stately, considering the rustic location, but Groningen was one of the more prosperous regions of Holland, its farmers becoming wealthy owing to projects to reclaim land from the ever-encroaching sea.

Ader was born during the height of World War II. His parents, uncomfortable with the situation and morally opposed to Nazism, were active members of the resistance and helped save around two to three hundred Dutch Jews from deportation to German camps. Ader's father was a major organizer in the resistance movement, helping, in particular, Jews who worked in an Amsterdam hospital find safe shelter in the countryside. The Aders hid Jewish families and individuals for indefinite periods of time, an enterprise that required everyone in the family, and everyone who worked for them, to maintain secrecy. The immense difficulty of the task was compounded by Nieuw-Beerta's geography. Its proximity to Germany intensified anxiety, and the flat landscape afforded no natural hiding places; Ader's family home was out in the open for all to see. Shuttling Jews in and out had to be done under the cover of darkness or the shroud of fog, with local members of the resistance relying upon their knowledge of footpaths to traverse the muddy fields.[40]

Ader had memories of artillery fire and the flashes of distant combat seen from the second-story windows of his family home.[41] It is hard to separate what he observed from what was added by his adult imagination—a projection of things he thought he should have seen growing up in the midst of war. His family did have several encounters with the Nazis. On at least one occasion, Nazi soldiers ransacked their home, telling Ader's mother to pack her things and remove herself and her two young children. Clothes were scattered about violently, pictures, furniture, and personal effects thrown carelessly out the windows. Worse, Ader's father, then in central Holland, was arrested for his involvement with the resistance and imprisoned by the Germans. It was during this confinement, knowing that his death was inevitable, that he came to truly know the strength of his faith. On the night of November 20, 1944, just sixteen days after his second child, Erik, was born, he and six other prisoners were pulled from their cells and taken to a spot in the woods where they were to face a firing squad. Ader's father asked to go last in order to comfort the others and prepare them for their journey to the next world.[42] This generous act meant that he had to see each of his companions killed. He then met his fate with a strength of conviction that haunted his eldest son for the rest of his life.[43]

After the war, the family moved to the nearby village of Drieborg, and it was here that Bas Jan Ader spent much of his youth. His mother was financially well provided for, not only because of a government stipend for families of war veterans, but because her parents were well off.[44] The house she had built in 1947 was sizable yet modest, especially compared to the palatial estates built twenty or thirty years earlier, which combined the manor house with a tremendously large barn. Situated close to the road, the two-story structure was separated from traffic by a neatly kept lawn. Across the road and visible from their living room was a cultivated field. Behind the kitchen was an attached one-story structure, a fairly large, rectangular room with windows on its long sides. Toward the front of the room was a small dais and space enough for twenty to thirty people to fit comfortably. Here Ader's mother conducted weekly services, providing pastoral care to the congregants of Drieborg. The room also served as an ad hoc community center, where people would gather during the week to discuss

concerns and share news. Home life and church life blended seamlessly, the domestic space of the family and the devotional space for the village residents separated only by a door.

Ader was an irascible child, antagonistic toward authority figures and indifferent at best when it came to his studies. His performance in school was poor and his behavior subject to discipline. When he was fourteen, his mother tired of dealing with his transgressions and sent him to a foster home. The period away lasted a year; upon his return home he continued his education at the local grammar school. The following year he was on the move again, attending a boarding school for the next academic year. Much of Ader's time outside of school, though, was spent on fishing boats that trawled the coastal waters not far from Drieborg. He also worked regularly on a nearby farm, and the owner's household became like a second family. Throughout this period of delinquency and manual labor, Ader's mother never hid her desire for her firstborn to follow in his parents' pastoral footsteps. Indeed, it was presumed that Ader would become a minister. Each Sunday he and his brother would help their mother with the service, doing many of the little things necessary to facilitate the congregation's worship. Calvinist Protestantism was part of the Ader's daily life, as it was integral to his mother's being. The sacred and the profane were never held in opposition, but melded into a deeply spiritual life in which faith was a constant and moral standards high.

In his *Institutes of the Christian Religion*, John Calvin stressed that the fall of man derived from Adam's lack of faith.[45] The descent from paradise, when man became manifestly human, occurred because Adam questioned the knowledge of the Divine. In Calvin's rendering, Adam's doubt was presumptuous. To try to comprehend God's will is an act of hubris; God's divinity is knowable only through grace. Calvin, who was deeply influenced by the writings of Augustine, reached a compelling understanding of Christianity, wherein man's will was essentially denied. At stake was not only the accountability of man in the eyes of God, but also an understanding of God's omniscience and the economy of his goodness. As Augustine states in both *Confessions* and *Of Free Choice of the Will*, the status of the will, its conceptualization as a human faculty and an attribute of reason, is necessarily a question concerning evil.[46] Augustine points out that God stands for all that is good and by his very nature is incapable of sin, yet evil still persists among

those who are made in his image, and it is necessary to account for the contradiction. The one logical explanation is that man was given the ability to exercise free will in order to choose whether to do good or to do evil. God did not foreordain transgression, but enabled each individual to decide the course of his actions. The role of necessity — what one essentially does, out of natural compulsion — creates a problem in Augustine's formulation, because of its connection to God and his creation of man. Nevertheless, the will gives individuals a degree of freedom from God's dominion, and is also the theological principle that relieves God of culpability for man's transgressions.

Calvin's conception of the will expanded upon Augustine's. There are moments when Calvin became more severe in his belief: at times he conceives of the will as nonexistent, except in the case of sin. Calvin laments man's flawed nature and the passing of God's punishment for Adam's transgression, original sin, from generation to generation. The path to the deliverance promised by God can only be opened by grace.[47] Calvin follows Augustine in ascribing any willed movement toward goodness to God's intervention. Faith is a gift from above, not something consciously attained. Any redemptive act by man or woman derives only from God's benevolence, while sin, not borne of necessity but committed through the power of reason, is the fault of man alone.

Ader never mentioned Calvin in any public statement, nor does his name appear in Ader's notebook or other written ephemera. Yet elements of the Christian reformer's conception of the will correspond with aspects of *Fall 1, Los Angeles* and *Fall 2, Amsterdam*.[48] The associations are at once general, in the way Ader describes gravity's omnipotence — a substitute for God's will — and specific, in the gestures through which Ader aids or hastens his descents, acts of will that would be impossible without gravity's impetus or, it could be said, God's grace. But to leave the link between Ader and Calvin at this point would be to disregard nuances in both. If one infers that Ader's engagement with falling bears a direct relation with his Dutch Reform background, then these ephemeral pieces speak to the fall of man. Calvin, as well as Augustine (and for that matter, almost all Christian thinkers before the Reformation), links the question of the will to that of morality: one makes a choice that invariably impinges upon salvation. Ader's works lack this theological sense of sin, which echoes through-

out Calvin's writings. Ader's moralism is more ambivalent, less spiritual. It is hard to tell in *Fall 1, Los Angeles* and *Fall 2, Amsterdam* whether something is righteous or not. Conceptions of good and evil are unimportant in this context; in the case of Ader's first *Fall* films the subject is closer to freedom as such. There are hints of the element of failure, but not as is commonly assumed: to the degree that he falls because gravity demanded it, his action is successful. To the degree that his interventions at once mark an interruption in the dominion of gravity's will and facilitate that which is preordained, he succeeds as well. Failure, in Ader's initial *Fall* films, lurks in the overall tragedy of the situations, not a tragedy that is necessarily romantic in the banal sense, but tragedy in the face of an inexplicable fall and the irredeemable loss of free will.

✦

Ader never fulfilled his mother's pastoral expectations. Not long before he headed to Washington, DC, for his year abroad, he renounced his faith in God, incapable of believing in a system that seemed untenable.[49] He did not criticize those who remained believers, nor did he disparage the importance of faith in other people's lives. But, for him, the Trinitarian structure of Father, Son, and Holy Ghost rang hollow, salvation seemed arbitrary, and God's justice appeared without reason. In doctrine's stead, like many young adults of his generation, Ader found refuge in the writings of Albert Camus.[50] Camus's philosophical works and literature provided a moral center for Ader, one that did not derive justification from a higher power, but instead focused on the individual and the choices he made in an inexplicable world. In the decade between Ader's immersion in Camus and the development of his *Fall* projects, a number of other intellectual influences (from Hegel to Wittgenstein) helped form his worldview. But throughout, he seems to have internalized aspects of Camus's thought, which served as a foundation upon which he built other ideas: a point of departure, often emanating from *The Myth of Sisyphus*.[51]

Camus begins his famous essay thus: "There is but one truly serious philosophical problem, and that is suicide."[52] This provocative statement takes the ontological question of being and frames it in terms of willful death. Yet from there he proceeds, not to think about the end

of existence, but to ruminate upon life and how to function in a world that is increasingly alien to man. Camus sensed that the meaning of life was fading rapidly, leaving the relation between man and the world strained, if not severed. He characterized this phenomenon as the condition of absurdity, and it is this state of being that he pits against suicide, the ultimate reproach to the habit of living. Yet suicide, after its initial prominence in the essay, fades away, as the life-affirming aspects of Camus's argument emerge, for it is not the meaninglessness of life that matters but how one lives it. Camus distills this understanding into the tension between rational man and irrational world, a dichotomy that the wide range of existential and phenomenological inquiries of the then recent past had been unable to resolve. Camus spends time parsing these various arguments, coming to the conclusion that what typifies the quest to divine true meaning of the irrational world in the writings of Martin Heidegger and Karl Jaspers is the desire to announce with confidence, "This is clear."[53]

The inability to take stock of the irrational world implies that apprehension of the absurd is not the same as the condition of the absurd. The irreconcilable nature of the sensory and the ideational precludes setting forth any generally acceptable definition of the phenomenon. Nevertheless, Camus, working through the writings of Søren Kierkegaard, suggests that "the absurd is sin without God"—a formulation that must have appealed to Ader, since the moral-theological structure in which he was raised had now been transformed into a secular model, wherein God's judgments no longer matter though free will does.[54] Camus's conception of the will began with the presumption that man sought to reconcile the rational and the irrational, with the understanding that the absurd rests between the poles. To unify the fundamentally opposite requires a leap of faith, and one no different from what Christianity asks of its followers. But the absurd man, caught between antagonistic positions, does not want to commit to something he does not fully comprehend. It would be irresponsible to embrace a position of passivity, to cede one's will to unknown forces. Instead, the absurd man chooses to live without appeal, without recourse to a faith blinded by the unknown. This allows one to accept one's fate consciously, all the while understanding that it is absurd. Camus sees this condition of self-reflexivity—what might be presented as the essential act for truly living—as creating a permanent state of revolt:

"Revolt is the certainty of a crushing fate, without the resignation that ought to accompany it."[55]

The paradox of this statement—that one willfully embraces what is foreordained—is for Camus the source of individual liberation. He is not concerned with metaphysical freedom, or what might be considered freedom, as such. Instead, he thinks of freedom as it relates to him as an individual, as a sentient being who experiences a world controlled not by an almighty God but by another ruthless force: the State. But what could become a political diatribe then slips into another sort of discussion; Camus argues that freedom is only possible with the promise of the eternal.[56] Freedom of this sort, and its connection to the afterlife, are illusions that arise without the revelations of the absurd, for the enlightenment that comes from the fundamental state Camus celebrates is the recognition that there is no future. Real liberation lies in the acceptance of one's circumstances, the acknowledgment of one's place within a causal chain of events. One is free only upon realizing that he is bound to his fate, a recognition that places death at the furthest reaches, its singular experience of truth repelled by a desire for the here and now, a desire to live, as Camus says, without appeal. It is a strange way in which to exist, with no teleological goal except forestalling the ultimate end, no real freedom when one considers that death will come whether one wants it to or not.

Does the freedom Camus describes say something about the will Calvin ostensibly renounces and Ader complicates in his films? Hannah Arendt commenced a series of reflections, just a few years after Ader began his work on falling, on both the faculties of thinking and the will.[57] In her ruminations on the will, which in many ways are a summation of the great thinkers on the subject, a quiet argument emerges that can be seen as a blend of Calvin's and Camus's positions. Her subtle claim helps reveal the full implications of Ader's engagement with the will, for as she contends, taking as her starting point, much like Calvin, the work of Augustine, a willed act is only that if there is a possibility for its converse. This profoundly simple observation leads to a fatalistic assessment that is akin to Camus's findings. Arendt hazards a claim that begins with Augustine's concept that being and time originate together, a point of view "affirmed by the fact that each man owed his life not just to the multiplication of the species, but to birth, the entry of a novel creature who *as* something en-

tirely new appears in the midst of the time continuum of the world."[58] Origins, therefore, are not located in creativity, but in what Augustine calls, in *City of God*, "natality," which leads Arendt to say that this tells "us no more than that we are *doomed* to be free by virtue of being born, no matter whether we like freedom or abhor its arbitrariness, are 'pleased' with it or prefer to escape its awesome responsibility by electing some form of fatalism."[59]

"Doomed to be free." Arendt's phrase is haunting, in large part because it captures many of the themes implicit in Ader's early *Fall* work. Her pithy formulation both speaks to Calvin's assertion that anything one wills toward the good is because of God's grace, and conveys Camus's sense that freedom comes from the realization that one is not free, that one essentially has no will, or at most a will that has little efficacy on events. Arendt's observation is shrewd because it does not directly pit determinism against the will; no opposition exists between freedom and fatalism, no reductive choice between radical passivity or its converse. Her approach is more fluid, in that it accounts for an exchange between one's will and forces of a higher power. That is not to say that the give and take is in equal measure, or that it strives for a kind of harmony where obviously there is none; instead, it says that one is in fact free, but not of his own choosing. Arendt's doom is an oblique fatalism — a determinism in which freedom is bestowed on the basis of birth. But this gift is not without conditions, and those conditions can be as much, if not more, of a burden than living life under the auspices of a divine will. Freedom, as she describes it, is not necessarily positive, nor is it a quality that allows one to be an agent of change. One may will something freely without any effect besides perpetuating the doom initiated with one's birth.

It is this last sentiment, so clear in retrospect in both *Fall 1, Los Angeles* and *Fall 2, Amsterdam*, that emerges fully in Ader's *Broken Fall (Organic), Amsterdamse Bos, Holland* of 1971 (fig. 7). Ader was once again in Europe for the summer, and during this time abroad he enjoyed a remarkably fecund period in his practice, making a number of works in Holland and in Sweden. *Broken Fall (Organic)* was filmed on the outskirts of Amsterdam, in a large, open parkland called the Amsterdamse Bos. Its spacious fields and numerous paths are crisscrossed by manmade canals, often separated from the earthen shores by wooden barriers. Like much of the Dutch countryside — spaces where the spread

Figure 7. Bas Jan Ader, *Broken Fall (Organic), Amsterdamse Bos, Holland*, 1971. © The Estate of Bas Jan Ader.

of civilization has been somewhat resisted — the perspective is skewed by the multiplicity of horizon lines formed by the planar landscape, the uniform tree line, and frequent low cloud banks.

Ader worked that day with Peter Bakker, one of Erik Ader's closest friends and a knowledgeable cameraman and film editor. They fixed the camera to a tripod, focusing it on a sizable tree whose bare branches extended over a narrow canal. The film opens with Ader hanging from a branch about fifteen to twenty feet above the ground. No clue is given as to how he got there; no backstory explains the unusual circumstance. Instead, it could be said, following Arendt's idea of natality and how one is doomed to freedom, that Ader was born into the piece. He is in a precarious position. He shuffles his hands slightly, moving himself further out on the limb. He adjusts his grip, looking up occasionally to check the integrity of the branch. After a short while, his body becomes still. He looks to the side. Again, his hands begin to move — his grip loosening and shifting — and, responding to that disturbances, his torso and legs sway. As calm subsequently returns, he glances again to the side and then above. The relative peace continues

for a while. It seems longer than it is—the entire event takes a little more than a minute—but the tension draws out time, as when Ader slowly tilted off his chair in *Fall 1, Los Angeles*. Just when things seem to settle into some degree of stasis, Ader looks down toward the water for the first time. In an instant one hand releases, then the other, his body plummeting. He lands forcefully in the canal no more than a foot or two deep.

As with *Fall 1, Los Angeles* and *Fall 2, Amsterdam* there is a critical moment, so brief it can be easily overlooked, in which Ader makes a choice. In the two earlier works, conceived in terms of the idea that a deterministic force, gravity, holds sway over the situation, the exertion of the will—shuffling to clear the veranda, leaning into the fall—both momentarily suspends gravity's reign and accelerates the event, suggesting that no way exists, even when one is not passive, to escape what has been foreordained. *Broken Fall (Organic)* is slightly different. The piece is expressly about freedom, about the will, about the ability to make a choice that has a corresponding nonchoice. Determinism lurks, but it is of a different kind, not something malicious like gravity or potentially random like God. Instead, it is freedom itself that controls the situation; it is this quality that has *doomed* Ader. Hanging from the branch, high above the canal, Ader was presented with a choice: he could continue to hang on, or he could let go. Whatever option he settled upon the result would be the same: a tragic descent, which was Ader's concrete truth.

REPRESENTING

5

In the autumn of 1970, when Ader made his famous declaration to Willoughby Sharp — "I do not make body sculptures, body art, or body works. When I fell off the roof of my house, or into a canal, it was because gravity made itself master over me" — he was attempting to set his practice off from that of others. Why he was so severe in his assessment is not entirely clear. He was not unaware of the Los Angeles contemporary art world, nor that of New York and beyond. He knew these scenes well, following developments, reading magazines and exhibition catalogs, seeing shows scattered throughout Los Angeles. If he was taking a stance toward contemporary art and its attendant community, it was one of irony and antipathy with a hint of detachment.

Perhaps what best captured his sentiment was the collaborative and playful "art journal" Ader published with Leavitt in 1969 and 1970.[1] Entitled *Landslide* — a parodic reference to land art — it was a handmade pamphlet, produced in small runs and printed on a Xerox machine. Ader and Leavitt sent their polemical pamphlets out anonymously, forgoing claims of authorship in order to intensify the critique. The content was peculiar: one illustration showed a car swept aside by a landslide, as other drivers, standing outside of their vehicles, looked on in disbelief. The third issue presented, under the heading "Expandable Sculpture 'Untitled' 1969," an editioned work by the fictional artist Paul Hopkins; it was an ugly object, looking like rancid sausage or even human excrement — perhaps a reference to a work featured in the first issue by another imaginary figure, Brian Shitart. Elements of *Landslide* are reminiscent of Ader's pranks at Otis, or even his enjoyment of the slapstick comedy of W. C. Fields.[2] The tongue-in-cheek nature of the bulletins seems removed from the *Fall* films, too playful to be considered rigorous but topical enough to suggest Ader's competitive relationship with the art world.

It has been assumed over the years that Ader's statement implicitly refers to Chris Burden, an artist four years younger than Ader who attended Pomona College around the time Ader was in graduate school

at nearby Claremont College, and who from 1969 to 1971 worked toward his MFA at the University of California, Irvine.[3] Ader might have known about Burden when he spoke to Sharp in 1970, although Burden had not yet exhibited, and canonical works like *Shoot*, from November 1971, were made after Ader had produced most of his *Fall* pieces. But by 1973 he must have been familiar with Burden's art, probably becoming aware of it around the time the documentation of *Shoot* was published in *Esquire* magazine in March of that year. The gallerist Claire Copley, who would show Ader in 1975 and had met him already in 1973 through Allen Ruppersberg, remembers Ader thinking Burden's art too physical and without a sense of poetics.[4] Ader's assessment may be only an example of his prejudices, but whether he liked it or not, there are aspects of Burden's practice that shed light on Ader's, especially when Burden says such things as, "In all of my pieces I have to be able to accept the outcome, whatever it is; this is how I can do pieces that to other people seem particularly dangerous or self-destructive. Once I make a decision to do a piece, it is as if it is fated to happen."[5]

Burden's quote appeared in an interview from 1975, in which he spoke about his performances in terms of sculpture and discussed how, like many other California artists, he thought of his work as primarily visual. There is merit to this view — especially since, as Burden describes, few people actually discuss the formal aspects of his art. But the evocation of fate, especially its action after a willed decision, seems similar to Ader's concerns from the first part of the 1970s. Burden, however, formulates the relation between the will and determinism differently; there are no omniscient forces controlling his actions. He makes an initial choice as to the constitution of his piece, and from that point forward fate runs its course. To a certain degree, what Burden describes is akin to the way Sol LeWitt devised instructions for wall drawings, which assistants would execute following the logic of his directions. There are many other instances of what might be considered an elision of subjectivity, where authorial voice — for example, that of Lawrence Weiner or On Kawara — was obviated by rule-based systems that depersonalized the work of art. Burden's situation is different from that of LeWitt or other conceptual artists because his primary medium is himself, not a concept or something pointing back toward an idea. His body was on the line, subjected to potentially life-

threatening circumstances in the name of art, but ultimately in the hands of fate.

On April 26, 1971, Burden climbed into a storage locker on the UC Irvine campus, where he remained for the next five days. The locker was two feet high, two feet wide, and three feet deep. Directly above was a five-gallon container of water; just below, in another locker, was an empty container of the same dimensions. Each container was connected to Burden's locker by a tube passed through a small hole. Much of *Five Day Locker Piece* is about Burden's body acting as conduit for the fluid, moving it from one place to another, its constitution changing on its journey through Burden's internal organs. In this light, Burden was just a medium, a facilitator for the movement of water, much as soil is a medium that brings rainwater to a tree's roots. Yet this aspect of the work, its giftlike quality, is overshadowed by the privation Burden willfully endured. He submitted to the logic of the piece, a claustrophobic captivity in which he could do nothing except wait for the allotted time to pass. In terms of the will, he made a choice that had a converse, and the subsequent work of art concerned the ramifications, which were never good and evil, but the possibility of death.

A few months later, on November 17, Burden initiated what would become his best-known performance, *Shoot* (fig. 8). It took place at a small nonprofit venue, F Space, in Santa Ana, in the heart of Orange County. Burden was there with a friend with a .22 rifle, as well as twelve others, whose identities remain unknown.[6] In a video produced several years after the fact, detailing many of his performances from the early 1970s, Burden describes the scene for *Shoot* without emotion. His prologue tells viewers what to listen for, as the audio recording begins before the visual. The voices one hears are muffled, although it is possible to discern the marksman asking Burden where he is going to stand. Burden replies, probably with a gesture, and then asks his friend, standing no more than fifteen feet away, if he is ready. The super-8 camera clicks on, its familiar whir audible in the recording. The footage shows the shooter, a long-haired man dressed in dark trousers and a white sweater, as he takes aim. Burden stands in front of a white wall, his left arm—the target—held slightly away from his torso. After a couple of seconds, there is a bang. Burden weakens a bit in the knees, making it seem as if he may have been hit somewhere other than his arm. The wound, he hoped, would need nothing more than a Band-

CHRIS BURDEN
Shoot
November 19, 1971

Figure 8. Chris Burden, *Shoot*, F Space, Santa Ana, CA, November 19, 1971. "At 7:45 p.m. I was shot in the left arm by a friend. The bullet was a copper jacket .22 long rifle. My friend was standing about fifteen feet from me." © Chris Burden. Courtesy of the artist and Gagosian Gallery.

Aid, but the impact he described as feeling as if a truck going eighty miles per hour had hit his arm.[7] In the film, he takes a few quick steps forward, regaining his balance. His right hand covers the injury, and only now he looks to see how severe it really is. A photograph taken a short time later shows a stunned-looking Burden seated in a chair, his arm already dressed, as the shooter applies a tourniquet. Burden soon left F Space for the hospital. In the police report he says that the injury was an accident, refusing to admit to his complicity in an illegal act.

In the ensuing years there has been much discussion of Burden's subjectivity, attempts to determine why he would submit to something so dangerous. Some writers have referred to masochism, while others have connected his act to Vietnam and violence in the United States, both literal and that found in television dramas and movies.[8] *Shoot* was Burden's way to know pain intimately, yet what is most disturbing about it is the involvement of an audience and a shooter in a situation that is a by-product of Burden's abdication of will.[9] Burden would do something similar a year or so later, in February 1973, with his work *Fire Roll*, performed at the Museum of Conceptual Art in San Francisco. On this occasion, he spent most of the opening for a group exhibition alone, watching television, barely interacting with others gathered in the space. After a while, he got up, walked around the room, and turned off the lights. He then grabbed an old pair of pants that had been passed around, placed them on the floor, and doused them in lighter fluid. He set them ablaze and put out the fire by rolling his body back and forth over it, whereupon he returned to the TV, leaving the audience to wonder what had just transpired. *Fire Roll*, despite having been performed in a circle of viewers (and having been documented), is essentially a hermetic act initiated and completed by Burden. It incidentally put spectators in a position in which they had to decide whether to prevent the act or passively observe it as if they held no moral responsibility. *Shoot*, on the other hand, gives deterministic powers primarily to a single person, the marksman with whom Burden trusted his life, although others in the space could have intervened as well. The event was out of Burden's control, dependent upon the competence and choices of others. There was no need, as with Ader, for gravity to be master over Burden—a gun aimed at him was sufficient.

For all the potential danger and attendant metaphorical associations of *Shoot*, it was nevertheless an event conducted in an art con-

text, an action, no matter how intense, that was aestheticized and compromised by mediation. During this time Burden instigated situations in which he places the onus of his existence on others. He does not ask viewers if they wish to participate; he does not demand it either. Instead, he is simply there, awaiting someone to offer help or turn away. This was the case with his *Bed Piece* from 1972 (fig. 9). Burden had been invited to do a show for the Market Street Program in Venice, California, and told he could do whatever he wished. He asked Josh Young, who ran the space, for a bed. On the day of the opening, Burden arrived, took off his clothes, and got into the twin-size metal bed, remaining there for the next three weeks. He had given no specific instructions beforehand, nor did he speak to anyone during the exhibition. He left it to Young to determine how to provide for his health and safety. Young could have treated Burden as just another object, a sculpture requiring nothing more than attentive looking. He could also have assumed that Burden would break from his performance and take care of himself, a separation of art and life borne of necessity. But instead Young felt obligated to look after Burden, who was soon given food, water, and toilet facilities, which he made use of when nobody was in the gallery.

The comparisons between Burden and Ader, especially with regard to Ader's comment in *Avalanche*, hinge upon the physicality of their work and the risks inherent in their projects. Connections such as these are more superficial than actual; to think of either artist only in these terms is to miss much of the intellectual core of their endeavors and to reduce their exertions to simple stunts that could be performed by an actor. Burden's work was no doubt more physically adventurous than Ader's, for Ader, with the possible exclusion of *Broken Fall (Organic)*, rarely put himself in harm's way. The distinction between the two was their relation to representation. Ader performed for the camera and posterity, while Burden had several layers of audiences: those at the initial performance, those making the documentation, and those seeing the work through whichever artifact Burden chose to stand for the event. The viewing possibilities in Burden's practice were missing in Ader's art, although it could be said that his wife, or Leavitt, or whoever else was there during the filming constituted a kind of audience.

This is the difference between Ader and Burden: Burden did something before a collection of people in an art context. He initially es-

```
Bed Piece
Market Street, Venice: February 18-March 10, 1972

Josh Young asked me to do a piece for the Market Street Program,
from February 18-March 10.  I told him I would need a single bed
in the gallery.  At noon on February 18, I took off my clothes
and got into bed.  I had given no other instructions and did not
speak to anyone during the piece.  On his own initiative, Josh
Young had to provide food, water, and toilet facilities.  I remained
in bed for twenty-two days.
```

Figure 9. Chris Burden, *Bed Piece,* 1972. © Chris Burden. Courtesy of the artist and Gagosian Gallery.

chewed traditional representational strategies, but the circumscription of both the idea of art and its institutional structure transformed his gestures, his acts of life (whether ordinary or spectacular), into art. He was aware of the ephemeral nature of his work, and produced documentation that in its selection—a singular image and particular artifact—become a separate piece that is tied metonymically to the original performance. In this regard, in its careful positioning vis-à-vis the connotations of depiction, Burden's art is quite sophisticated. The back and forth between the primary event and its secondary presentation color the way each is read. Ambiguities remain unresolved, held in suspense by the complexities of the art.

The specter of an actual event, regardless of its subsequent portrayal, was something Ader did not allow in his work. He did not confront viewers without a screen, and with the exception of the rope-cutting in *Light Vulnerable Objects*, his performative presence never faced another person in the here and now. Ader's self remained on the secondary level of expression, as representation, which made his films function like other works of art. Yet he was, according to Leavitt, reticent regarding representation, wanting to make art that spoke of concrete truths. His works literally took their representational quality at face value, as if they were somehow denotative facilitators for conveying ideas. Something, though, began to change in Ader's work in the middle of 1971. He must have grown suspicious of the place of representation in his work: how his art was unable to offer an unquestionable truth because of its detachment from presence, a recognition that altered his depiction of falling.

6

The doubt creeping into Ader's work, a disquiet that corresponded with the lessons imparted in *Broken Fall (Organic)*, did not undermine the importance of his claims. The notion that one is doomed to be free is in fact compelling when taken metaphorically and applied to the broader sociopolitical climate of 1971 America. It was a time when collective political action fractured into more specific affinity groups. Belief in the government, let alone the ability of individuals to affect change, waned to such a degree that some would label the 1970s the "me decade."[10] Ader's work also speaks to the dilemma artists faced

with regard to making art when everything could be art. The unlimited freedom to create in any manner was not without complications, but this issue would become acute for Ader only in a year's time. At the moment, his work was becoming increasingly self-conscious about its status as art, as works participating not only in a philosophical discourse but also an art historical one, not only with his peers but with the larger history of art.

Ader concludes his December 19, 1970, letter to Van Ravesteijn and Van Beijeren — the same one in which he says that he is making works that silently declared everything there is to know about falling — with a line in English (the letter is otherwise in Dutch): "I'm a Dutch Master." The quick phrase comes out of nowhere, a playful ending to a correspondence that speaks glowingly of Ger van Elk's *La Pièce* (1970) and mentions Eugenia Butler's desire to show Ader's work. It has been assumed that Ader's quip referred to the history of Dutch art, the great tradition of painters like Rembrandt and Hals, the radicality of modernists like Piet Mondrian and Theo van Doesburg. But Ader smoked cigars and must have been familiar with the popular American brand Dutch Masters, and its ubiquitous image of seventeenth-century Dutchmen huddled around a table as if for a group portrait. His claim for affiliation with the greats of Dutch art was thus laced with a joke. He makes it difficult to read too much into the clever turn of phrase, even as it offers clues as to how to approach several other *Fall* works made during the same trip as *Broken Fall (Organic)*. The works stand in contrast to both *Fall 1, Los Angeles* and *Fall 2, Amsterdam* and seem increasingly distant from the concerns of *Broken Fall (Organic)*. The issue of the will fades to the background; *Broken Fall (Organic)* seems to have concluded Ader's ruminations on the topic, its melancholy presentation of freedom's determinism subsequently exchanged for the idea of Mondrian, who became a ground upon which to contemplate the problems of representation, the lingering issue dogging Ader's philosophic statements on the will.

On a few occasions, Ader and his wife visited the coastal town of Westkapelle in the state of Zeeland, and there Ader made several photographs and one film. Almost all are engaged with falling and all allude to Mondrian, who began his course toward neoplasticism in front of the original Westkapelle lighthouse. In an undated note made for an art history class he was to teach (probably at Mount San Antonio Col-

lege, where he worked until 1971), Ader outlines a trajectory of modern art that begins with Manet and works its way to Fluxus, Happenings, and performance. Just below this sketchy chronology he jots some names and quick thoughts about early twentieth-century artists. It is here that he mentions "Mondrian's purity"—the last word written above "austerity," which had been crossed out. Possibly from this time, although it could be from two or three years later, is a note describing a work that would have been a horizontal painting, showing Ader lying down, his various body parts depicted in the styles of different artists: Manet, shoes; Monet, socks; Braque, pants; Mondrian, shirt; De Kooning (perhaps), face; an unknown conceptualist, hair—all to appear possibly in a setting evoking Monet's water lilies.[11]

There may have been aspects of Mondrian's art or his theories that were appealing to Ader, for Mondrian, like Ader, was greatly indebted to Hegel.[12] Hegel's dialectical thinking facilitated the creation of an art Mondrian called abstract-real: paintings that placed things in opposition in order to achieve sublation. There are hints that Mondrian's time with De Stijl caught Ader's attention, since that was the period in which Mondrian, often in dialogue with Van Doesburg, developed his ideas of art as part of a teleology heading toward an assimilation by life.[13] Ideas such as these allude to Hegel's sense of history progressing forward in a constant state of construction built upon destruction. Mondrian saw his work as striving toward something of this kind, what he called the universal, a concept that remains ambiguous in his writings from the early 1920s. "Universal" floats in and out of his prose, referring to a pictorial strategy that is less about making representation per se and more about paintings that function as independent things. Figure and ground are folded upon one another, providing a means to see differently, to experience what Mondrian called in 1920 "the new harmony."[14]

It would be conjecture to see Mondrian's thoughts from the early 1920s as directly shaping Ader's work from 1971, as the Westkapelle photographs and film do not give many clues as to what Ader took from Mondrian besides his aura.[15] Several works presumably made on the same day focus on a narrow road that recedes into the distance, bending slightly toward the left at the furthest reaches of the photo. In the background, serving as a counterpoint to whatever Ader does in the foreground, is the Westkapelle lighthouse (which Mondrian often

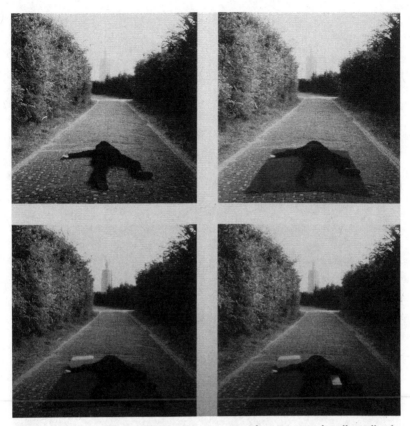

Figure 10. Bas Jan Ader, *On The Road to a New Neo-Plasticism, Westkapelle, Holland,* 1971. © The Estate of Bas Jan Ader.

painted), an eighteenth-century church tower that in the nineteenth century had a sailor's beacon added to its top. The first of the works, *On the Road to a New Neo-Plasticism, Westkapelle, Holland* (1971; fig. 10), is a four-part piece that shows the evolution of a Mondrian-esque painting, with Ader, dressed entirely in black, serving as the line, a blue blanket as the pictorial ground, and a yellow and red canister as the other primary colors. There is humor in Ader's title, poking fun perhaps at the severity of Mondrian's ideas. This implied levity is offset by a somewhat tragic depiction in a subsequent work, staged a few feet on from the previous one. *Pitfall on the Way to a New Neo-Plasticism, Westkapelle, Holland* (1971; fig. 11), presents Ader with all the same gear — the blanket in his left hand, the yellow jerry can and the red box near his right — tripping over a slight depression in the road and falling

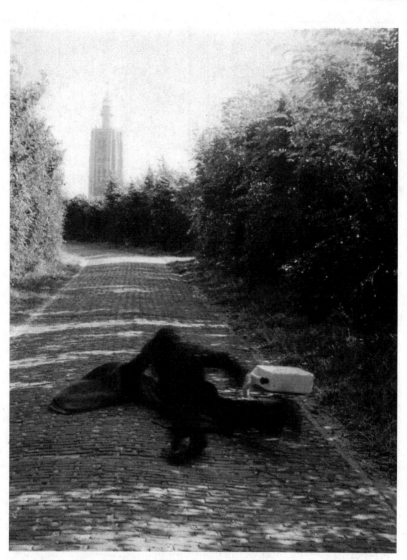

Figure 11. Bas Jan Ader, *Pitfall on the Way to a New Neo-Plasticism, Westkapelle, Holland*, 1971. © The Estate of Bas Jan Ader.

face down, the blur of the image suggesting the speed of his descent. Ader's fall, almost complete in the picture, seems a prelude to the earlier work. There are ways to read the piece as a comment upon the failure of Mondrian's theories or, even more broadly, the failure of modernism. Conversely, it can refer to Ader's own shortcomings, his inability to live up to Mondrian's ideals, to fulfill the hope of achieving

something where life and art never separate — an idea he would soon disabuse himself of.

Three other works, two photographs and a film, all from 1971, show Ader on the same path, this time standing next to a blue sawhorse. The photographs are in color, the film in black and white, and Ader's placement in relation to the objects again suggests that he embodies Mondrian's beloved black line, while the sawhorse is a nod to Van Doesburg and his introduction of the diagonal into the neoplasticism debate. In the first photograph, *Broken Fall (Geometric), Westkapelle, Holland* (fig. 12), Ader has just crashed into the sawhorse, aligning himself perfectly with the wooden structure. The lighthouse remains placid in the background, something solid in a pictorial field filled with movement. The film fails to fix Ader's expression; his features, smeared by motion, are transformed into a series of small, horizontal gestures, varying in tone. The resulting image seems akin, presumably by chance, to the divisionist technique Mondrian employed in his 1907 depiction of the Westkapelle lighthouse. The other photograph, *Broken Fall (Geometric; blue-yellow-red), Westkapelle, Holland*, is less dramatic. Ader is turned away from the viewer, his body listing to the left, parallel to the sawhorse, which is centered with the lighthouse off in the distance.

The two still images make more sense in relation to the film, *Broken Fall (Geometric), Westkapelle, Holland* (fig. 13), which like the other *Fall* films is short in duration but pregnant with tension. Of the films Ader had made to this date, it has the least to do with the will, overshadowed as it is by the specter of Mondrian and other concerns. Ader stands listlessly before the camera, his hands to his side. The lighthouse is in background and the sawhorse in its familiar position. A gentle breeze blows from right to left. Ader sways in the wind, moving in response to the strength of each little gust. There is the implication that he is not moving willfully but has instead given himself over to nature. Back and forth he teeters, occasionally coming close to toppling. It is hard to determine when this might happen, since the wind does not seem particularly strong. Eventually, almost surprisingly — even though it is clear from the beginning what will happen — he falls over the sawhorse, collapsing in a heap at the side of the road, the result of his submission to the wind or perhaps the irresistible lure — he is the black line, after all — of the diagonal.

With *Broken Fall (Geometric)*, both film and photographs, as well as

49

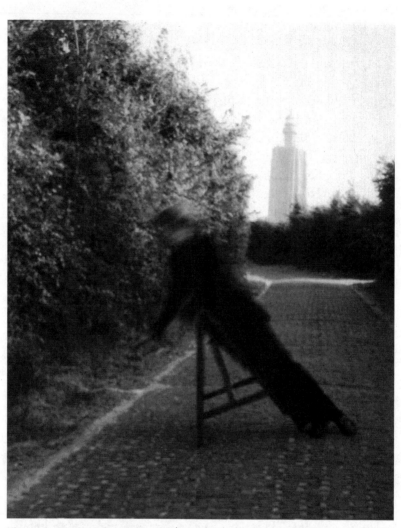

Figure 12. Bas Jan Ader, *Broken Fall (Geometric), Westkapelle, Holland*, 1971. © The Estate of Bas Jan Ader.

the *On the Road* and *Pitfall* pictures, a new issue has been broached, one that is also apparent in *Untitled (Sweden)* (1971; fig. 14). Presented as a double slide projection when it was exhibited in early 1972, the work consists of two images almost exactly the same in composition. The one on the left shows Ader standing tall, his body not quite centered in the photo and dwarfed by sizable pine trees. His stance mimics the trees—another vertical line in a space filled with them. The right-hand image, taken from the same spot, has him prone on the

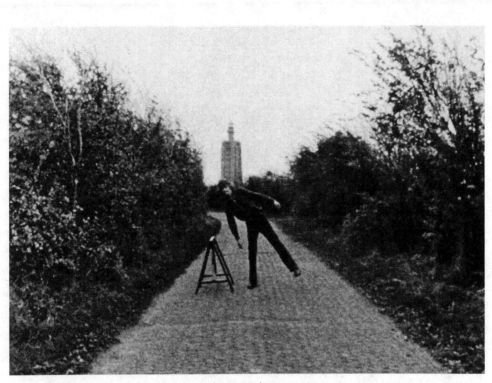

Figure 13. Bas Jan Ader, *Broken Fall (Geometric), Westkapelle, Holland,* 1971. © The Estate of Bas Jan Ader.

ground, his feet pointed toward the viewer, the rest of his body at an angle. As before, his position mirrors that of the trees, although now he lies in a line with those that have been felled. He iterates features found in nature, a type of homology that turns the logic of the work inward to become more aligned with ideas of representation, composition, and interior structure. Previously, Ader's presence was forthright, the mediated aspects of the works mere inconveniences, if not inconsequential elements, in the broader problem of conveying concrete truths. Now, a shift has occurred, one that becomes magnified by the references to Mondrian's paintings and their forms, with Ader going so far as to become the black lines — his literal self as a depiction. He is something other than the reification of a philosophic principle, for now he makes works within a work, or representations within a

Figure 14 *(following pages).* Bas Jan Ader, *Untitled (Sweden),* 1971. © The Estate of Bas Jan Ader.

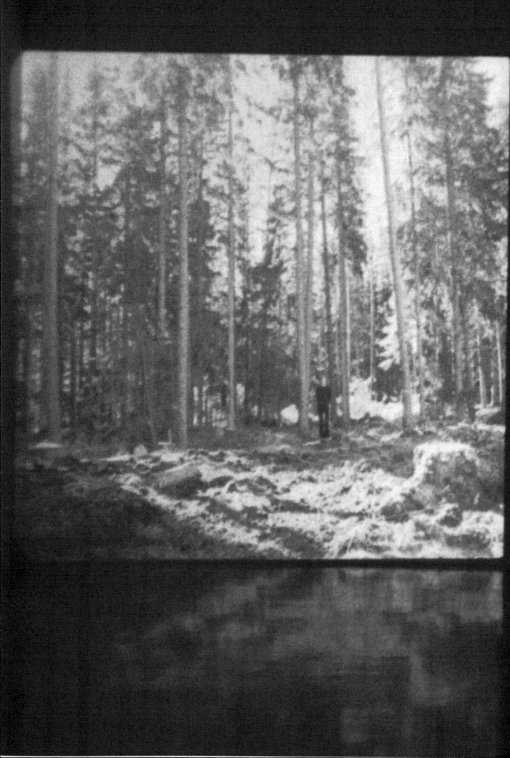

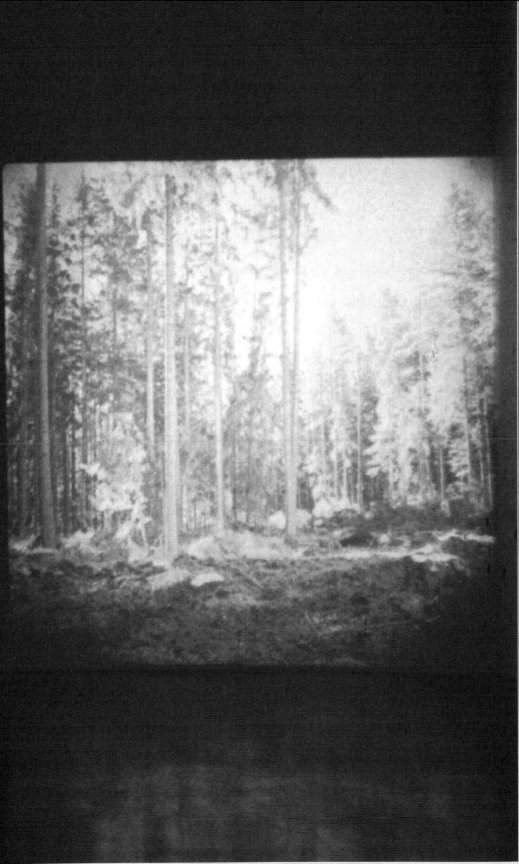

representation. Ader was becoming increasingly aware of his art's material qualities — of the fact that ideas, regardless of how fundamental they might be, are always conveyed through a medium. The insight led him, it seems, to modulate his philosophical queries such that no aspiration toward a truth could come without taking into account its mode of exposition. Ader's concern gave rise to a new sense of what a concrete truth is, or could be, but the shift in artistic tenor did not occur in a vacuum, as his revelation derived from a particular context, in Los Angeles, where others, especially those close to him, were having similar thoughts.

7

In a downtown Los Angeles loft, in April 1971, a group show took place in the studio of Jack Goldstein and Hirokazu Kosaka. Called the *Studio Show*, it included, in addition to Ader and Goldstein, Paul Drake, Ger van Elk, William Leavitt, Allen Ruppersberg, Stephen Sher, and Wolfgang Stoerchle.[16] Though Goldstein organized the show in consultation with his friends, who were all in the exhibition, he asked his girlfriend, Helene Winer, to be the curator; her professional stature would give the venture added imprimatur. She thought highly of the work, appreciating the exhibitors' forays into conceptualism, something she had encountered while working at the Whitechapel Gallery in London in the late 1960s.[17] Winer understood that what they were doing departed from the rest of the Los Angeles scene, in which conceptualism had no real purchase. Knowledge of conceptual art passed by word of mouth and reflected the vagaries of the sprawling metropolis.[18]

But the Los Angeles art world in the early 1970s was in a state of transition, no longer dominated by the Ferus Gallery and the pop art it championed. By this time, as Peter Plagens explains, "Pop's self-effacingness, sugared sarcasm, and ability (if modernist art still has a social quotient) to bore from within, are the best qualities of minor Pop spin offs, but Pop itself, seemingly at one with the flow of vulgarized California, is now just another thesis in the struggle of modernist art to stay alive in a society that has relegated it to an intellectual amusement."[19] Plagens, himself a painter, was not against pop, and he was certainly no advocate of conceptual art.[20] He was worried about the lack of institutional structure in Los Angeles, where only a few galler-

ies, Eugenia Butler and Riko Mizuno, showed progressive art, and museums like the Los Angeles County Museum of Art and the Pasadena Museum of Art had poor historical holdings, a disinterest in contemporary developments, and boards of trustees that interfered with day-to-day affairs.[21] The paradox of a city with no institutional support but many interesting artists was compounded by the fact that most artists worked in relative isolation.[22] Here, sprawl, Hollywood, and the growing aerospace industry coalesced into a society in which "all levels of reality and fantasy [merged] into the single concept of a push-button environment, a pill for every mood, with the automobile as the ultimate time machine."[23] This was the Los Angeles of dreams, a city, especially in terms of art, conceived in opposition to New York, with its abundance of galleries, venerable museums, and artists who thought they were at the center of the artistic universe.

The late 1960s marked the period when what was loosely called the "LA look" was codified both critically and visually in works of art that captured the fantastical idea of Los Angeles and its progeny, Hollywood.[24] Yet much of what was said at the time concerning the work of Larry Bell or Robert Irwin or even Ed Ruscha revolved around how contemporary art production in Los Angeles had no historical precedent. In addition to the legacy of Jackson Pollock or other modernist masters, artists in late 1950s and early 1960s Los Angeles also reacted to a conservative strand of painting, vaguely abstract and expressionist, but hardly with an avant-garde aspiration to be relevant beyond the local community. It was not uncommon for critics to single out Irwin as an origin for much advanced art, a first-generation contemporary who served as a starting point for ambitious young artists.[25] Irwin, along with others like Bell, Craig Kauffman, James Turrell, and Douglas Wheeler, made art that commentators saw as responding to not only the natural conditions of Los Angeles but also its proximity to advanced technology, custom car culture, surfing, and the entertainment industry. Works that were slick, reflective, and playful with regard to pictorial space appeared. It was a type of formalism little known in New York, one seemingly so bound to a specific context that these abstract works became, in the eyes of some, didactic expressions of the Southern California ethos.

In many ways the work of Turrell or Irwin reflects different concerns than that of Ader or his peers in the *Studio Show*. So too the art

being made in Venice Beach, a kind of sculpture and painting that in many ways internalized the clichés of Southern California, but nonetheless received both critical and market success in the early 1970s. It is possible to see Ader's art as antithetical to both Light and Space and the work produced in Venice, although he never mentioned anything of the sort. Like many in Los Angeles, it appears he was more interested in the tabula rasa nature of the scene, aware of what was going on, condescending at times to works he did not like, but not so invested as to set his work in opposition to some person or movement. Despite the intimacy of the Los Angeles art world, discrete clusters of individuals rarely commingled, segregated in part because of geography but also because of interests. Like minds tended to congregate, forming feedback loops of approval. Moreover, many of the most famous artists—Irwin, Ruscha, and Turrell, for example—chose not to exhibit in Los Angeles, except occasionally in studios or galleries like Eugenia Butler or on the campuses of CalArts and Pomona College. The *Studio Show* rectified this situation to a degree, providing a platform to display a nascent form of conceptualism.

The *Studio Show* received no press and was only documented by a friend of Ruppersberg. Ader most likely exhibited an early version of *I'm Too Sad to Tell You*, a piece he would soon deem inadequate and later remake in Holland during the same months in which he produced *Broken Fall (Organic)* and the Mondrian work. What is telling about the show is how much Ader and his peers were part of a conversation that was rooted in Los Angeles but extended to Amsterdam, London, Bremerhaven, Genoa, and elsewhere.[26] It was Van Elk, in fact, who made many of the practical connections, since he lived in both Los Angeles and Amsterdam. By the time of the *Studio Show*, he was quite accomplished, having already exhibited in *Arte Povera*, *Op Loose Schroeven*, and *When Attitudes Become Form*. His work from the late 1960s was more sculptural in its orientation, a sort of postminimalist practice with a touch of humor, but by 1970 it had become more conceptual. It was during this period that he began his relationship with Art & Project Gallery.

Not long after his exhibition in January 1970, Van Elk put Ader in touch with Art & Project, which would remain, throughout Ader's career, his principal gallery. Ader and Van Elk shared much in their sensibility, although Van Elk's films were never quite like Ader's. Several of

Figure 15. Ger van Elk, *Paul Klee—Um den Fisch, 1926*, 1971. © Ger van Elk.
Collection Rijksmuseum Twenthe, Enschede, depot VBVR (photograph: R. Klein
Gotink).

Van Elk's 16-millimeter shorts are quite humorous, but not in the slap-
stick manner that can sometimes be read in Ader's work. An element
of absurdity is prominent in much of his work from the early 1970s. *The
Flattening of the Brook's Surface*, from 1972, shows Van Elk floating down
a canal in a yellow inflatable raft, passing a mason's level over the al-
ready flat water. The humor in his photographs, typically deadpan and
situational, is exemplified in his diptych *The Haircut, Big Cut, Big Sav-
ings, Los Angeles* (1971). The paired images are almost identical in com-
position, with Van Elk sitting outdoors, legs crossed, next to a potted
tree resting atop a glass table, but in the second, both the top of the small
tree and Van Elk's long, parted hair have been lopped off, presumably
by the garden shears resting in his lap.[27] A work like this seems akin
to Ader's *Sawing* from 1971, which reveals Ader in the process of cut-
ting a handsaw with a circular table saw.[28] But one of the most inter-
esting comparisons between Ader and Van Elk stems from Van Elk's
piece *Paul Klee — Um den Fisch, 1926* (1971; fig. 15), which he exhibited
at Art & Project in January 1971: in a sequence of eight slides projected
on a wood table with a white tablecloth, Van Elk devours the contents
of a restaged still life by Paul Klee. The connection to Ader's Mondrian

Figure 16. Ger van Elk, The *Discovery of the Sardines, Placerita Canyon, Newhall, California*, 1971. © Ger van Elk.

work is obvious, with Ader and Van Elk each taking a key figure of modernism as a starting point for a self-conscious play on the history of art and the construction of representation.

Ader and Van Elk had been helping one another with their work since at least the summer of 1970, when Van Elk assisted Ader in the filming of *Fall 2, Amsterdam*. Ader in turn aided Van Elk with *The Discovery of the Sardines, Placerita Canyon, Newhall, California* (1971; fig. 16),

a diptych similar in form to *Big Hair, Big Savings*, with color photographs showing two instances, the first with a red muscle car flashing by, of sardines emerging from fissures in the road. The scene, shown from two different angles, is suggestive of B movies, as if the sardines were launching an invasion of earth. The work was made not long after February 9, 1971, when the San Fernando Valley in Los Angeles was hit by a magnitude 6.6 earthquake.[29] This dramatic event caused

the collapse of both the San Fernando Veterans Hospital and the Olive View Sanitarium. Several highway overpasses gave way, fires raged in a shopping center, and giant cracks appeared in the dam for the Van Norman Reservoir.[30] Sixty-five lives were lost, which gives Van Elk's playful images potentially greater gravity. Yet this tragedy is alluded to only obliquely, through the specificity of the location in which the pictures were made, several miles from the epicenter. Instead, the almost surreal photographs can be said to reflect the particular confluences that make Los Angeles unique: the omnipresent power of nature, car culture, and the fantastical world of cinema.

Ader's collaboration with Van Elk continued throughout 1971, and included his helping with what is perhaps Van Elk's best work from the time: *The Co-Founder of the Word O.K. — Hollywood* (1971; fig. 17).[31] It consisted of a series of photographs that shows Van Elk in several spots in Hollywood, standing in the shape of the letter *K*, with a cheaply framed, cartoonishly rendered *O* placed next to him. Van Elk's irreverent works are interesting in their depiction of Los Angeles, for while he situates the work in Hollywood, it is not the Hollywood of movies and perceived glamour, but the Hollywood of everyday life, of busy streets with slapdash architecture, of a seemingly endless array of signage that competes for the attention of passing drivers. In the second and third photographs of the series, the visual cacophony of the advertisements is muted by the vertical regularity of streetlamps and signposts.

There is much, on the surface at least, that resembles Ader's *Broken Fall (Geometric)* photographs. While Ader's work is set in a small village and Van Elk's in a vast metropolis, both artists contextualize their pieces with architectural features, and each utilizes his body as a means to represent something else, and can thus be present without being entirely himself. Van Elk's posture in *The Co-Founder of the Word O.K. — Hollywood* is also much like Ader's in *Untitled (Sweden)*, with each mirroring the contours of the dominant vertical feature. The affinities, both conceptual and visual, are not entirely due to chance. Ader and Van Elk, along with Leavitt and Ruppersberg, came together, not in terms of a movement or in opposition to the rest of the Los Angeles art world, but in recognition that their work was similar in both aspect and ambition. As Jack Goldstein recalled many years later, "Another group included Bas Jan Ader, Bill Leavitt, Al Ruppersberg, Wolfgang Stoerchle, and Ger van Elk. This group felt like it was the most elite be-

Figure 17. Ger van Elk, *The Co-Founder of the Word O.K. — Hollywood*, 1971 (detail).
© Ger van Elk.

cause they went to Europe a lot and were hooked up with Artt Projects [*sic*], in Amsterdam, and with many European galleries."[32] Within this group there were various affiliations, the German-born Stoerchle perhaps being the odd man out — his most infamous piece being a performance that among other things had him urinating drop by drop onto a red carpet.[33] One of Goldstein's closest friends, the Japanese artist Hirokazu Kosaka, who was also on very good terms with Stoerchle and Leavitt, remembers how Ader and Leavitt were always together.[34] The bond between the latter two was well known, and while almost everybody liked Leavitt, his association with Ader led some, like Tom Wudl, to say, "At that time Bas Jan Ader and Bill Leavitt were extremely affected and feigned to be Duchampians . . . they wore European-style slippers and would both be sitting on chairs, smoking big, fat cigars."[35]

The friendship between Ader, Van Elk, and Leavitt, with Ader the common bond, was undoubtedly tight. It was the premise for their show together at the Pomona College Gallery, which ran from January 18 to February 20, 1972. The show was organized by Winer, who wrote in her brief catalog essay, "The exhibition of recent work of Bas Jan Ader, William Leavitt, and Ger van Elk issues not only from an interest in the artist's individual work, but more specifically, from their mutual respect, friendship and wish to show together."[36] This initially seems to be a weak foundation upon which to build an exhibition, but Winer was deeply attuned to the Los Angeles art scene, and her emphasis on the close ties of Ader, Van Elk, and Leavitt spoke to her understanding of how things were unfolding.[37] During her brief tenure — she would soon be let go over funding disputes — she concentrated on presenting conceptual and performative works from the region. Besides this group show, she curated a two-person presentation of William Wegman and Goldstein, a Ruppersberg solo show, and another major group exhibition featuring performances by Burden, Kosaka, and Stoerchle.

Pomona marked the first time Ader presented his *Fall* work in Los Angeles, and he took the occasion to exhibit almost all of what he had done, with the notable exception of the *Broken Fall (Geometric)* photographs. Ader clearly had the most works, as was mentioned in the show's single, pithy review.[38] Three of the five *Fall* films were on view — *Broken Fall (Organic)*, *Broken Fall (Geometric)*, and *Nightfall* (made during the same trip to Holland) — as well as the final version of *I'm Too Sad to Tell You*. There was also the double slide projection *Untitled (Sweden)*, *Pitfall on the Way to a New Neo-Plasticism* (shown either as a projection or a photograph), and, representing *Fall 1, Los Angeles* and *Fall 2, Amsterdam*, sixteen film stills that revealed a kind of visual stutter of his descents. Van Elk showed four pieces, three of which continued the theme advanced in his *Paul Klee — Um Den Fisch, 1926*, but with reference points ranging from kitsch painting to Giorgio Morandi to Pierre Bonnard. As before, the artifice of representation was exposed. In *The Return of Pierre Bonnard, 1917–1971* (1971; fig. 18), for instance, Van Elk juxtaposed two photographs: one showed a Bonnard painting and the other, placed almost directly in front of it and mounted back to back with a mirror that reflected the first photo, presented the reverse of the same Bonnard canvas. Van Elk's piece, obviously mischievous, de-

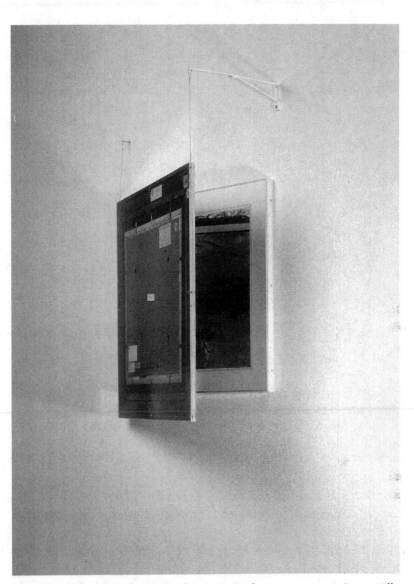

Figure 18. Ger van Elk, *The Return of Pierre Bonnard, 1917–1971*, 1971. © Ger van Elk.

flates art historical tradition while adding more representational layers to his intellectual conceit.

The Return of Pierre Bonnard, 1917-1971 was echoed by Leavitt's contribution to the show, which saw him delve further into themes he had previously explored in an exhibition at Eugenia Butler Gallery in 1970. Around this time Leavitt had begun to construct elaborate environ-

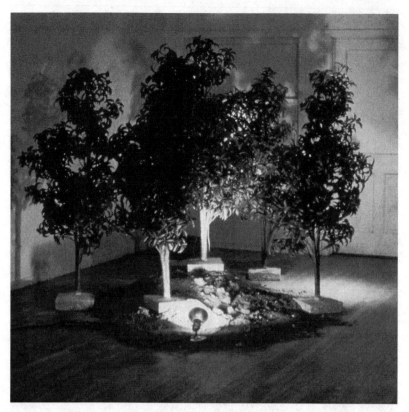

Figure 19. William Leavitt, *Forest Sounds*, 1970. Courtesy of Margo Leavin Galley. Collection of the Los Angeles County Museum of Art.

ments that resembled stage sets. They were highly contrived, meticulously constructed, and despite their aspirations to representational veracity looked undeniably artificial. It is this element of elusive familiarity that makes the work so unsettling. For the Eugenia Butler show, Leavitt had installed a pile of dirt surrounded by six artificial trees, a spotlight, and a recording that played the sound of a trickling stream (fig. 19). Plagens described the work as a form of "ideological entertainment," a concern that was the furthest thing from Leavitt's mind.[39] Leavitt was instead fascinated by Michael Fried's essay "Art and Objecthood," and he took to heart Fried's duality of theatricality and what would later be known as absorption, siding with theatricality and its antimodernist associations.[40] The idea of theater, which

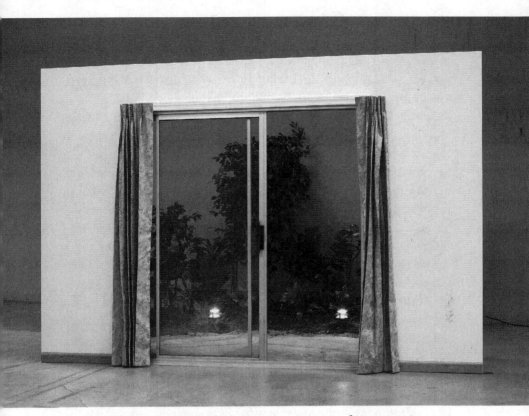

Figure 20. William Leavitt, *California Patio*, 1972. Courtesy of Margo Leavin Galley. Collection Stedelijk Museum Amsterdam.

Fried derided as non-art or as existing between media, was for Leavitt the perfect conduit for investigating the vagaries of Los Angeles and its continual negotiation through representational strata. Leavitt made scenes, and in the case of *California Patio* (1972; fig. 20), exhibited at Pomona, the narrative alludes to a party taking place in the hills of Los Angeles: men gathered together by a fence, women and girlfriends sitting around the pool, while through the patio door—the essence of the piece, separating the interior world (marked by fashionable curtains) from the exterior (fieldstone, a slight hedge, a manicured garden lit by outdoor lights) —comes the hostess, who announces that dinner is served.[41]

It was within the context of this exhibition that Ader's work was

received in Los Angeles. He wrote Van Ravesteijn and Van Beijeren a few days after the opening, describing how beautiful Leavitt's work was and reporting that many people had offered a variety of positive responses.[42] Ader was now part of an art scene that was at once provincial and cosmopolitan in its outlook. It is noteworthy that for this exhibition he decided not to show the film versions of *Fall 1, Los Angeles* and *Fall 2, Amsterdam*. It seems that he wanted to leave this theme in the background, thinking perhaps that, having already shown them in *Sonsbeek buiten de perken* and *Prospekt '71: Projektion* in Düsseldorf, his newer concerns should be brought forward. But his decision also seems appropriate given the works on view by Van Elk and Leavitt—pieces that dealt with the constructed nature of representation. Ader was not as insistent in these pursuits, never making his art fully about the way images function. His search for concrete truths continued, although his earlier determination had become muddled, for he was now caught between the philosophic pronouncements of his initial *Fall* work and the more self-consciously representational pieces from the past year.

8

In the letter Ader wrote to Van Ravesteijn and Van Beijeren about the Pomona exhibition, he mentioned that he wanted to set a date for his spring exhibition, which was eventually slated for April 15 to 21. The one-week showing was to be Ader's first with Art & Project, and he took this opportunity to present *The Boy Who Fell Over Niagara Falls* (1972; fig. 21), which in retrospect was a synthesis of the two strands in the *Fall* work. The origins of the work are obscure. The title comes from an article entitled "The Boy Who Plunged Over Niagara," which originally appeared in the January 1962 issue of *Reader's Digest* and was reprinted in March 1972.[43] (Ader was already familiar with this popular publication, having made, in 1970, *473 Reader's Digests Digested*, an installation done in his Claremont garage, where he composted that number of magazines.) Ader's version of the title, of course, aligns it more clearly to his concerns with falling. Leavitt thought highly of the work, which showed twice a day, at two o'clock and five o'clock. The piece was not long—around fifteen minutes—and required little in terms of equipment. Nestled into a corner of Art & Project's ground-

Figure 21. Bas Jan Ader, *The Boy Who Fell Over Niagara Falls*, Art & Project Gallery, Amsterdam, 1972. © The Estate of Bas Jan Ader.

floor space was a wicker chair, a circular side table, a glass of water, and a reading lamp with a conical shade. Behind the chair was a bank of windows partially obscured by vertical blinds.

At the appointed time, Ader entered the space, took his seat, and began to read from the magazine article, which details the harrowing misadventure of a group of boaters on the Niagara River. Jim Honeycutt, a transplant from North Carolina, went to the house of his friend Frank Woodward and, after a cup of coffee, asked Woodward's two children, seventeen-year-old Deanne and Roger, ten years her junior, if they wanted to go for a boat ride. Deanne was initially reluctant but was persuaded to go by her mother and brother. The party soon set out in Honeycutt's small craft powered by an outboard motor. He was

not the most experienced boatman, and for whatever reason, probably ignorance, he pointed the boat downstream. After a while the placid water became noticeably choppy. In the distance the thunderous roar of Niagara Falls could be heard, and it soon became clear that the boat was in trouble, unable to turn back because of the strength of the current rushing toward the cataract. The boat capsized, throwing all of its passengers into the water. Honeycutt and Roger Woodward were almost instantly swept over the falls. Deanne somehow managed to swim and was rescued, only ten feet from the brink, by a brave tourist. Miraculously, Roger survived the plummet, the first ever to do so without any equipment. Honeycutt was not as lucky; his mangled body washed ashore four days later.

The pages of Ader's *Reader's Digest* were intermittently marked with X's, which indicated when he should take sips of water. His demeanor throughout the performance was calm. Sometimes he shifted his legs, but regardless of movement, he continued to read in a steady, almost flat voice. It seems as if Ader found a way to address both issues of the will—the story certainly questions the efficacy of free choice in the face of deterministic powers—and the problem of mediation: the primary nature of the performance eliminated secondary elements of depiction. On at least one occasion, his reading was documented, a decision that withers the work's purity, bringing *The Boy Who Fell Over Niagara Falls* back to the very problem of representation Ader had been working to avoid. But like many conceptual artists of the time, Ader struggled to reconcile ephemeral acts with their status as art.[44] It did not seem possible simply to do a performance; it was already enough that his practice had shifted so far, that he had made his self the site of his art. In many ways, he was slow to respond to the issues inherent in performance art, although he was not concerned with performance per se. He was working through his own problems, following where his self-reflection and attempt to address concrete truths began to lead him, toward an art that could communicate without recourse to representation. As the performance progressed, Ader would continue to drink at the designated moments. At the end, right after he read the word "death," he took the last sip of water, placed the magazine down, and silently walked out of the room.

A couple of months later, Ader did another performance of *The Boy Who Fell Over Niagara Falls* for a solo show at the Kabinett für Aktuelle Kunst, an intimate nonprofit space run by Jürgen and Christina Wesseler in the small seaside town of Bremerhaven, West Germany.[45] The Kabinett was a labor of love, something the Wesselers attended to in their free time and opened to visitors upon request. However small the audiences, Jürgen Wesseler believed the community of Bremerhaven needed exposure to the most progressive art.[46] Ader's exhibition seems to have been organized rather spontaneously, as a postcard from Ader to Wesseler that spring had made no mention of a possible project but simply informed Wesseler of Ader's temporary address in Amsterdam and his hopes that Wesseler would visit sometime before August. It did mention that Ader planned to travel to Bremerhaven and that, in case Wesseler was unaware, "I'm in the midst of a show at Art & Project."[47] The Kabinett's small size limited Ader's options in terms of what he could present. In the end, he decided to project all of his *Fall* films. They were shown in the back of the room, in the alcove formed by a slight partition. For *The Boy Who Fell Over Niagara Falls* (fig. 22), Ader sat on a simple wooden chair placed next to a long table with a file cabinet below. In photographs of the performance, there is a reading lamp, a glass of water, and the requisite *Reader's Digest*. Ader's dress is more causal, his hair longer and messier than in Amsterdam. The performance proceeded as before with one noticeable exception: upon completing the reading, swallowing the last sip of water, and putting both glass and magazine down, he ran out of the room with tears streaming down his face.[48]

Ader performed the piece again in April 1973, but by this time, already back home in Los Angeles for many months, his intellectual concerns had changed.[49] The Kabinett version of *The Boy Who Fell Over Niagara Falls*, along with its initial presentation in Amsterdam, brought to a close themes Ader had been investigating since the first part of 1970. The exhibition marked the final time he presented his *Fall* films, and *The Boy Who Fell Over Niagara Falls* was the last work in which he displayed his face. Ader never made mention of the latter fact, and the suspension of his engagements with questions of the will placed him at a crossroads in his practice, one still committed to divining fundamental truths. The uncertainty arising from pressures both within his

Figure 22. Bas Jan Ader, The *Boy Who Fell Over Niagara Falls*, Kabinett für Aktuelle Kunst, Bremerhaven, 1972. © The Estate of Bas Jan Ader.

work and external, in the discourse of conceptual art, created in Ader a deep suspicion regarding the nature of art. The boundaries of art's basic state, its existence within an art context and reliance upon a system of signs to communicate ideas, began to preoccupy him. His work in the months and years after his Kabinett für Aktuelle Kunst show was an attempt to see if art could simply *be*, without an institutional context or means of representation. These explorations were at times muddled, and latent in his probing of art's outermost borders was a doubt about art's efficacy, its relevance, even its necessity in Ader's life.

TRADING

9

Ader returned from Europe in the autumn of 1972, and soon after he and his wife moved from their home in Claremont to an apartment on South Madison Avenue, close to the heart of Hollywood. Leavitt and his wife had relocated earlier in the year, and many of Ader's other peers also lived in the city, part of a scene that, while occasionally prone to hermeticism, had far more to offer than the college community Ader had called home for the past seven years. The contrast between Claremont and Hollywood was great. Ader settled in a neighborhood where just a couple of years earlier Satan worship had been fashionable and where the memory of the Manson murders remained fresh.[1] Fervent Christians walked the streets preaching the end of days, their apocalyptic claims echoed by environmentalists foretelling oxygen depletion and the imminent death of the oceans. Los Angeles's infamous smog and vexed relation with its natural surroundings only heightened the anxiety.[2]

Contemporary commentators analyzed in dramatic tones the perceived strangeness of the city, and of Hollywood in particular. Those from the eastern United States found the wanton consumption of space unnerving. They spoke of Angelinos' inability to find people with shared affinities and presumed that their unmatched reliance on automobiles made for a society of detached souls shielded from chance occurrences.[3] The abundance of cars and the omnipresent freeway system led many to think of the urban sprawl as a glimpse into an illusory, dystopian future. This was more than a sense of seeing a film set from behind. It was a conviction that ordinary people could wish to be distracted and consequently embrace a belief in a type of technological deliverance that displaces nature with its mechanized representation.[4]

Such extreme views are potentially a product of cultural shock, for what is unsettling to others is absolutely normal to those living in Los Angeles and its vicinity. Los Angeles is a part of one's identity, something hardly to fetishize. As Joan Didion commented in 1973, much of

what is written about the movie industry and the people working in it "approaches reality only occasionally and accidentally."[5] Didion observes from the perspective of an insider, a screenwriter of several successful films, but her acerbic descriptions of Hollywood — both place and industry — are nevertheless acute. It is in line with the Dutch novelist Cees Nooteboom's own experience of the city from this time. He had planned to see Los Angeles by foot, but the difficulty quickly proved too great. He eventually rented a car, taking in the city the way most residents do on a daily basis. His impressions were at first celebratory, sharing the architectural historian Reyner Banham's joy in being in a city dependent upon individual transport. But Nooteboom's enthusiasm soon collapsed, as the seediness of West Hollywood clashed with his celluloid fantasies.[6] Nooteboom's surprise belies the image of Los Angeles portrayed in the novels of Raymond Chandler and Nathanael West. In their novels, as in the early 1970s, there are many layers to the city, many spaces for a variety of lives, for Los Angeles was a place of endless contradictions, where reality and artifice lived in coexistence.

Ader loved Los Angeles. Its ambiguities and inconsistencies only strengthened the appeal. He mentioned in letters how much he enjoyed the Southern California weather, writing to Van Ravesteijn and Van Beijeren that returning to Los Angeles from the dour grayness of the Dutch winter was like turning off a little black-and-white television and switching on a big color one.[7] Ader's whimsical reference spoke to more than the pleasures of a warm, sunny afternoon in January. He was intrigued by Hollywood, the glamour and the spectacle, and was taken by the immediacy of things. Here he was at ease, and he wrote about the joy he experienced in an unpublished note from 1973. Written in Dutch and provisional in form, it begins with a disclaimer for the use of his native tongue. Quickly the tone changes, and he describes how much he likes the wild, untamed nature defining the city and the excessiveness of all facets of life there. Sitting at the Los Angeles marina, looking at the boats, cannot compare, he wrote, to the same experience in Amsterdam. He was enthralled with how small he felt in relation to the surrounding environment, how the possibility of natural disasters was ambrosia to him, and how the beautiful solitude of a nocturnal drive on the freeway elicited romantic feelings. He concludes his short love letter to Los Angeles with this summary line: "I really love this wild romantic metropolis of extremes."[8]

When Ader composed the note he was several months into a venture that would consume much of his time in the coming year. In a letter to Van Ravesteijn and Van Beijeren dated October 29, 1972, he writes that he has become fascinated with speculating in grains and metals, that the activity engages him both night and day, and that he has financed his new passion by pawning his Mercedes. He goes on to detail the workings of the commodities market, using soybeans as an example, and finishes his description by saying how exciting it all is.[9] He gives no explanation of how he became interested in futures trading, an activity that, in the early 1970s, was often seen as akin to gambling. It is easy to presume that Ader's engagement reveals a tendency toward risk-taking activities; indeed, this is one of the recurrent tropes in the Ader literature.[10] Many involved in commodity exchanges disagree with this assessment, arguing that unlike games of chance, which provide only individual pleasure, futures trading benefits society by helping maintain the consistent pricing of goods.[11]

The buying and selling of commodities is a practice built upon speculation. In trading stocks and bonds, one purchases shares in a tangible entity and expects to profit from the business's growth or the government's continued solvency. The trading of futures, which occurs on specialized exchange boards (like the Chicago Mercantile Exchange), offers profits based on shifts in price. Investors buy the option to purchase, at a given price, perishable goods like wheat and lettuce or metals such as copper and zinc. The buyer does not actually own, for example, fifty thousand bushels of wheat at the point of sale but rather the wheat's fiscal potential at a later date. Because many of the traded commodities follow a seasonal cycle, there can be relatively wide fluctuations in prices. Investors generally look to purchase goods at a low price, hoping that in time the value will rise, whereupon they will sell their futures to other investors or to producers who will actually take delivery.

Ader regularly went to an office in the mid-Wilshire area of Los Angeles, where he spent much of his time on the phone with the brokers who placed his orders.[12] Investments of this sort cannot be made haphazardly. They require research into historical price variations, current market conditions, crop forecasts, weather predictions, and estimates of consumer demand. As Ader suggests in his letter to Van Ravesteijn and Van Beijeren, he was deliberate in his decisions, keep-

ing a notebook, for example, that meticulously recorded his investments and plans for further speculation.[13] Throughout the course of his investing, which lasted about a year, his fortunes varied. At times he enjoyed significant gains, but the profits were offset by a series of losses. In the end, he most likely broke even, never once getting caught holding a future at the time of its delivery.[14]

Sometime in January 1973, Ader and his wife went to dinner at a Japanese restaurant with Bill and Nancy Leavitt. An acquaintance, Richards Jarden, and his partner accompanied them. Jarden, a conceptual artist interested in the limits of representation and the untrustworthiness of photographs, was visiting Los Angeles for the holidays, hoping to secure a teaching position at CalArts. He had met Ader the previous summer in Amsterdam, while visiting the city with his colleague Charlotte Townsend, the curator of the Mezzanine Art Gallery at the Nova Scotia College of Art and Design. Their encounters in Amsterdam were brief, Jarden remembers, never allowing much time for art talk. At the time, Jarden only knew of Ader's work through the reproduction of *I'm Too Sad to Tell You* (1970) published in *Avalanche* magazine.

After dinner, the couples returned to the Aders' apartment, where Ader and Jarden fell into a discussion of Ader's work in the commodities market. Jarden was impressed with Ader's knowledge of the topic, how he was always on the phone with brokers, investing large sums in lettuce and other farm products. The discussion was serious but, according to Jarden, not exactly intense. Ader explained that he thought his work on the commodities market was art — a claim Jarden struggled to accept because he believed art must be communicated to someone other than the artist. Jarden believed that Ader had given little attention to the dissemination and reception of the work. When he pressed Ader for clarification, Ader resisted offering any answers. It seems that, for Ader, commodity trading was simply an artwork, even if exclusive to him. Jarden could not be swayed from his opinion that as long as the activity remained private it failed to qualify as art. The evening was the last time the two would see or speak to one another. Theirs was a passing friendship, but the exchange left an impression on Jarden, who came away thinking that Ader was walking away from art, an interesting artist who had given up on his practice.[15]

Jarden was not alone in this belief. Those who knew Ader better held similar opinions. The dealer Claire Copley remembers how Ader

was hesitant to show his work in Los Angeles. Like Leavitt, Ruppersberg, and Van Elk, he was very serious about his activities, working long hours and reading constantly. She had known of his art since 1971 and had seen it at Pomona in 1972. She was taken by it, and when she opened her gallery in 1973 she had asked him to exhibit with her. Ader declined, because of his disregard for his potential audience as well as his wish to wait and see what sort of venue Copley would develop. He was also, according to Copley, skeptical of dealers, believing they all eventually go crazy. This last remark Ader might have made in jest. Copley knew how charming Ader could be, how in many ways he was a very nice person. Still, it was clear to her that during the time Ader traded commodities he was caught up in the confusion of both his life and his art. She thought they were blurring to such an extent that it was difficult to separate one from the other, and that his work on the commodities market was definitely a part of his art practice.[16]

Ader's wife also agreed that his trading of futures was a work of art.[17] But there is no tangible evidence of this status; apart from his letter to Van Ravesteijn and Van Beijeren, he never mentioned it in print. It hovered close to everyday life, and only his spoken declarations that this activity was in fact art tethered it to a context of expanding formal and conceptual possibilities. In the years after Ader ceased trading, and the time since his death, his commodity work has been deemed a part of his life and not his art. It does not fit into his concise oeuvre and seems beyond even the generous boundaries of the already expansive idea of art promulgated in the early 1970s. There is the chance that Ader left this work unrealized or in a state of incompletion.[18] There is also the possibility that the commodity trading work, a project devoid of a title, is about absolute privacy: a piece that is essentially secret.

It is no coincidence that Ader began to work on the futures market soon after returning from Europe, where he had performed *The Boy Who Fell Over Niagara Falls* more than ten times. Nothing else he had done in his brief career had ever been so public. His previous work was self-contained, sealed off from chance. With the performance there was no physical mediation between Ader and his viewers. For the Amsterdam art world (and certainly that of Bremerhaven), it was a radical piece that seemed different from anything else being done at the time. What left many confused was how, when Ader walked out of the

room, he refused to speak with viewers.[19] He stayed in character. He enabled the work to continue until the next performance, finding a way to be the art without turning his subjectivity into its content. But the performance of the piece in an art gallery established the limits of its reception. It could not fully escape those institutional confines, no matter what Ader did. Despite its contrived hermeticism, *The Boy Who Fell Over Niagara Falls* was from the outset understood as a type of progressive conceptual art.

The fact that Ader kept so much of *The Boy Who Fell Over Niagara Falls* to himself makes it compelling in relation to his public avowal that his commodity trading was art. The interiority of the performance suggests that the private nature of the futures market project was the thrust of the piece. Yet the activity also speaks obliquely to context. Trading existed only for Ader—existed as art, without the traditional institutional structure that in the end compromised *The Boy Who Fell Over Niagara Falls*—yet the simple act of telling someone about it, declaring the activity to be art, undid that particularity and entwined it with the discourses of conceptual art.

It is curious, then, to consider the other work Ader made while trading futures. He did an installation for a show organized by Jarden's colleague Charlotte Townsend, at the Nova Scotia College of Art and Design.[20] Paired with an edited recording of *The Boy Who Fell Over Niagara Falls*, the piece was to be installed by students, since Ader could not travel to the exhibition, which took place the first week of April 1973. Ader sent Townsend a letter with specific instructions. Ader asked that a single wall be painted white. A vase holding various flowers was to be placed on the floor, with a spotlamp illuminating them and a two-line, four-word text painted four feet, six inches from the ground. The awkward block letters, around five inches in height, spelled out, "THOUGHTS UNSAID, THEN FORGOTTEN" (fig. 23). After several days, with the flowers left to wilt, the statement, like the rest of the wall, was to be painted over in its original color.

The work is reminiscent of Robert Barry's *A Work Submitted to Projects Class, Nova Scotia College of Art and Design, Fall 1969*, which specified that twelve students were to agree upon an idea and keep it to themselves. Ader's phrase also recalls another Barry piece from 1969, in which Barry typed, "Something I was once conscious of, but now I

Figure 23. Bas Jan Ader, *Thoughts Unsaid, Then Forgotten*, 1973. © The Estate of Bas Jan Ader.

have forgotten," on a standard, letter-size sheet of paper. Both works come from a time when Barry was pushing the material limits of art. He wanted to make things that were actual and real, yet defied visuality. In a series of projects that included exhibiting radio carrier waves, releasing inert gases into the atmosphere, and suggesting thoughts telepathically, Barry paradoxically exhibited invisible things. Yet he could never fully divorce himself from some sort of image, some readily identifiable sign that determined his activity as art. For each of his pieces that flirts with nothingness, there was some corresponding documentation: a photo of the canister from which helium was escaping, a

text announcing a telepathic action, an invitation stating that the gallery would be closed. Written language allowed Barry "to indicate the situation in which the art exists."[21] There was never a question about art's relation to a context, since his work depended on it if it was to be understood as art.

Ader and Barry did not know one another, though Ader might have been aware of Barry's work through his *Closed Gallery* (1969) piece, presented at both Art & Project Gallery in Amsterdam and Eugenia Butler in Los Angeles. Despite its apparent affinities with Barry's piece, Ader's *Thoughts Unsaid, Then Forgotten* is the more ambiguous, since it is not clear if what Ader had written was an instructional command, a declaration of fact, or even an aspiration. It is even uncertain whether the austere pronouncement refers to Ader. Barry's use of the first-person singular allows viewers to imagine his subjectivity, while Ader's notice was simply there on the wall. It was self-contained, never giving its secret, as with his refusal to speak to viewers after the performance of *The Boy Who Fell Over Niagara Falls*. But to consider the two lines — THOUGHTS UNSAID, THEN FORGOTTEN — in relation to his engagement with commodity trading is to see them as speaking to the conditions needed to make a totally private work of art, one immune from the insincerity of representation.

Nevertheless, to have observed a dictate of silence when speaking with Jarden or anyone else who learned that his futures trâding was art would have placed a nearly impossible restriction on Ader's art and life. Such a demand contradicts the social and intellectual conventions governing the roles of art and artists. The seeming isolation of the project also begs the question that Jarden had already raised: could something be art if it was not communicated, if the artist did not reach out to others? Ader seemed unable to publicly cast judgment on the issue, and there was no indication that he thought art created for no audience other than its maker was superior to what was traditionally understood, even among the most extreme conceptualists, as art. It becomes clear in hindsight that his commodity trading was a way to reach art's most elemental nature. The effort engendered a conviction of such strength that it led Ader to push the limits of art so far — in this piece and later with *In Search of the Miraculous* — that in the end only his life remained.

There is a precedent of sorts for Ader's commodity trading work. Marcel Duchamp, who had essentially given up art by 1923, issued a bond the following year in order to support his playing of roulette. Entitled *Monte Carlo Bond* (1924), the handmade promissory note was to be issued to thirty individuals at a price of five hundred francs each.[22] In return, investors would receive a 20 percent dividend. The document is humorous in its construction, with a lathered-up Duchamp (photographed by Man Ray and encircled by a roulette wheel) looking like a diabolical creature. The rest of the note, which hints at the surface of a craps table, lays out the fiscal obligations of all parties and is signed by both Duchamp and his alter ego, Rrose Sélavy. Duchamp wrote to friends about the monotony of the affair, and how his Martingale betting strategy should prove sufficient.[23] He also mentioned to the collector Jacques Doucet in 1925 that he tried to eliminate the specter of chance by forcing "the roulette to become a game of chess."[24] There are obvious connections in Duchamp's actions to the relation between art and gambling. He accepts the speculative aspects of both activities, highlighting how success in either venture, no matter one's skill, depends upon a degree of luck.[25]

Like many of his peers, Ader admired Duchamp. He mentions Duchamp in his notebook and was known to sport corduroy pants similar to ones Duchamp wore late in life.[26] If trading future commodities was a type of homage to Duchamp and his art, there are nevertheless differences between their forays into capitalism. Duchamp, for example, traded upon the value of his name. He knew his signed bond was worth more than the offering price, and his status ensured that collectors would see the bonds as a worthy investment irrespective of his honoring the contract. Duchamp's act was tied to the art world, and its material liquidity was dependent on his symbolic worth. Ader lacked this advantage; he generated investment capital by pawning the car he had bought for his wife. He traded commodities, and doing so constituted the piece. Duchamp brought art and its context closer to an aspect of ordinary life. It was a gesture predicated upon his involvement with the art world, and held in check by a work of art. Ader, by contrast, tried to remove art from its normative context, divorcing it from what

causes it to be understood as art. He wanted, it seems, to see if by art's close proximity to life it could become simply art as such.

While Duchamp provides an antecedent that helps qualify Ader's project as art, Ader's involvement with conceptual art is also relevant. One of the characteristics of the commodity trading piece is its relation both to artistic labor and to a general sense of labor. It has been assumed that conceptual art brought about the "de-skilling" of the artist, but the move from technical facility to mental virtuosity led to questions about the consequences of substituting managerial work for physical labor.[27] Many conceptualists were involved in the presentation and dissemination of information, and it is no coincidence that Kynston McShine's 1970 survey of conceptual art at MoMA was called *Information*. Information was a buzzword that had associations with emerging concepts of immaterial labor. It also spoke of a world being recognized as increasingly global and interconnected. Trading in information denoted white-collar activities and stood in contrast to the blue-collar aspects of fabricating a work by hand. Conceptual art's engagement with the dissemination of ideas quickly became the apposite artistic form for the new economic context, where manufacturing and skilled labor were becoming things of the past.

Instances of this development can be seen in images of Joseph Kosuth reading philosophic tomes for his *Information Room (The Third Investigation)* (1969), in John Baldessari's hiring professional sign painters, and in Lawrence Weiner's creation of a contract that enables anyone to realize his work. Other examples abound: Hans Haacke culling statistical data, Sol LeWitt having others follow his instructions, Marcel Broodthaers serving as the director of his own museum. The equation between these endeavors and managerial professions holds only in comparison with expressions of working-class labor in conceptual art. The associations demystify the status of the artist and change the terms of artistic work from that of creation to that of production.[28] This is, to a certain extent, a case of incidental art justifying its existence through an emphasis on physical effort, yet this explanation has the danger of glossing over important issues raised by the pieces: namely, the idea of an artist and what he or she does in relation to the nonartistic world. This dichotomy grew in significance as artists became more self-conscious of their rarified social status and attempted to mitigate the situation by grounding their artistic sensibili-

ties in the wider spectrum of work, the labor movement, and antiwar activism.

Ader's futures project, despite its formal relation to the work of his contemporaries, lacked those political and subversive undertones. His trading in information seems innocuous, hardly an effort to undermine art world structures. He displayed little noticeable concern for issues of artistic and nonartistic labor, which he made equivalent by failing to call attention to the strangeness of his activity. His trading does, however, suggest striking associations between art and commodities—both gain value through price variations, and neither promises fiscal reward—and his year-long venture offers one of the more compelling ways in which to read the problematic relation between contemporary art and its market. Ader, in fact, sidesteps the commodification of his own piece not only by providing little, if any, tangible evidence of its existence, but also by making the goal of the project the buying of actual commodities. Considerations stemming from his work in its contemporary context give way somewhat when taken alongside Ader's earlier art and his quest to advance philosophical truths. Nothing had changed in this regard from when he first fell from the roof in Claremont. What had altered was the increased antagonism between art and life.

In the late 1960s and early 1970s the blurring of art and life in Los Angeles and New York, but also in Europe, was a central issue. The origins of this multivalent problem, which reaches back to the avant-garde ideals of historical modernism, are quite broad. In the wake of Happenings, Fluxus, performance art, pop, and minimalism, a climate favoring conceptual art emerged; artists could create works relevant to the encroaching forces of a social and political world that was no longer separated from the concerns of advanced art. By the end of the 1960s, the Vietnam war and the uprooting of middle-class values by a vocal student movement had brought current events to the center of public consciousness. Many artists actively protested the war and held progressive views, but, at least initially, they were ill prepared to integrate their convictions with their art. Keeping pace with the political activism of the times posed a challenge to contemporary practice for several reasons, but principally because art was caught up in its own searing critiques.[29] The idea of art had been torn asunder, making it possible for everyday life to be not the subject of art but simply art.

The transformation from an art world engaged with its own hermetic issues to one that connected with the most pressing concerns of other parts of society happened in fits and starts. But sufficient social pressure came to bear, leaving little option but to think of art and life as coterminous. This was apparent when Lucy Lippard described, in 1969, how jet airplane travel — watching the geometric forms of farms and urban centers from nearly six miles high — altered the way one thinks about art, or when, in the same year, Kosuth wrote how his art, or any art for that matter, could not compete with the lights of Time Square or images of flying to the moon.[30]

A passive acquiescence to the world's encroachment on art eventually occurred. Embracing the convergence of life and art also held great appeal for those engaged with performance. In an interview from 1971, Vito Acconci explains how he spent much of his time crossing the divide between art and life.[31] In pieces in which he took private acts and made them public, he tried to escape the mediated limits of video in an effort not only to make his art and life one but also to conjoin the resulting unity with that of the spectator. Acconci's work often intruded upon the viewer's space, but his blend of art and life was safer and less threatening than Adrian Piper's, whose *Catalysis III* (1970), for instance — in which she rode a New York City bus with a sock in her mouth — emphasizes both her gender and her race, forcing conceptual art to confront some of the most pressing social issues of the moment. Indeed, the growing feminist art movement, especially that coming from the Women's House project in Los Angeles, also sought to blur the distinction between art and life. As with other aspects of American society in the early 1970s, the personal became the political in the contemporary art world; art and life were by necessity becoming essentially one and the same.

There was a lurking danger in this fusion, and it was that art would lose its autonomy and become fully enveloped by life. This was Allan Kaprow's fear in 1971, when he wrote that the almost immediate acceptance of non-art or anti-art as actual art leads art to become superfluous to societal needs. Art can never trump life, Kaprow argues, and will always be secondary, especially when the two are thrust into an unbalanced symbiosis.[32] Kaprow's dire views were not held by everyone, and many found the incorporation of art with the rest of the world liberating. It removed various hindrances that made con-

temporary art seem detached and unable to speak to current events. Contemporary art had a newfound agency, but its pertinence could not hide the fact that its engagement with life was also an expression of a doubt about its efficacy in a world increasingly saturated with visual images. It was now more than ever, when anything was possible, the prerogative of artists to determine what was art. Implicit within this challenge was the continued search for art's limits in its relation to everyday life, and despite the calls for an art that spoke to these conditions, art without some boundaries was almost impossible to conceive of in the early 1970s. Artists risked pushing the creative act into a chaos of undifferentiated objects and gestures, making galleries and museums the only entities maintaining the distinctions between art and life. It is here that institutional critique had one of its beginnings. Its invectives against art's structural undergirdings are in many ways formal responses to the aesthetic difficulties created by the blurring of art and life. The institution had become a medium, and under the guise of politics, under the banner of progressive social change, the institution as a site to expose false pieties and systemic injustices also became a safety net, a situation in which the most radical iterations of art were provided a definable context and this art's trafficking in the quotidian aestheticized.

In 1971 Daniel Buren wrote that the museum is an ideal weapon of the bourgeoisie, for its mission to preserve the cultural trust is hardly innocent. In its supposed benevolence, the museum asserts power covertly, making it the only place in which art can exist.[33] His argument, skewed in its analysis of the flow of power and resistance, echoes many of the cries that the student movement directed against the state, protests that pictured the world in broad strokes of good and evil. Buren's point is well taken, especially when considering the rise of conceptualism. He hints at the fact that any kind of art—even that which attempts to negate art, the anti-art of Kaprow's warnings—will be identified, embraced, and domesticated by the museum. The critic René Denizot concurred with Buren's assessment when he reviewed, in harsh terms, Harold Szeemann's *Documenta 5*. Denizot believed *Documenta 5* lacked any sense of political urgency, something even Szeemann felt had been lost in the run-up to the show's opening.[34] Denizot's complaint focused on the invisibility of dissenting artists. There was no speaking to power, he claimed, no presentation of a viable op-

position, "as the artistic campus/concentration camp identified police and art in the name of art and to the advantage of the system."[35]

Denizot's claim was purposefully hyperbolic in order to show contemporary artists' capitulation to institutional authority. His views stand in contrast to other appraisals of the sprawling show, which saw it as "anti-establishment and anti-capitalist — directed, in other words, against everything that had helped it into being."[36] Such disparate positions were possible in part because of the exhibition's ambitious goals. Utilizing a wide array of spaces available in the city of Kassel, Documenta 5 interrogated the idea of reality through the speculative nature of conceptual art. Deepening the problem was the fact that the art on view was contrasted with ordinary objects. There was, of course, little confusion as to what was and was not art; still, the institutional envelope Denizot lamented was strong enough to imply a leveling of distinctions between art and the everyday. As was happening in much of the contemporary art world by 1972, the move to blur art and life made art even more dependent upon the idea of art as such, perversely strengthening the institutions that much of the work sought to make irrelevant.

Ader's show at the Kabinett für Aktuelle Kunst, which closed just as Documenta 5 opened, received a couple of reviews from local newspapers. One commentator suggested that Ader's work concisely summarized the major themes on view in Kassel, even though, much to Ader's disappointment, he was not included in Szeemann's exhibition.[37] Ruppersberg and Van Elk were a part of it, as were several other artists from Los Angeles. Ader was rankled by the choices. But while he complained about the lack of attention accorded to his work and his exclusion from certain art events, he spent little time courting the attention of those who might have facilitated his participation, believing the quality of his art sufficient to warrant critics and curators coming to him. This position frustrated Van Elk, who thought being an artist meant negotiating art world politics. Van Elk went to great lengths to help his friend's career, but his acts of generosity were often rejected, as when Ader refused to meet Wim Beeren at the opening of Sonsbeek buiten de perken for no reason other than that he did not want to talk about his art.[38]

It is difficult to cite petulance as the reason either for Ader's initiating his commodity trading piece in the autumn of 1972 or for this

work's divergence from the tropes of the blurring of art and life that were then suffusing contemporary art. His hesitancy to speak about his practice hinders explanation, yet his actions related to futures speculations suggest a project that had taken the measure of the art and life discourse. If much of what passed for engagement was meant to change the nature of art by bringing life toward it, then Ader's piece moved in the opposite direction and sought to bring art to the world. He did this without aestheticizing life, or attempting to alter the nature of art. If anything, his project was a claim for art at its most basic level, an effort to remove it from its context, to allow it to exist in a fully idealized form. Contingent upon the utopian sense of art was the need to protect the purity of the work, and minimizing its connotative existence kept the project's primary nature essentially intact. In theory, Ader took art to the edge of life, where whatever gap remained between art and life ensured that the piece remained unmediated to an extent he had not achieved in his previous work.

11

Slightly more than a year before Ader's Kabinett für Aktuelle Kunst show, on May 7, 1971, Allen Ruppersberg opened *Al's Grand Hotel*. Perched atop a small hill set slightly back from Sunset Boulevard, the converted single-family house had five guest rooms, a place for breakfast, a sitting area, and a fully functioning lobby where Ruppersberg managed the hotel's affairs. The peculiar establishment did business for little more than a month—and only on the weekends—hosting such luminaries as Joni Mitchell and Dennis Hopper.[39] Ruppersberg had integrated commercial ventures with his art practice before. In 1969 he started *Al's Café* (fig. 24), a fully functioning coffee shop that was open one night a week. The café was an extension of his *Locations* pieces and satisfied his desire to get away from the confines of the studio.[40] He wanted *Al's Café* to be a meeting point for the Los Angeles art community, and for several months it was. It was only when the work's status as art became lost in its commercial aspect that Ruppersberg decided to close it.[41]

The hotel rooms were themed. They ranged from the Jesus Room (fig. 25), with a fifteen-foot wooden cross that bisected the space, to the Al Room, filled with life-size photographic cutouts of Ruppersberg.

Figure 24. Allen Ruppersberg, *Al's Café*, 1969. Courtesy of Margo Leavin Galley.

There was also a Bridal Suite, an Ultra Violet Room (where films by the eponymous actress played), and another called the "B" Room. The brochure, published at a later date, advertised the place as a "friendly resort hotel" that offered "live entertainment on selected evenings, free television, bar, continental breakfast, free ice cubes and daily maid service."[42] It stressed the hotel's proximity to Hollywood attractions like Grauman's Chinese Theater and Lawrence Welk's Palladium, to numerous restaurants, and to the meeting point of the stars—Hollywood Boulevard and Vine Street. Ruppersberg was known at the time for his detached demeanor. He worked in an office building on Sunset Boulevard and was famous for carrying his art in a black briefcase. There was an air of the non-art professional about him, and as Helene Winer wrote in her catalog essay for his 1972 solo show at Pomona, "He thus significantly cuts himself off from the art community of Los Angeles

Figure 25. Allen Ruppersberg, *Al's Grand Hotel* (The Jesus Room), 1971. Courtesy of Margo Leavin Galley.

and from the traditional dependence of a studio working and showing space, in favor of mobility and a more variegated milieu."[43] Although the contents of the hotel were eventually offered for sale, the attraction of the project for Ruppersberg was that it was removed from current ideas of art and its context.[44] The piece was art in the vicinity of life. As he explained years later, "They [*Al's Café* and *Al's Grand Hotel*] had to be real to escape being looked at like art."[45]

There was a great deal of integrity to *Al's Grand Hotel*. Even so, the complete severance of the work from an art context was made difficult by the fact that it was exhibited in conjunction with the Los Angeles County Museum of Art's exhibition *24 Young LA Artists*. Ruppersberg had conceived of the piece well before the fact, rented the home for a year, and with the support of private patrons spent nearly six months preparing the hotel for operation.[46] The hotel was always meant to be

a work of art, but there is little to indicate that it was an effort to either subvert the museum structure or to call into doubt contemporary art's relation to rarified spaces like LACMA. At the time, the Los Angeles art scene was not caught up with issues of anti-art or institutional critique, in large part because it already seemed like an alternative to "the system."[47] *Al's Grand Hotel*, then, became an effort to see how such a piece could function in *both* an art and a non-art context. It slid between roles, one never compromising the other. In terms of art, it could be interpreted as an installation juxtaposed to an institutional setting, couched in a long art historical tradition that includes Kurt Schwitters, Marcel Duchamp, Allan Kaprow, and Claes Oldenburg.[48] As non-art, as simply a hotel, it served its role capably, even if its interior was far different from that of much of its competition. The mutability of *Al's Grand Hotel* is similar to how Winer described Ruppersberg's conception of the artist as an actor, for just as an actor is at once himself and the character portrayed, so is *Al's Grand Hotel* at once an artwork and a hotel — two distinct things unified in a single form.[49]

The links between Ruppersberg's persona, his hotel, and Ader's work on the futures market are many. It is hard not to see Ader's regularly going to an office, calling traders, and researching commodities as similar to Ruppersberg's heading to his studio in an old office building, his black briefcase in hand. Ruppersberg's ability to run a hotel and have it also seen as art shares common ground with Ader's declaration that his buying and selling of commodity futures was also art. The straddling of distinct worlds by this pair seems less about bringing art and life closer together than about an affinity for leading several kinds of lives. Ruppersberg spent much of the late 1960s and 1970s moving around Los Angeles, sometimes changing addresses three or four times a year.[50] He liked the transitory existence because "you could have a new life, and then do it again the next month or the next week."[51] He did not actually take on new identities, but Los Angeles, with its vast geography and distinct enclaves, made it easy to start anew, almost as if one were continually acting. Ader had thoughts along the same lines, and it was around this time that he began to share them with Van Elk. The two would often drive around Los Angeles, admiring the city. On these excursions, perhaps while heading out for a long night on the town, they dreamt about the different lives and identities they could assume.[52]

These projections were in many ways mere fantasy. There is, however, something telling about these statements in relation to Ader's developing practice, one in which privacy grew in importance and oppositions, almost dialectical in nature, emerged in both his art and his life. A challenge for Ader was to make sense of the commodity trading piece's implications, to come to terms, for example, with its mutability, akin to that of *Al's Grand Hotel*. Ader, it seems, had no interest in infusing art with aspects of life, and to maintain a separation between these two entities he relied on his presence. This implies a kind of mediation, although his silence, or secrecy, often hid that fact. There was another model, besides Ruppersberg's hotel, that Ader could follow in the months he traded commodities. It was concerned not with the blurring of art and life but with the movement between categories, with life's relation to art and the identities one can assume seemingly at will. It came in the form of Gilbert & George.

Ader concluded a note to Van Ravesteijn and Van Beijeren in January 1972 by mentioning how much he liked the latest bulletin from Gilbert & George.[53] He was certainly familiar with their practice from conversations with Van Elk, who for a period of several years was good friends with the pair. The idiosyncratic duo exhibited regularly with Art & Project, and Ader must have come across their work in this context on more than one occasion. In March 1973 Ader was included in a small group show with Gilbert & George—organized by Art & Project—at the Galerie Waalkens, an unusual space in the town of Finsterwolde, Holland, just a few miles from Drieborg. Although Gilbert & George had no real presence in Los Angeles, they were nevertheless the object of discussion by Ader and his peers, who were taken by their *Drinking Sculptures* and unique conception of the self—notions that potentially held great appeal for Ader.[54]

Done in the early 1970s, the *Drinking Sculptures* (with individual titles like *Balls or the Evening before the Morning After*) are images of Gilbert & George—dressed in their standard staid suits, flamboyant ties, and sturdy dress shoes—having a beer or a spirit in pubs throughout London. The photos vary in content and form. Some show George leaning comfortably against a bar, drink in hand. Others present the two in increasing states of inebriation. They normally abstained from alcohol, but felt compelled to alter their habits because many artists, they observed, spent their nights in a drunken stupor. They were con-

founded by the thought that the nocturnal overindulgences of their peers were countered by sober works of art made the next morning. It seemed to Gilbert & George a strange divide, and the *Drinking Sculptures* fused these two elements of the art world.[55]

From the beginning of their career in 1968, Gilbert & George have been associated with the blurring of art and life.[56] Their notion of living sculpture was initially quite radical, placing their work beyond the reach of even the most progressive performance art because they never clarified when something was or was not art. They posited that their lives — often by implication, sometimes by the parameters of a piece — could always be art. In *Underneath the Arches* (1969), they lip-synched in a variety of locations — galleries, museums, art schools, even rock concerts — a melancholic tune from the 1920s, adorned in their usual wardrobe, with face and hands painted bronze (or other colors), one holding a cane, the other a glove.[57] They hardly made a distinction between themselves atop a table mouthing the words to a dusty song and their lives in their home on Fournier Street in East London. Their mode of comportment and their art were essentially indistinguishable, individual identities subsumed into the singular-plural of Gilbert & George. Everything they did, every gesture or movement, every inconsequential thing, was somehow, presumably, linked to their art practice. Like Ader and his commodity trading, they simply declared this to be the case, leaving viewers to take them at their word. But it is not immediately clear if their claims to being living sculptures refer to their own selves — Gilbert Proesch and George Passmore — or to the shared identity that has them dressed in costumes they never take off.

The confusion that arises from Gilbert & George's cultivated ambiguity is enhanced by their professed relation to art. During this period, around the time Ader made his *Fall* films, Gilbert & George wrote extensively.[58] Their prose and poetry appeared mostly in small pamphlets and artist's books. Some texts took the form of correspondence; others found life on the pages of magazines. There is undoubtedly a literary air to these pieces, and the faux naïveté latent in each bit of writing suggests carefully thought-out reflections. Most of their texts advocated "Art for All," a concept that does not imply that everything is art or hint at Joseph Beuys's claim that everyone is an artist but, rather, removes barriers between art and the populace. It also, strangely, maintains a separation between art and life, for in many of

their musings they do not talk about how their lives subsume art, or even the converse, but how they search for art, how they wish to be with art, alongside it, able, for some time, to relax with it. Art in this sense is almost a supranatural entity, a kind of deity that exerts a will and has powers beyond the artist's creative intent.[59]

The languid description Gilbert & George provide of their daily life suggests that only they know when they are art and when just ordinary individuals. Critics nevertheless have seen them differently, as inhabiting a Victorian reception of Romanticism, where "*everything can be seen as art.*"[60] Even this definition, however, implies that art is outside of them. Regardless of whether or not they ironize, as has been suggested, the art-life binary, they have established within their collective subjectivity an opposition between art and life. Like Ruppersberg with his hotel, Gilbert & George move effortlessly between the two poles, never completely forsaking one for the other but also not blending the two, despite the consistency of their appearance and their claims to be, on occasion, sculptures. Their assumption of an identity linked to their actual selves but separate enough to be something else entirely, enables Gilbert & George to establish a private-public dichotomy. The border of these states of being remains known only to the pair, and despite the presumed intimacy of their work much is withheld from public view. It is quite similar to Ader's *The Boy Who Fell Over Niagara Falls*, the only work he made in the months following his mention, in the letter to Van Ravesteijn and Van Beijeren, of Gilbert & George's work. The parallels are also there with his commodity trading — a project whose deep-seated privacy seemed to call out for something public.

12

Ader continued to trade futures until the fall of 1973.[61] In the wake of his decision to stop, he made *In Search of the Miraculous (One Night in Los Angeles)* (1973), a series of either fourteen or eighteen photographs (there are two versions) that eventually became the first part of the unfinished triptych *In Search of the Miraculous*. The connection between this work and Ader's sail, in the summer of 1975, stems not only from their shared title but also from its inclusion in his April 1975 show at Claire Copley Gallery.[62] In the period between the completion of

In Search of the Miraculous (One Night in Los Angeles) and this exhibition, Ader presented the eighteen-photo version at the Kabinett für Aktuelle Kunst, in November 1974; the smaller iteration was on view at Copley's. There are other discrepancies as well between the two editions. Not only is the sequence of images different but also the size of the prints. That Ader felt it possible to alter the constitution of a finished work is unusual; the shifting nature of the piece would seem to imply that, in its inception, it was less about initiating a multipart project than about the need for a response to his commodities trading.

In Search of the Miraculous (One Night in Los Angeles) (fig. 26) details a nocturnal walk through various parts of the city: from the hills to the coastline, from urban to residential. The exact route is difficult to determine. Each small, black-and-white image shows Ader dressed in dark clothing, holding a large flashlight. He appears as a solitary wanderer who never reveals his face or comes out of the protective embrace of the shadows. There is humor in this Sisyphean act, a joke that seems connected to his early *Fall* films, for Ader must have known that miracles cannot be sought but instead appear by grace.[63] Pictures show him walking along a freeway, climbing atop a roof, at the far end of a pedestrian underpass, surveying Los Angeles from the hills, standing forlornly on the shore. Inscribed on every image, in Ader's distinctive handwriting, are lyrics from the 1957 song "Searchin'," written by Jerome Leiber and Mike Stoller and recorded by the Coasters.[64] Ader's wife took the photographs during a single night. They drove

Figure 26. Bas Jan Ader, *In Search of the Miraculous (One Night in Los Angeles)*, 1973. © The Estate of Bas Jan Ader.

around the city looking for ideal locations, and Ader posed in the selected spots.[65]

Of Ader's work, this was the most obviously about Los Angeles. Ruppersberg recalled how *In Search of the Miraculous (One Night in Los Angeles)* was very much a product of its environment. "As with most transplants to L.A.," he said, "there is an initial fascination with the place itself. With my close friends, most of our conversations about art took place within the context of talking about L.A."[66] Ruppersberg's own work from the early 1970s was rooted in the city. His *Greetings From L.A.: A Novel* (1971) — a 240-page book in which all but ten pages are blank — offers snippets of a hardboiled detective story in which the oblique narrative emphasizes place: the corner of Coldwater Canyon and Ventura Boulevard, somewhere on Devonshire, the best way to get to Venice from Hollywood. Another piece from this time, *Summer Days* (1971; fig. 27), shares a similar subject. Three eight-by-ten-inch photographs of Ruppersberg talking with three different men find meaning in corresponding typed dialogues, presumably exchanges between Ruppersberg and the individuals. The conversations are brief and revolve around directions, around knowing specific locations throughout the city. The work is obsessive with its geography, its factualism countered by images that could be about almost anything.

Van Elk and Leavitt had also made Los Angeles a focus of their art, as demonstrated by pieces like Van Elk's *The Co-Founder of the Word O.K. — Hollywood, 1971* and Leavitt's *California Patio*. Concurrent to Ader's

In Search of the Miraculous (One Night in Los Angeles), Van Elk created *Los Angeles Freeway Flyer* (1973) — six wooden canes, wrapped in color contact strips, hung end to end, forming a line on a wall; the affixed pictures capture cars racing along the Hollywood and Santa Monica Freeways. There are obvious connections to the images of Ader walking. Van Elk's work, though, is laced with paradoxes, caught up in the contrasts between Holland and Los Angeles. In its coiled photographs, *Los Angeles Freeway Flyer* implies a critique of Los Angeles's overreliance on automobiles and the spectacle of its freeway system. At the same time, the familiar hooked walking stick alludes to a European fixation on the past, a resistance to change and the deliverance prom-

Figure 27. Allen Ruppersberg, *Summer Days*, 1971. Courtesy of Margo Leavin Galley.

ised by modernity, evoking Old World, elegiac qualities far removed from the celebratory tones of Reyner Banham's 1971 book *Los Angeles: The Architecture of Four Ecologies* or even the passive acquiescence Joan Didion portrays in her 1970 novel *Play It As It Lays*.

As with much of Ader's photographic work, *In Search of the Miraculous (One Night in Los Angeles)* came alive in editing. The images taken that night fill seven contact sheets, and most did not make the cut. A literalism haunts the outtakes: Ader is seen lying on the street, looking down at the ground, among police caution signs. In one he beams his light into an obstructed doorway (fig. 28); in another he peers into a hole in a low-rise building's wall (fig. 29). In these photos Ader has

Figures 28 and 29. Bas Jan Ader, *In Search of the Miraculous (One Night in Los Angeles)* (outtakes), 1973. © The Estate of Bas Jan Ader.

a more prominent presence, which in the end he chose to exclude, selecting instead pictures in which he either is absorbed by shadow or shows only the back of his head. His interest at the time lay in making art in which he disappeared or slowly faded from sight. Several notes for unrealized works, undated but presumably from this period, speak to the opposition of day and night, light and dark: he would stand in a field and "have shadow of tree move over and become invisible," or "stand at streetcorner have shadow move over and become invisible." The prospective work was to produce a tension between the organic and geometric, passive and active — themes familiar from his early *Fall* pieces. Other potential projects called for him to "walk away from the camera into slow disappearance," or "find object in nature that late in the day throw shadow to hide you."[67]

The photographs constituting *In Search of the Miraculous (One Night in Los Angeles)*, especially the set shown at Claire Copley Gallery, contrast light and dark. Each has elements, beyond the beam of Ader's flashlight, that glow within the darkness. At times, this luminescence seems like an aura: the lights of Los Angeles seen from the hills or the lamps illuminating a peer jutting into the ocean. They stand out against the blackened details of scenery distinguished only by gradations of opacity. Within this optical tension, Ader's body slips in and out of sight, his presence a small element in an environment that swallows him. He seems to have thought further about the black-white dichotomy when conceiving the exhibition poster for his Kabinett für Aktuelle Kunst show. He could not travel to Bremerhaven because of teaching obligations, but worked with Wesseler on the announcement's design. They talked on the phone, settling on a simple text that stated the essential information. Two versions of the poster exist: one with a white background and black lettering, the other exactly the same except that the background was in a slightly different shade of black, enveloping the text such that it is barely legible.[68]

The light-dark duality reaches an almost mystical conclusion in the final image of *In Search of the Miraculous (One Night in Los Angeles)* (fig. 30). It shows, in the distance, Ader standing on a beach, his feet about to be washed by the incoming tide. His small figure is in the middle of the composition; the black sand and the moonlit water form an untamed line that moves from the horizon to the lower, right-hand corner of the photograph. Occupying the upper register of the

you know I'll bring her in someday

Figure 30. Bas Jan Ader, *In Search of the Miraculous (One Night in Los Angeles)* (detail), 1973. © The Estate of Bas Jan Ader.

picture is a hazy, white apparition: possibly clouds, perhaps the residue of city lights cast into the night sky. It appears strangely omniscient. Yet it is not a sense of Ader's insignificance that suffuses this atmospheric shot, but the strikingness of his isolation, his absolute solitude in an urban area teeming with life. Read through this lens, *In Search of the Miraculous (One Night in Los Angeles)* takes privacy and withdrawal from the social as its subject, making it seem, at least speculatively, closely aligned to his commodity trading. The photographic piece's temporal proximity to the cessation of his work in the futures

market suggests a compelling bond, for in other ways too their themes are similar. *In Search of the Miraculous (One Night in Los Angeles)* represents, or makes public, central aspects of the commodities project that remained only with Ader. That is, to allow the commodity work to remain in silence, Ader devised a means by which to represent the unrepresentable. The isolation depicted in *In Search of the Miraculous (One Night in Los Angeles)* is the solitude demanded by the commodities trading piece and conveyed, albeit implicitly, in *Thoughts Unsaid, Then Forgotten*. The oppositional logic that emerged in the *Fall* films appears once again. Now, however, the implications are greater. Ader, it seems, established a dialectic between a type of privacy and its representation. Its sublation was still to come.[69]

SAILING

13

Ader began teaching at the University of California, Irvine, in the first part of 1974, just a couple months after making *In Search of the Miraculous (One Night in Los Angeles)*. He had taught previously at smaller schools in the greater Los Angeles area, but this was his first time as a member of a more rigorous program in which some faculty members, like James Turrell, were well known. Ader's classes were open in structure, run in the manner of someone engaged with the contemporary art world.[1] His methods were favored by ambitious students, many of whom were taken by his intelligence, his good looks, and his propensity to dress entirely in blue.[2] His appointment allowed him to meet well-established peers. On one occasion he ran into Sol LeWitt, with whom he struck up a conversation about Amsterdam and Art & Project Gallery.[3] He also encountered Daniel Buren, an artist he greatly admired, and a photograph from that time shows Ader sitting in class next to Lawrence Weiner, who was presumably a visiting artist.[4]

Ader's teaching success did not necessarily transfer to his art. As in the previous year, his artistic output dwindled. Much of this was due to his deliberate practice. As Van Elk pointed out, "I know from the conversations we used to have in California that you didn't really want to have anything to do with producing just anything in order to reach clarity by way of repetition."[5] Ader believed, his former Irvine student Jane Reynolds recalled, that his career was to be long, and that he had plenty of time to become known. He wanted his entire body of work to have a cohesive meaning, not just be a collection of parts.[6] Around this time, Ader began to experiment with new media, taking advantage of the university's facilities. He worked on a video that included students from the dance department, who were to carry light tubes, using them, along with their movements, to make shapes. Sometimes the dancers threw the lights to one another; in flight the cylindrical lamps darkened, but upon being caught they lit up once again. The work was supposed to be fluid in nature, but Ader eventually abandoned the

project, feeling it was too fussy in composition. He continued to explore new creative avenues, including a computer work entitled *Artist Game*.[7] He even contemplated writing an application for an internal UC Irvine grant so that he could host a television show about artists' videos.[8]

It was the easy access to video equipment that marked his early months at Irvine. Besides the dance piece and the possible television show, he made a twenty-six-minute video called *Primary Time* (1974). A separate twenty-one-part photographic work, *Untitled (Flower Work)* (1974), corresponds to the video. Both show Ader dressed in black, his torso and the upper half of his legs visible. His face is out of view as his hands systematically arrange and then remove red, yellow, and purplish flowers. In a letter to Van Ravesteijn and Van Beijeren, Ader mentions briefly that he has a couple of new works about Mondrian.[9] The allusions are obvious, but there is the sense, he hints in another letter to his Amsterdam dealers, that the new works, in contrast to the philosophic character of the *Fall* films, are primarily about form — concerns that had never been central for Ader.[10] It is not clear to what ends Ader thought his formal explorations would take him, and compounding the confusion are doubts regarding whether or not the pieces were meant to be exhibited (although *Untitled (Flower Work)* was shown, along with the longer version of *In Search of the Miraculous (One Night in Los Angeles)*, in March 1975, at the Saman Gallery in Genoa, Italy).[11]

For students who knew Ader well, it was clear that he was at an aesthetic impasse, struggling to find form and expression adequate to his ideas.[12] He was uncertain about his practice, its validity, and whether or not it was superior to what he felt were the no longer relevant media of painting and sculpture. To his students, Ader was a performance artist. In class, he once did *The Boy Who Fell Over Niagara Falls*, and he also presented *Thoughts Unsaid, Then Forgotten*. Reynolds, who was close to Ader, thought he worried that his art was becoming routine, as when a student did a performance that consisted of burning some personal items and then writing words with the ashes. Ader critiqued the work severely, yet the faults he found were less about the piece in question, Reynolds suggests, than about his own practice: a fear that if this person could do something similar to him then what he did had no significance at all.[13]

14

In the midst of this confusion revolving around his work, and ever-increasing doubt about his art's validity, Ader began to make preparations for his solo crossing of the Atlantic Ocean. Some of the literature and commonly held assumptions about Ader's art and life imply that he was an inexperienced sailor, embarking on a naively romantic journey, for which a tragic death could be the only outcome. These beliefs arise in part from an unfamiliarity with Ader and in part from the difficulty in squaring his act with either radical artistic gestures or any commonsense understanding of man's relation to nature. Ader was, however, an accomplished sailor, having spent a great deal of time in his youth on small shrimpers, learning to read currents while out in the Eems-Dollard Estuary—a narrow body of water that runs between Holland and Germany and into the North Sea. He also worked briefly on a steamer that traveled to Scandinavia, and he sailed regularly with his brother in nearby lakes.

At the age of nineteen, just months after his return from Washington, DC, brooding over a distant love in America and unable to adjust to the gray clouds hanging over Drieborg, Ader left for Morocco, lured by the possibility of cheap studio space. His stay was relatively short, but while lodging in a youth hostel in Casablanca he met Neil Tucker Birkhead (fig. 31), an American looking for a crew member for his impending sail to Los Angeles. Ader jumped at the opportunity, not even bothering to call his mother. A hastily written postcard sufficed, and after a few days of preparation Ader and Birkhead set off for the Canary Islands.[14] Normally, the sail from Casablanca to Las Palmas is a comfortable, four-day trip.[15] The pair prepared accordingly, but were beset from the outset by heavy storms that greatly hindered their progress. Birkhead's yacht, the *Felicidad*, took a beating, with the main mast breaking, the mizzen sail blown away, and a single jib unable to be hoisted. With the boat's motor swamped, they found a Spanish Air Force vessel willing to tow them to safe harbor, bringing to a close their fourteen-day misadventure.

Birkhead and Ader stayed in the Canaries for several weeks. Once everything was repaired, ready for the next leg of the voyage, the Spanish authorities nixed their departure, claiming fees for salvage. Birkhead was short of money and unable to pay the debt. They decided to

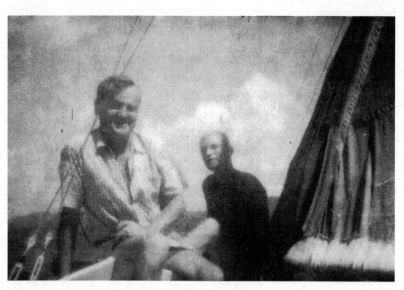

Figure 31. Neil Tucker Birkhead and Bas Jan Ader aboard the *Felicidad*, 1962–1963. © The Estate of Bas Jan Ader.

sneak out of harbor under the cover of a storm, figuring that no officials would be on watch. Their assumption proved correct, and they left before sunrise during a particularly nasty gale. They suffered through two days of rough seas, but soon afterward the conditions eased. Over the next thirty-three days, en route to Martinique, they benefited from favorable weather. It was here, in the open waters of the Atlantic, that Ader got his first real taste of solo ocean sailing, as he and Birkhead alternated watch — one taking the day, the other the night.[16] Their arrival in Martinique was not without complication. They ran aground, stuck atop an unsighted coral reef. Unable to break loose, the *Felicidad* was battered by the outer bands of a passing hurricane. Eventually the yacht was freed, and the following weeks were spent on ship maintenance, procuring funds, and getting ready to make their way westward to the Panama Canal. They made it to the Central American gateway to the Pacific with relative ease; their only real difficulty on this leg of the crossing was being becalmed for slightly more than a fortnight.

The passage through the canal was made under sail, as the *Felicidad*'s motor struggled to work. Entrance into the waters of the Pacific Ocean signaled the start of the final part of their voyage. It was to be the most arduous: the lack of a reliable engine forced them to follow

the old square-rigger route to California, which took them first south-west, then west toward the Galapagos Islands, then west again another fifteen hundred miles, before heading north in the direction of Los Angeles. Half of their potable water was spoiled a thousand miles out of Panama. This caused a food shortage, since they could not cook much of their dried food without water. They supplemented their diet by catching tuna and the ubiquitous flying fish; rainwater and moisture caught in their sails presumably added to their drinking supply. Just south of Guadalupe Island off the coast of Baja, Mexico, they encountered rough seas. Their mizzenmast was broken and the rigging on the main mast damaged beyond repair. Several days later, as they were still reeling from the previous storm, a rogue wave crashed upon the *Felicidad*, ripping out nearly six feet of cabin wall. They patched the gaping hole with old sailcloth and pressed on. Limping slowly home, they spotted American naval vessels conducting war games not far from San Diego. Upon seeing the *Felicidad*'s condition, the captain of one of the ships offered Birkhead and Ader a tow to San Diego, where they stayed until the yacht was seaworthy. A month and a half later, in the first part of 1963, they arrived in Los Angeles.

By the age of twenty, then, Ader had completed a voyage of roughly eleven thousand miles under harrowing and strenuous conditions. He continued to sail, although not as regularly, while living in Los Angeles. He and his wife would go out on the Pacific in a small Styrofoam boat barely large enough for the two. During visits to Holland, they would join Erik Ader and his girlfriend for day sails in the lakes around Friesland.[17] Ader's love of sailing did not flag as his art career developed. They were simply parallel interests. Tony DeLap, the chair of the Irvine art department and a sailor himself, remembers Ader as being of the sea.[18] Ader's intimate and respectful understanding of the ocean guided him in his preparations. He spent hours poring over nautical charts, studying the flow of various currents. He examined weather patterns, trying to anticipate the conditions he would face in the North Atlantic, and began to regain his feel for small boats in the open sea by borrowing DeLap's fiberglass dinghy, sailing it back and forth from Marina del Rey to Catalina Island.

The time was also spent reading the wide array of literature on solo ocean sailing, a genre of nautical writing that has its origins in Joshua Slocum's classic, turn-of-the-century account, *Sailing Alone around the*

World. Over the years, volumes by a variety of adventurers have appeared, detailing the toils and isolation of journeys that at times took many months. These accounts became more varied in the 1960s and early 1970s, as single-handed ocean sailing changed dramatically with Sir Francis Chichester's circumnavigation in 1966–1967. His 226-day sail, with a stop in Sydney, was the fastest solo, round-the-world trip that passed the three major capes.[19] The voyage kindled public excitement, prompting questions as to whether or not it was possible to make a similar journey without stopping. The *Sunday Times* of London, in an attempt to answer the query as well as drum up readership, sponsored, in 1968, the Golden Globe Race.[20] Nine participants took part; only one, Robin Knox-Johnston, completed the competition. Knox-Johnston and another competitor, Bernard Moitessier, wrote about their experiences, and their stories, much like Chichester's, are filled with details about the challenges faced during storms—having their boats knocked down in heavy seas, supplies and equipment strewn about the cabin, water pouring into the already cramped living space, radios damaged, self-steering mechanisms giving out—and the difficulty of being utterly alone.[21] Moitessier's narrative is perhaps the most peculiar. A natural seaman, spiritual at heart and uncomfortable with the demands of everyday life, he enjoyed a significant lead in the Golden Globe upon rounding Cape Horn. But instead of heading toward England, where prize money and media attention awaited, he continued eastward, choosing to stay in the Roaring Forties for as long as possible. Day in and day out he often faced gale-force conditions, with twenty-foot seas the norm. He felt at ease here, happier than he could ever imagine. His journey came to an end in Tahiti, but not before he had rounded the world one and a half times.

Moitessier's boat, the *Joshua*, was built for this particular kind of endurance cruising. Nearly forty feet in length, it had a steel hull and a telephone pole for a main mast. Its incredible durability helped it greatly in the rough waters of the southern oceans, but the type of sailing Moitessier did was different from what Ader had planned. Ader intended to cross the Atlantic in a thirteen-foot yacht, following a tradition of open-water, small-vessel sailing. Kenichie Horie, for example, had sailed his nineteen-foot boat *Mermaid* from Nishinomiya, Japan, to San Francisco in 1962.[22] Hugo Vihlen, a Vietnam veteran and pilot

for Delta Airlines, embarked on a quixotic voyage in 1968 from Casablanca to Miami in a specially designed six-foot vessel named *April Fool*.[23] Both Horie and Vihlen succeeded in their journeys, but there were also failures, like John Riding, who left from San Diego in 1973 and disappeared in the Tasman Sea, or William Willis, who in 1968 was lost in the North Atlantic, his eleven-foot boat *Little One* found floating several hundred miles from where Ader's boat would be recovered eight years later.[24]

Ader seems to have been most aware of the exploits of Robert Manry, a copy editor at the *Cleveland Plain Dealer*.[25] A devoted husband and a man of faith, Manry set sail in the summer of 1965 from Falmouth, Massachusetts, in his thirteen-and-a-half-foot sailboat *Tinkerbelle*. His goal was Falmouth, England, a journey that took him seventy-eight days. Since his childhood in India (his parents were missionaries), he had dreamed of making an ocean crossing. And as with everything he did in life, he was meticulous in his preparations, refitting his thirty-seven-year-old sloop so that it would be seaworthy no matter the conditions. In the days leading up to his voyage, he kept the details secret from everyone except his family and the Falmouth harbormaster. His colleagues at work were under the impression that he was sailing with a friend on a larger boat, and Manry did not feel it was right to dissuade them from their belief.

His sail began uneventfully, as he followed the westerly winds, trying to stay below the shipping lanes. He encountered no major physical problems or technical mishaps. There were times when he faced severe storms, riding down twenty-foot waves, but *Tinkerbelle* was remarkably adept at handling rough seas, displaying a grace that belied her wide beam and unsleek appearance. Nonetheless, she was knocked down on one occasion, and Manry fell into the water at least six times, his lifeline keeping him tied to his craft. Manry loved his life away from land. He enjoyed tracking the differences in the textures and surfaces of the water. The adrenaline rush of rough weather brought him increasingly in tune with his boat, but trouble arose when he had little sleep, manning the tiller for long hours in treacherous gales. Sometimes he took uppers to counter his drowsiness, but the amphetamines caused him to hallucinate, creating horrific visions that clouded the distinction between reality and fantasy. Outside of these uncomfort-

able occurrences, Manry's greatest challenge was combatting loneliness, especially when *Tinkerbelle* was becalmed, floating in a seemingly endless liquid expanse. He brought books along to help fill the time, but the demands of sailing, even in calm weather, prevented him from ever looking at them. He also had a 16-millimeter movie camera, with which he took several hours of footage. These distractions, however, could not always overcome the monotony of wind-starved days, a tedium deepened by his often eating the same canned meal over and over again.[26]

It is hard to know what, if anything, Ader took from Manry. He did not share the details of his reading with his wife, preferring that she not know the hardships he would face. Manry's book, like many others in the genre, is predictable. Whatever adventure is recounted, whatever brush with death described, foreknowledge of the author's survival diminishes the drama. Manry's detailed account captures in a humble and understated tone the magnitude of his accomplishment. But what perhaps caught Ader's attention more than anything was Manry's utter ordinariness. He was in appearance and lifestyle an unspectacular individual, a solid and upstanding citizen who dutifully got along. There must have been something compelling for Ader in this picture, something that spoke to his own doubts about his practice and the efficacy of his art, to his desires to become someone else, to shift roles and lifestyles, to his imagined self-image as an artist who wore a tie while driving a Mercedes, someone who made it seem to others that he would simply cease to be an artist and become a regular person.[27] In Manry, there was a contradiction between heroic accomplishment and the ability seemingly to be just one among many. Manry, it seems, searched for the transcendent, and he described his voyage aboard *Tinkerbelle* as a means to discover truth, as giving him a way to express life the way an artist does with paint on canvas. Ader could not have expressed it better. As Manry writes, seemingly capturing the concerns that defined Ader's practice in the run-up to his sail, "I had to concede that my voyage would benefit few persons other than myself, except insofar as it might, momentarily, lift some who heard of it out of the routine of their own lives, but it did give me a segment of existence that, God willing, I might fashion into something nearer to a work of art than my life on land had been."[28]

15

Ader faced numerous difficulties in organizing exhibitions for *In Search of the Miraculous*. Around the time he made the Los Angeles night walk, Jürgen Wesseler contacted him about having another show in Bremerhaven. Ader's schedule was at that moment in disarray.[29] He had hoped to do a project in London at the Situation Gallery, in February 1974. The gallery's owner, Anthony de Kerdrel, who had met Ader in Los Angeles through Ruppersberg and Van Elk two years earlier, extended an invitation in April 1973.[30] There was talk of doing a book around *In Search of the Miraculous (One Night in Los Angeles)* and of Ader's coming to London several months before the show opened.[31] But the plans were put into limbo by the gallery's financial difficulties, the extent of which were not known to Ader when he wrote to Wesseler, in halting German, that a show in December, January, or February would be ideal.[32] A letter dated December 7, 1973, then arrived from de Kerdrel, describing his gallery's precarious state. Unable to produce Ader's book, let alone afford his airfare to London, he delayed Ader's London debut until the cash flow stabilized.[33] Not long afterward, Ader sent a telegram to Wesseler that read, "no show in January letter follows."[34]

Ader received a letter in the first weeks of the new year from Françoise Lambert, who was in regular contact with Art & Project and other leading European galleries. She had heard about the Situation's dire circumstances and wondered about the possibility of presenting Ader in Milan.[35] Ader's response, if any, is not known, and the urgency with which he pursued these matters seems to have declined as his teaching responsibilities at Irvine increased and his formal experiments intensified. By August 1974 he had received an offer from Poul ter Hofstede of the Groninger Museum in Groningen, Netherlands — roughly thirty miles from Drieborg — for a show in the autumn of 1975. Ader sent a letter accepting the invitation on August 20, 1974, and it seems from the outset that he believed this venue offered the proper context for concluding *In Search of the Miraculous*.[36] The same day he wrote to ter Hofstede, Ader sent Wesseler a short note about his upcoming show. Nowhere in that letter does he mention *In Search of the Miraculous*. Instead, he proposed showing the videos and photographs of the UC Irvine dance students.[37] Only a month before the opening did he decide

Figure 32. Bas Jan Ader, *In Search of the Miraculous (One Night in Los Angeles)*, 1973. © The Estate of Bas Jan Ader.

to present *In Search of the Miraculous (One Night in Los Angeles)*, which suggests that Ader thought of the video of the dancers as nearly finished but regarded *In Search of the Miraculous (One Night in Los Angeles)* as a work in progress nearly a year after its creation (fig. 32). His quick letter to Wesseler outlines the essentials of the piece. It also mentions that either the sixth image, which shows a luminous Los Angeles, or the eighteenth image, the work's ominous conclusion, could be used for the exhibition poster — choices that were scuttled in the end.[38]

It was probably in late 1974 that Ader took up Copley's offer to show with her. There had previously been talk of Ileana Sonnabend helping him realize *In Search of the Miraculous*, although nothing came of it.[39] Copley had promised Ader that he could show whatever he wanted.

She was struck, however, in preparing for the show, by how removed from the art world he had become; he thought making art was about living one's life, a sentiment she attributed to the time he spent with his friend James Turrell. Ader seemed caught up in the idea of having a double identity and was becoming increasingly strange, ever more drawn to secret lives. She felt that, by the time of the exhibition, his desire to be an artist had waned. It was as if he no longer cared.[40]

When Copley opened her gallery, in 1973, she was essentially the only gallerist committed exclusively to conceptual art. Eugenia Butler, who had previously worn that mantle, had already closed, and Riko Mizuno, who took on a number of artists from Butler, had diverse interests, which left Copley to fill a void in the Los Angeles art scene. The

impulse for the gallery arose in 1972 when she was traveling in Europe with Ruppersberg, her partner at the time. Ruppersberg had a show in Milan with Lambert, who was keen on opening a space in Los Angeles and thought it would be good to collaborate with Copley. Lambert had provided the initial start-up money, but within weeks she pulled out of the project. Copley was left to figure things out on her own, and relied on the help of Ruppersberg, Leavitt, and Van Elk to put the program together. It was decided to give the gallery a go for at least three months, with William Wegman as the first artist shown. She was excited to present someone of his stature, and over the next few years she exhibited such artists as Michael Asher, Daniel Buren, Hamish Fulton, Joseph Kosuth, David Lamelas, Barry Le Va, and Lawrence Weiner. Ruppersberg, Leavitt, and Van Elk also showed there, and even David Salle had work on view in the summer of 1975, while still a student.

Copley's greatest challenge was generating sales. Her relationships were mostly with artists, not collectors, and even if she attempted to cultivate connections with the latter there was little interest in the art she had on view. There was also the fact that some collectors or institutions preferred to deal with New York galleries. On one occasion, Maurice Tuchman, then the curator at the Los Angeles County Museum of Art, wished to buy a work by Sol LeWitt that was on view at Copley's and approached Leo Castelli, LeWitt's New York dealer, about acquiring it. LeWitt refused to authorize the sale unless Tuchman purchased the piece from Copley, which he eventually did. In the few years it was open, the gallery was beset with financial difficulties. Ader's work, for example, did not sell. To keep her space afloat she had to sell her personal assets, particularly paintings by her father, William Copley. Her business model eventually proved untenable, and in 1976 she closed the gallery.[41]

Ader's exhibition ran from April 22 to May 17, 1975. It was his first solo gallery show in Los Angeles and marked the first time since Pomona, three years earlier, that his work had been readily available to a wide swath of his peers. Many of his shows, up until this point, had occurred in relative obscurity, in places like Bremerhaven, where visitors were few, or in Amsterdam or Genoa, where progressive art communities existed but were still small in number. To a certain extent, Ader's reputation relied on word of mouth. His peers admired his work and he was an integral member of the Los Angeles concep-

tual art scene, but little of his art was available for viewing. *In Search of the Miraculous* was by far his greatest public statement. Never had his art been so visible.

Copley was surprised by the show's content. The installation seemed quite removed from the person who appeared to be turning inward and growing more detached from those around him. For Copley, the exhibition was a spectacle, a particularly apt description of a project that at its core was about the relation between presence and absence.[42] Copley's space was small, longer than it was wide. Toward the back was a partition that hid her office from the rest of the gallery. Along the left and rear walls of the office, Ader hung the fourteen-photograph version of *In Search of the Miraculous (One Night in Los Angeles)*. On the right wall, close to the gallery's entrance, were lyrics to nineteenth-century sea shanties. During the opening, Ader had nine UC Irvine students, accompanied by a pianist, sing the wistful and romantic tunes (fig. 33). They stood in front of the divider—six on a low riser, three just below—facing the pianist, whose instrument sat at a slight diagonal. The performers continued the light-dark opposition evident in the fourteen melancholy photographs. Dressed all in black, in front of a white wall, the singers either held white sheet music or rested it on black music stands. The theme was further emphasized by the geometry of the lacquered, black piano with its black and white keys, the white sheet music now before the pianist, and, as a final touch, her white hair (fig. 34).

The songs, simple in composition, one tune often blending into the next, were nostalgic, presenting an idealized conception of the sailor, of the insatiable desire to spend one's life at sea. The awkward voices of the art students enhanced the state of disquiet created by the lyrics and jerky piano playing. They sang of sailors bidding goodbye, of mariners promising lovers their hearts. Some lyrics spoke of the excitement of setting off, finally leaving land for the rolling ocean. The signal song of the group was "A Life on the Ocean Wave," written in the 1830s by Epes Sargent and Henry Russell. It was from this tune that Ader took the name of his boat. The two-verse shanty describes "a home on the roll-ing deep," and proclaims "the flash-ing brine, the spray and the tem-pest roar" superior to anything on land. Undoubtedly, the choir's performance set an ambiguous mood for the event. It was at once absurd—the seemingly untenable admixture of the content of the songs,

the gallery context, and their relation to Ader's previous work—and affecting: the nature of the lyrics, seen alongside the photographs, suggests a farewell, an oblique effort to express the dangers of the upcoming journey, risks that, as the songs imply, were accepted from the outset.

Photographs of the students' performance, taken straight-on and excluding extraneous details, were, for the duration of the exhibition, projected on the partition wall (fig. 35). A Dutch projector was used, and its carousel tray tended to destroy slides.[43] The machine was on a timer, advancing through the slightly different images at a regulated pace. An audiorecording of the choir's performance played in the background, creating, in combination with the slides, a double representation of the original event. The feeling of both a literal and a metaphorical absence was strong. There were now layers of self-conscious dissimulation never before apparent in Ader's art.

The one reviewer of the show, William Wilson, captured in a somewhat condescending way the manner in which representational strata dominated the show. He writes about how the "slides of the black-garbed students projected almost life-size look like New Realist paintings of a church choir," and offers that "it all becomes a kind of sentimental rococo kitsch."[44] This last observation, though laced with derision, intimates the sense of spectacle Copley observed. Ader had spent the past five years attempting to drain all traces of representation from his art. Their ability to distort meaning had not always been his primary concern, but in the last couple of years, especially with the commodity trading work, he had made a greater effort to eradicate any element that might disrupt the purity of the art. The ascetic austerity demanded by the logic of the commodity project proved impossible to maintain; its quality of privacy, though, was figured in the photographs that constituted *In Search of the Miraculous (One Night in Los Angeles)*. An opposition was established; it may have arisen from chance as much as anything else, and yet a similar pattern emerges with the Copley installation, making the previous effort of forging a dichotomy seem more intentional. What was to make Ader's upcoming sail unique was its absolute singularity. It had the potential to be an experience that defied representation. To emphasize that point, to in essence portray that which cannot be represented, Ader's Copley show had to be extravagant. It had to make explicit the relation between absence and presence.

Figures 33 and 34. Bas Jan Ader, *In Search of the Miraculous* (rehearsal and performance, Claire Copley Gallery, Los Angeles), 1975. © The Estate of Bas Jan Ader.

Figure 35. Bas Jan Ader, *In Search of the Miraculous* (installation view, Claire Copley Gallery, Los Angeles), 1975. © The Estate of Bas Jan Ader.

16

The preparations for the sail were arduous. Few things went according to plan. Costs quickly escalated, and Ader's attempts to find sponsorship were unsuccessful. In the first part of March 1975, he wrote to Van Ravesteijn and Van Beijeren at Art & Project, asking them to pay him the money owed by the Dutch Ministry of Culture for the purchase of some *Fall* films. In the same note, Ader revealed his intention to sail, asking his Amsterdam dealers to keep the information to themselves. He said that his journey was to be both adventurous and romantic. He also hoped the gallery would publish a bulletin announcing his trip.[45] Several months later Ader had still not received the money. He asked in another letter that they transfer the funds to his bank in Winschoten, the Netherlands, describing how he has managed, with great difficulty, to pay for the trip, although he is still concerned about having no money when he arrives. He also inquired as to how things were going with the Groninger Museum, which it seems was uncommitted or at least uncertain as to how Ader's show would come off.[46] Logistical confusion abounded, none of which was ameliorated by the fact that, at the time his Copley show closed, Ader still had not found a boat.

In the beginning of June he finally purchased a used Guppy 13.[47] The twelve-and-a-half-foot pocket cruiser was a serious yacht designed for overnight trips and open-water sailing. Made entirely of molded fiberglass, the boat had foam flotation embedded within its hull. It could self-right in case of knockdown, and unlike many boats of its size it had a fixed keel. The cabin slept two and its bunks were almost seven feet long, allowing someone of Ader's height to stretch out comfortably — assuming the space was not filled with months' worth of provisions. Moreover, it was built with performance in mind, flying a mainsail and a jib totaling eighty square feet of sail area. The mainsail even had roller-reefing gear, equipment normally found, at the time, on ocean racing vessels. Other technical aspects, such as allowing a sailor to trim and cleat the sails from inside the cockpit, combined with its speed and capacity to withstand rough conditions, made the Guppy 13 perform like a yacht far bigger in size.[48]

Ader spent the following weeks having his new boat modified by a professional shipyard. They strengthened the rigging and reinforced the washboards with extra layers of fiberglass. It was on this divider between the cockpit and cabin that the bolt to which Ader fastened his lifeline was located.[49] While the boat was getting ready, Ader saw to other affairs. He wrote to Art & Project at the beginning of June, telling his dealers that he planned to leave the east coast within three weeks. He was anxious to determine the layout of the bulletin, which would be an aspect of the second part of the triptych. Upon departure, he told them, a package of photographs would be sent with instructions for publication. He asked if they could print extra copies of the bulletin so that Copley could also send them to people on her mailing list.[50] Ader said he expected to arrive sometime in September. He could not be sure of the exact date, but his most optimistic calculations predicted landfall at the start of the month, the most pessimistic toward the end. He knew that he would not return to Los Angeles until after the fall quarter at Irvine had begun, so on the second-to-last day of spring classes he met with Tony DeLap, the chair of the department. By then they had come to know one another fairly well; DeLap had had Ader to his house for dinner and even took him to the Magic Castle in Hollywood, where DeLap, an outstanding illusionist, was a member. During their meeting, Ader told DeLap of his intentions to sail across the Atlantic. He said that the boat was fully outfitted, and

that he would soon drive to Cape Cod. He made clear to DeLap that this was not a suicide mission, something DeLap did not doubt. He was familiar with Ader's experience at sea, and it was clear that Ader had prepared carefully. DeLap told Ader that it would be no problem if he began the fall quarter two weeks late. They could easily find someone to cover his classes until his return.[51]

Copley recalled that she was not worried about Ader's impending voyage. He had convinced her that he was fully prepared, and she remembers that his wife was also confident about the trip.[52] Others who spoke with him at the time came away with a similar impression. All seemed manageable, and Ader, never one to rush into anything, had taken every precaution. Still, some sensed strain on his part. Reynolds, who had a show that summer at Copley's—arranged with Ader's help—spoke to him by phone before her opening. He could not make it because he was working on his boat, but he wished her good luck. To her mind, he sounded sad, as if he were saying goodbye forever. She attributed this sentiment to the larger malaise he was feeling about the state of his art.[53] Her impression seems to be in the minority, but others did recognize an air of disquiet about him. Copley thought it had to do more with the great personal strain he was under because of a long-standing affair. He had been spending half the week with his mistress and half with his wife.[54] It was a situation Van Elk remembered as being too much for his old friend. Ader supposedly struggled to choose whom he should be with, loving both equally, not wanting to hurt either.[55]

It was under this cloud of uncertainty—partly personal but more related to the hurried nature of his final preparations—that Ader and his wife left Los Angeles with *Ocean Wave* hitched to the back of their Mercedes. They departed sometime in mid-June, and headed toward Syracuse, New York, where Mary Sue Ader had family. There, Ader bought provisions for his trip, to which he must have given extensive thought.[56] One of the greatest logistical challenges he faced was the storage of his supplies. In contrast to his previous ocean crossing in the *Felicidad*, Ader had little space available. Everything had to be carefully considered, not only food and water but also spare equipment, medical supplies, tools, and personal effects. He most likely had calculated his daily caloric needs and the minimum amount of water he

needed to survive, including the water required to prepare canned and dehydrated food. It was essential that whatever he ate be easy to prepare. He also had to devise ways to stow the food and water such that it would not be spoiled by the seawater that would inevitably fill the cabin during storms.

Upon arrival in Chatham, Massachusetts, Ader quickly proceeded to get ready for the sail. There is some color film shot by Mary Sue Ader of her husband at work. *Ocean Wave*'s mast is yet to be set, still separate from the yacht after the cross-country drive. The cockpit is strewn with materials. Ader is seen making adjustments to his self-steering device. He would have strategically arranged his gear throughout the cabin and probably, if there was storage there, beneath the cockpit. He seems to have taken enough food for at least two months and enough water for three.[57] The latter, obviously, was critical, although if supplies dwindled he could replenish with captured rainwater. He could also supplement his food stock with fish—both those caught with a rod and those, as with flying fish, that landed on the deck. He took a Primus stove for cooking. He also had a small battery-powered radio receiver but not a two-way radio, since he lacked the capacity to generate enough electricity to make it operational. In case of emergency he had a transponder that could alert overflying airplanes his position. To navigate, he would rely on the same instrument sailors had used for hundreds of years: a sextant.[58]

Ader was ready to set sail on July 9, 1975. In the two days before leaving he wrote a letter and two postcards. The letter was to Ida Gianelli, his gallerist in Genoa, asking, as with his earlier correspondence to Art & Project, for payment for the sale of two editions of *Untitled (Flower Work)*. Ader was concerned with how his wife would cover expenses while he was at sea.[59] The postcards were sent to Ader's two great supporters in Europe: Art & Project Gallery and the Kabinett für Aktuelle Kunst. Both cards were the same, and both came with an annotation by Mary Sue Ader saying that her husband had left at 2:00 p.m. and expected to arrive in Europe in sixty to ninety days (fig. 36).[60] The image on the cards is nostalgic, verging on kitsch. It shows the sun rising off the coast of Cape Cod National Seashore. The bluish-green water glimmers with light. The photo draws the viewer toward the unknown on the other side of the horizon. The picture, taken by Sylvia A. Sawin,

Figure 36. Bas Jan Ader, postcard to Jürgen and Christina Wesseler, July 9, 1975. © The Estate of Bas Jan Ader. Courtesy of the Kabinett für Aktuelle Kunst, Bremerhaven.

can be seen as the converse of the concluding image of *In Search of the Miraculous (One Night in Los Angeles)*: instead of an ominous specter floating in the night sky there is the inspirational power of the morning sun.

Ocean Wave was towed out of the harbor (fig. 37). A photograph, taken from the towboat by Mary Sue Ader, shows the mustard-colored

Figure 37. Bas Jan Ader aboard the *Ocean Wave*, being towed out of Chatham Harbor, July 9, 1975. © The Estate of Bas Jan Ader.

yacht looking lively, its name legible in black, block lettering, its sails furled.[61] Ader sits on the starboard side, his left hand, it would seem, on the tiller. Clear of the harbor, in the open expanse of the Atlantic Ocean, his towline was released (fig. 38). With the white mainsail and the bright red jib raised, *Ocean Wave*'s sails filled with wind. He was off.

Figure 38 *(following page).* Bas Jan Ader aboard the *Ocean Wave*, about to set sail, July 9, 1975. © The Estate of Bas Jan Ader.

DYING

17

Mary Sue Ader waited for her husband in Holland, fully expecting him to arrive. But a week into September she had to return to Los Angeles because of a teaching commitment. She assumed that his landfall was imminent, and even when he did not show by the end of September she remained hopeful, taking comfort from experienced sailors who said a trip such as Ader's could take upward of 150 days. In December she traveled back to Holland, still with no word of whether her husband was alive or dead. She and Erik Ader went to the embassies of countries bordering the Atlantic to inform them of Ader's status. They also alerted the British Coast Guard, which conducted two unsuccessful searches.[1] Given Ader's uncertain status, his scheduled show at the Groninger Museum was postponed.[2] It was to have had a feel similar to that of the exhibition at Claire Copley's Los Angeles gallery. Dutch performers, who had already been practicing, were to sing sea shanties at the opening. On view would be the photographs from an Amsterdam night walk; they were to be, it seems, comparable in composition to the Los Angeles images taken two years earlier. There might also have been photographs and audiorecordings from the voyage, but it is not known how, let alone if, these elements were to have been presented.

On April 18, 1976, the Spanish fishing boat *Eduardo Pondal* came across a small vessel floating vertically. Its position at the time was 49 degrees, 58 minutes north latitude and 11 degrees, 2 minutes west longitude, in the middle of what the Spanish call the Gran Sol, an area south of Ireland and west of the southern coast of England. The captain of the *Eduardo Pondal*, Don Manual Castineira Alfeirán, ordered his crew to draw alongside the distressed boat, whose stern broached the surface. Wary that the yacht might harm his nets or those of someone else, Alfeirán had his crew hoist the abandoned pocket cruiser onto the trawler's deck. They pumped out the excess water from the craft, then proceeded to search its cabin. Inside the dank compartment they discovered some spoiled tins of food, a paraffin stove, a plastic sextant, sunglasses, six pairs of socks, a sweater, three pairs of slacks, a driv-

er's license, a health insurance card, a University of California, Irvine, ID card, and a damaged Dutch passport belonging to Bastiaan Johan Christiaan Ader.

The *Eduardo Pondal* returned to harbor in La Coruña ten days later. Captain Alfeirán had the *Ocean Wave* stored at the far end of the San Diego Pier and ordered his valet to look after the yacht while it was drydocked. Sometime between May 18 and June 7, 1976, however, the *Ocean Wave* disappeared without a trace. Rumor had it that she was sold for scrap. Others have suggested that the boat, which Spanish authorities estimated had a value of fifty thousand pesetas, was sold and is still being used as a pleasure cruiser. Capitan Alfeirán was quoted in an April 29, 1976, article in the local newspaper, *Voz de Galicia*, as saying he was surprised that no life vest was found on board. He also remarked that barnacles covered *Ocean Wave*'s hull, which led him to surmise that the boat had been adrift for about six months.[3] If his supposition is correct, Ader would have been at sea for roughly three months.

A month after *Ocean Wave* was brought ashore, Mary Sue Ader received a call from Interpol informing her of the yacht's recovery.[4] She contacted Erik Ader immediately, and the two soon arrived in La Coruña, where Spanish naval authorities told them that an explosion had occurred on board the boat. This conclusion was based on damage to the washboards, but when Erik Ader, who did not have a chance to inspect *Ocean Wave* himself, asked if scorch marks were visible around the cabin's entrance, the answer was no. Ader's brother, who only a year later circumnavigated the globe as a crew member on a boat competing in the Whitbread Round the World Race, did not believe an explosion was the cause of his brother's disappearance. He surmised instead that Ader was knocked overboard. This could have happened during a storm or even in relatively calm weather. That no life vest was found aboard *Ocean Wave* suggests that Ader was wearing it at the time. Some event, whether the force of a wave or an unusual jerk of the boat, then caused the lifeline to rip the washboards from their casing, leaving Ader in the water, severed from his boat, which carried on without him.[5]

At Irvine the previous fall, the school year had begun as planned. DeLap found someone to cover Ader's class, but after four weeks he was forced to call Mary Sue Ader to tell her that he could no longer hold the course for her husband.[6] In the following months, rumors began to

circulate. Some suggested Ader had started another life, continuing his engagement with double identities. There were murmurings that he might have set out to hide for a period of three years, a disappearance that would satisfy his interest in shadows and in obscuring his presence.[7] Talk of suicide abounded, ideas that were given more credence upon the discovery, in Ader's UC Irvine locker, of the book *The Strange Last Voyage of Donald Crowhurst* by Nicholas Tomalin and Ron Hall.[8]

Crowhurst, at best a good day sailor, had competed in the 1968 Golden Globe Race that Robin Knox-Johnston won after Bernard Moitessier chose to bypass the finish line. At the time, as Tomalin and Hall tell it, Crowhurst's company, which had under development a navigational device for ocean-going yachts, was on the verge of bankruptcy. Crowhurst was desperate, and entered the race in hopes of generating publicity for his business. Seduced by technology, he had a trimaran designed for the competition. A multihull boat such as Crowhurst's could achieve faster speeds than a traditional, monohull vessel, but in heavy seas was at higher risk of pitchpoling. Crowhurst's preparations were rushed, if not amateurish. Delays in the boat's production, plus his own technological modifications, which later proved useless, caused the start of his race to be beset by mishaps.

According to Tomalin and Hall, Crowhurst was of two minds while at sea. In his film and tape recordings for the BBC, he appeared happy, full of verve, calling his daily duties "sailoring." But when not before the camera or microphone, his thoughts were darker, filled with the impossibility of the task ahead. He searched for an honorable way to leave the race, but none presented itself as he approached the Cape of Good Hope. The prospects of pitting his overmatched skills against the southern ocean were too much for him, and unable to bring himself to withdraw from the competition, he turned around and cruised back and forth in the comparatively tranquil waters of the South Atlantic, sending race organizers cryptic messages that falsely reported his position. Those on land and in the race believed he was progressing admirably and even, for a time, nearing the lead. Meanwhile, Crowhurst was cracking under the strain of the journey and perhaps the guilt of his tremendous deception. He was losing his sense of reality, and as the days went by he became increasingly delusional. He wrote furiously, expounding upon his place in the universe, the meaning of life, how man can transcend his earthbound existence. On July 1, 1969, he con-

cluded his rambling disquisition. Ten days later his abandoned boat was discovered. Crowhurst was nowhere to be found.

Any equation of Ader and Crowhurst is doomed to be superficial, particularly if one is aware of Ader's extensive sailing background. But without this understanding, or the knowledge that Ader had been thinking of undertaking a solo crossing since the age of twenty and that his preparations spanned well over a year, his regular references to the romantic qualities of his impending trip might seem to hint at suicide. It is an image of such power — Ader alone in his small boat, hoping, in the name of art, that a miracle might grant him safe passage — that it is hard to dispel. When asked by Liza Bear and Willoughby Sharp, in an interview conducted on May 28, 1976, only days before she received the call from Interpol, if she thought her husband committed suicide, Mary Sue Ader answered emphatically, "No, I'm absolutely convinced that was nowhere in his consciousness. We talked about it, and he assured me repeatedly these were not his intentions."[9]

A few months later a memorial service was held for Ader in Drieborg. It was conducted by his mother, who was deeply pained by her son's disappearance.[10] Accounts of the service were recorded in the newsletter she wrote for her congregants. She quoted from scripture — 1 Corinthians 12 and 13, Psalm 30 — and also made public a poem she had written in English, one that came to her, she says, telepathically on October 12, 1975 — roughly six months before the *Eduardo Pondal* found *Ocean Wave*:

From the deep waters of sleep I wake up to consciousness.
In the distance I hear a train rumbling in the early morning.
It is going East and passes the border. Then it will stop.

I feel my heart beating too. It will go on beating for some time.
Then it will stop.
I wonder if the little heart that has beaten with mine, has stopped.
When he passed the border of birth, I laid him at my breast,
Rocked him in my arms.
He was very small then.

A white body of a man, rocked in the arms of the waves,
Is very small too.

What are we in the infinity of ocean and sky?
A small baby at the breast of eternity.

Have you ever heard of happiness
Springing from a deep well of sorrow?
Of love, springing from pain and despondency, agony and death?
Such is mine.[11]

18

It is possible to read Ader's death as an inextricable part of *In Search of the Miraculous*, as a condition of the work, not, it would seem, by choice but by fate: a chance occurrence that forever altered the interpretive possibilities of the piece and the reception of Ader's practice. A tragic end such as his is unprecedented in the history of contemporary art. There are few, if any, examples that help contextualize it. In 1973 Robert Smithson died in a plane crash while surveying his uncompleted *Amarillo Ramp*. Like Ader, he was in the midst of making the work. His flight, though, was not an aspect of the piece, and neither *Amarillo Ramp* nor his other works of land art is completely defined by the accident. Plane crashes, even when associated with the creation of an artwork, are mundane, though infrequent, parts of ordinary life. The very nature of Smithson's late work — large-scale objects on which entropic forces are allowed to run their course — also mitigated the overemphasis of his death. What might be called the agency of *Spiral Jetty* (1970) or *Broken Circle/Spiral Hill* leaves Smithson's subjectivity as just one of many factors constituting the work. With Ader the situation is different because of the ephemeral nature of the voyage. There was nothing substantial that linked the trip to art besides his presence. Ader's life, his intentions, shifted the journey categorically from just a sail (a part of life) to something symbolic (a part of art).

Still, if his death is central to *In Search of the Miraculous*, it must be possible to read the work and its tragic conclusion in relation to other pieces in which death is the main theme, a condition that was the case for some of Ader's peers around 1972 and 1973. Ruppersberg has stated that the idea of death was an important topic for him, which does not deny the fact that his work, or that of Goldstein or Burden, can be read against the backdrop of Vietnam, violence in the media, and the Man-

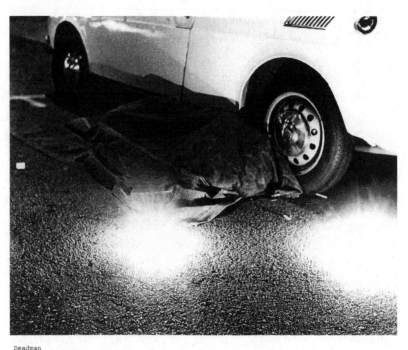

Deadman
Mizuno Gallery: November 12, 1972

At 8 p.m. I lay down on La Cienega Boulevard and was covered completely with a canvas tarpolin. Two fifteen-minute flares were placed near me to alert cars. Just before the flares extinguished, a police car arrived. I was arrested and booked for causing a false emergency to be reported. Trial took place in Beverly Hills. After three days of deliberation, the jury failed to reach a decision, and the judge dismissed the case.

Figure 39. Chris Burden, *Deadman*, 1972. © Chris Burden. Courtesy of the artist and Gagosian Gallery.

son murders.[12] The specter of death loomed large in American culture, and in the case of conceptual art in Los Angeles it was linked to issues of artistic subjectivity.[13]

On November 12, 1972, at the stroke of 8 p.m., Chris Burden laid down next to a cream-colored Saab 99 on La Cienega Boulevard in Los Angeles (fig. 39). A gray tarp covered him. Two fifteen-minute red flares announced his presence to oncoming traffic. A small crowd gathered around either to further protect him from passing cars or to get a better look at his performance, entitled *Deadman*. The piece was part of his show at Riko Mizuno Gallery, and it had affinities to other works from the time, such as *Dos Equis*, from a month earlier, in which he placed two large wooden X's in the middle of Laguna Canyon Road and set them ablaze, or *Through the Nightly Softly*, completed a year later,

which had him crawling, hands behind his back, across a stretch of broken glass on Main Street in Los Angeles. All of these works, to various degrees, are aggressive interventions in public spaces. *Deadman*, however, is more metaphorical, since the potential for severe harm or death is mitigated by an audience that is aware of what is happening.

It is possible to see Burden's *Deadman* in relation to another performance done at Riko Mizuno's just a week later, a re-creation of a project carried out several months earlier on the campus of CalArts, where Jack Goldstein had himself lowered into the ground as he lay inside a coffin. A breathing tube extending from the box to the surface was his only source of air. A stethoscope was attached to his heart and connected to a red lightbulb about twenty feet away from where he lay; in the descending dark of evening, it flashed to the beats of his heart. Goldstein was relatively new to performance, which he came to through his friendship with Kosaka.[14] Kosaka thought *Burial Piece* was trite, but Goldstein's mentor, John Baldessari, believed "it was one of the most risky pieces I have ever seen. . . . What a terror being buried like that must have induced."[15] Some of Kosaka's frustration may have had to do with Goldstein's restaging *Burial Piece* at Mizuno's gallery, for this time he was not placed underground but displayed in the coffin. Like Burden's *Deadman*, *Burial Piece* had become fully symbolic from beginning to end—not death per se but its representation.

Ruppersberg's photographic works in the early 1970s had a few dominant themes running through them; death was one, and in several series he depicted his own demise. In all of the pieces there is a strong absurdist sentiment, as with *100mph* (1972; fig. 40), a series of five eight-by-ten-inch photographs showing the development of a car crash. The cars, visibly manipulated by Ruppersberg, are small toys, and the ensuing accident is like the minor disasters children devise when playing. The penultimate image of the sequence presents the cars in a heap, their wheels ripped away. Concluding the narrative is a picture of Ruppersberg, who lies on the ground, presumably dead, a small fire spreading in a line across his back.[16] His depiction of death is more detached than that of Burden or Goldstein. In works like *Between the Scenes* (1973) and *To Tell the Truth* (1973), the end of life occurs without reason, punctuating stories that do not necessarily point to such morbid finales. The comical costumes Ruppersberg's wears—a plastic mask in *To Tell the Truth*—deflate the seriousness that might otherwise

be associated with images of a gun pointed toward his head. For Ruppersberg, death is just another event.[17]

These pieces by Burden, Goldstein, and Ruppersberg were done during the same period in which Ader made *The Boy Who Fell Over Niagara Falls* and traded commodities. The specter of death, so strong in the practice of his peers, lurks in Ader's transitional works only as a sentiment evoked in the story he read in Amsterdam and Bremerhaven or a quality that can in retrospect be seen in his activity in the futures market. Works produced by the same peers in the months before Ader left Cape Cod help further contextualize the artistic consequences of his disappearance. Both Ruppersberg and Burden moved their investigations into death toward more ambiguous territory, with the transience of subjectivity, not its erasure, becoming the focus. Ruppersberg, for instance, did a detailed, text-based performance in 1975 that highlighted the tragedy of the death of illusionist Harry Houdini. Ruppersberg's engagement with the twentieth century's greatest magician also relates to one of his earlier pieces, *Where's Al* (1972; fig. 41) — a collection of 160 small color photographs and 110 note cards with typed dialogue arranged, gridlike, on a wall. The notes and photos present a disjointed narrative that constantly refers to Ruppersberg's absence. Pictures of what one assumes are Ruppersberg's friends — at a bar, a beach, a party — are juxtaposed with pithy texts that ask, "Where's Al?" or "Why didn't Al come?" The uncertain answers — "he went to New York I think" — only heighten the feeling of indeterminacy.

The mystery of *Where's Al* was literalized in Burden's February 1975 performance *White Light/White Heat*, at Ronald Feldman Gallery in New York. It lasted for twenty-two days and is arguably his most intense piece, placing extraordinary demands on himself and, obliquely, the viewer. Burden saw *White Light/White Heat* as a continuation of *Bed*

Figure 40. Allen Ruppersberg, *100mph*, 1972. Courtesy of Margo Leavin Galley.

Piece, a chance to further realize that earlier work's potential.[18] Constructed high in the corner of Feldman's Soho gallery space was a triangular platform that resembled a minimalist object. It became Burden's home for the duration of the show, and its design ensured that neither he nor the viewer could see one another. To prevent any possible contact, Burden fasted during the entire run of the exhibition. With *Bed Piece* observers began to see Burden as an object, but those who went to Ronald Feldman Gallery could not be sure if he was actually there. No noise emanated from above, no hints of life alerted viewers to his presence. It was an act of faith to think one was sharing the room with Burden.[19] Viewers found themselves in the unusual circumstance of wondering whether or not they were actually experiencing a performance. In the end, the piece hinged less on Burden's hardship and more upon what viewers believed they were encountering: presence or absence.

The distinction between such projects by Burden, Goldstein, and Ruppersberg and Ader's is obvious: Ader's peers mostly made representations; *In Search of the Miraculous* was something else. Ader's body was never found, and three years after *Ocean Wave* was recovered he was legally declared lost at sea. It is impossible to know what happened to him. No records survive that could shed light on the tragic event; the camera and tape recorder he took with him disappeared as well. Since the beginning, with works like *Fall 1, Los Angeles*, Ader had been very conscious of the distortions inherent to representation, working to eliminate their negative effects on the conveyance of philosophic truths. There was, of course, some confusion in his position, particularly as he chose to work primarily in film and photography in the

Figure 41 *(following pages)*. Allen Ruppersberg, *Where's Al* (detail), 1972. Courtesy of Margo Leavin Galley.

he: Where's Al?

she: I don't know. Nobody's up yet.

she: Where's Al?

he: Holed up in his room probably.

she: I suppose.

TV·ROOM

ree

she: It's

he: Excep

she: Yeah,

he: I don

she: You ne

he: Nope.

me?

He's been working

he: How come Al's not here?

he: I don't know.

she: Was Al in town when you left?

he: No. I think he went to Texas.

she: Yeah.

body could make it.

ne?
He said he would call.

from him?

he: Where's Al?
she: I don't know. Probably out in the
 Valley. Fantasy can't compete with
 reality you know.
he: Yeah, I know.

Where's Al?
Who knows.
I thought he was coming with you?
That was three weeks ago. I haven't
seen him since.
Huh.

he: Where's Al?
she: Haven't seen him. Maybe he was too
 broke to come.
she: Bought too many beers in the Valley.

he: Everybody's here but Al.

: Has anybody seen Al lately?

: Not me.

he: Al's not coming, huh?
she: I guess not. I'll drink his beer
 for him.
he: Me too.

beginning, but by 1972, with his ruminations on free will concluded, projects like *The Boy Who Fell Over Niagara Falls* opened new possibilities. The commodity trading he did soon afterward can be seen as an attempt to think of art existing beyond an institutional context and without any need of representation. Even the failures of his effort were somewhat redeemed when considered in relation to *In Search of the Miraculous (One Night in Los Angeles)*, which sets in contrast to his futures market work two different presentations of privacy — one that is representational, the other actual. Ader's dialectical mode of thinking, already emerging in his two series of *Fall* works, grew stronger with *In Search of the Miraculous*. The installation at Claire Copley Gallery was a spectacle, and the documentation of the performance at the opening added extra representational layers. Ader's attempt to avoid semiotic structures was always related to his quest for fundamental truths. Up until his sail, he had never achieved his goal, never reached a point where an idea or experience could exist perfectly. In every instance some form of mediation interfered.

Once at sea, Ader was absolutely alone. It seems he had no contact with any other vessel, and because he lacked a two-way radio he was unable to communicate with people on land. He may have listened to his shortwave receiver, but as to whether it worked for the duration of the voyage or not, let alone whether Ader wanted the outside intrusion, one can only speculate. Essentially, a segment of his life lasting, perhaps, two and a half months remains utterly unknown to all but him. He was subject to nothing except the dominion of nature. The conventions of the art world and human existence were only as disruptive as his mind allowed. One can imagine his days by looking to the accounts of sailors like Manry. Waking hours would have been occupied with sailing matters, with little if any time given to reading or idleness. Ader would have had ample opportunity to contemplate the ever-changing seascape, and despite having much of his life dictated by routine, there would have emerged rituals in which subtle variations arose from the intensity of living in so confined a space.

Ader did not specify whether the quest for fundamental truths was for him alone or was to be a gift to his viewers. Most likely, it was a combination of the two, ends that he probably assumed to be interrelated when he mentioned his philosophical goals to Leavitt in the early 1970s. While at Irvine, Ader befriended James Turrell. On occasion,

Ader would fly with Turrell in his single-engine airplane from Los Angeles to Irvine, where the airport was not far from the university. They spent a good amount of time talking, often about Ader's upcoming sail. Turrell was sympathetic to the mindset of the solitary adventurer, and he liked how Ader had no need to be macho or unnecessarily heroic. Ader, Turrell recalled, was aware of the dangers he would face. He knew death to be a possibility, but it was not something he dwelled on. It was clear that Ader was not suicidal. He was too caught up in the sail, in the experience of being absolutely alone. It was this last aspect that Ader regularly came back to in conversations. The central appeal of the voyage was that it could not be captured adequately in words or images. Ader could depict it, of course; he could explain in great detail the daily travails of his crossing. But neither effort would close the representational gap his voyage inherently entailed. The beauty and truth of Ader's sail was for him alone.[20]

Ader's death made this definitively the case. Had he arrived in England, his journey, despite these inherent degrees of incommensurability, would have been framed both, literally, by the coastlines of the United States and Great Britain and, figuratively, by the networks of daily life that were absent for the duration of the sail. He would most likely have talked about the trip, shown the photographs he took, played the audio he recorded. All of these gestures would have helped others picture events only Ader experienced, but they would also, ultimately, have diminished his aspirations for the journey. In the end, none of these concerns were an issue, and the unknown aspects of the voyage remain irretrievable because of Ader's death. This is a fundamental truth of the work, although not Ader's. His concrete truth was completely singular, and because he achieved it in the midst of an experience for which his presence confirmed its status as art, his truth became a part of the piece as well.

It was in the moment of death that Ader encountered his absolute truth. Nothing is as unmediated as the end of life. It is the only event one faces absolutely alone. Death's truth is the unknown, and for most it is experienced—before one's own—through others. One watches life expire, one observes the pain, anguish, or resolve that marks someone else's last moments. The liminal point demarcating being and non-being is a knowledge that is singular. It is never passed on, never accrues meaning through interpretation or dissemination. In whatever

happened to Ader in the waters of the North Atlantic — perhaps, as his mother envisioned, rocked gently in the waves — he discovered truth as such, and in the process also made *In Search of the Miraculous* unrepresentable. Remnants like the battered *Ocean Wave* provided testament to the journey but nothing of the art, which rested in Ader's person, his presence, and now his aura.

It could be said that the second part of *In Search of the Miraculous* is incomplete, rendering it difficult to comprehend. Ader never specified his intentions for the sail. His wife recalled that "he thought that [*In Search of the Miraculous*] was a very very special piece and very important in the development of his work. He thought it was a step ahead, I'm sure, progress not culmination."[21] How this advancement would take shape is difficult to determine. Ader attempted to distill art to its most basic state. It was him, his actions, his will in the face of nature, that made *In Search of the Miraculous* as it is now conceived. But to think of the piece as complete — made such by events known only to Ader — allows one to understand it as offering a reorientation of the conception of an artwork, how it is constituted, and how it communicates.

In 1972, a few years before Ader set sail, Jacques Derrida published an essay later translated as "Signature, Event, Context" in his book *Marges — de la philosophie*.[22] His project at the time was nothing less than re-conceiving the Western philosophical tradition, an effort that saw him take his inquiry into being to the semiotic level. Derrida observes, in the broad tradition of Western thought, a lack of criticality toward communication. For him, a central issue is how writing, the primary medium of philosophy, supplements speech. Writing has not been understood as having properties of its own, and it is from this perspective that Derrida begins his inquiry with a rereading of Étienne Bonnet de Condillac's *Essay on the Origin of Human Knowledge* from 1746.

Condillac argues that writing forges an insoluble link between the text and an author who is no longer present once the act of reading commences. The authenticity of the original thought continues without modification in the written document. Derrida finds flaws in this formulation, especially when considering the mechanisms that underpin written communication. He contends that for a written statement to function it must be able to communicate without recourse to the author's presence. Yet this is just half of the equation, since Derrida is

also wary of written communication that may be understood only by the addresser and the intended addressee. A situation such as this demands a specific addressee, and the lack of his or her presence invariably makes the writing unintelligible. Writing, as Derrida describes, has always operated independently, for if it is to communicate, it must be able to function in spite of those who write and read. This is how it signifies in the moment as well as in the future. This also means that what writing represents is contingent, that the written text is not a direct conduit to presence, that in its state of signification it is the thing itself.[23]

The situational dependency of writing leads Derrida to question the very nature of context in speech — the other primary representation of individual thought. He picks a more contemporary example, J. L. Austin, to work against, since Austin argues that the ability of language to make sense to someone else requires its context to be clearly bracketed. Signification occurs in the fencing of speech from the world, turning each speech-act into a linguistic island. Derrida doubts the isolation of specific words and phrases and suggests that spoken language is never cut off from its chain of signification, nor is it the creation of a single individual. When speaking, one merely iterates language, saying words that have already been said. Words are things one breathes air into, making speech free from bondage to a specific presence or referent. Speech is determined by situation and usage. It simply *is* on its own.[24]

Derrida's analysis of writing and speech and their relation to presence shows that what were understood as incidental by-products in the communication of thought are in fact independent entities. If Western metaphysics exists in language, the medium of the discourse is without link to being as such. In the case of *In Search of the Miraculous*, a work in which being was thrust by circumstances to the forefront, the piece enacts a similar operation to Derrida's, one that reorients the normative understanding of the bond between art and artist, since at the time of Ader's sail the artist was considered supplemental to the representation. It was the work of art and not its creator that was given emphasis. This is not a statement about historiography, about how biography is at times used to find meaning in a work. It refers, instead, to the general condition of art in the 1970s, when the art object, even as art and life became conflated, was ultimately divorced from its

creator. The work of art, not the artist, is what goes on display, and it is the work of art that in the end provides the source of both symbolic and actual value.

One could argue that the rise of performance art in the 1970s subverted the fetishization of the art object by ephemeral gestures. To a certain extent this is true, but for performances to be considered art an institutional framework had to be enlisted to wall off the artistic act from everyday gestures. This slight concession to the imperatives of the art world does not mean that a particular performance is complicit in a system it opposes; rather, in almost every instance, even the most fleeting work of art requires a medium to communicate, a conduit that more often than not is the institutional network of the art world. What further enhances this point is the role of documentation. Seemingly incidental photographs — often in black and white — form much of the visual history of conceptual and performance art. Alluring in their casualness, these pictures not only show a work of art but invite one to imagine what it was like actually to be there. Such is the appeal of a great deal of conceptual art. It gives viewers access to a sliver of life that by its association to radical art seems progressive, ideal, even utopian. It is these images, often shown in institutions, that have helped these acts be considered as art.

Ader's sail was not a performance. There was nothing staged, something Goldstein, even many years after the fact, could not comprehend: "The difference between Bas Jan and me is that I wouldn't have to take that boat trip; a flyer would have been enough. He came out of a time when the artist had to be involved in making a piece; he physically had to make the journey, while I would have treated it as pure theater, so a publication would have been enough."[25] Goldstein's observation speaks to the differences in their practices, especially as, in later years, he became increasingly concerned with the constructed nature of images. But his recognition of the utter corporeality of the piece allows *In Search of the Miraculous* to be read in the way Derrida examined both writing and speech. Just as Derrida placed emphasis on the marginal in the broader conception of Western metaphysics, so does *In Search of the Miraculous* in regard to the history of art. Ader stressed life instead of the represented work of art. *In Search of the Miraculous* — outside of the image that graced the Art & Project Bulletin (fig. 42) — leaves nothing to be depicted. Something happened, but it remains forever un-

known, enabling the work to ask if life can communicate without a context, without a representational system. It is a question that asks if Ader can simply *be*, and by so doing have some efficacy, some ability to evoke compassion or feeling from others. The eventual reception of Ader's art suggests that under the right conditions it can.

19

In the months and years following the discovery of *Ocean Wave*, little attention was trained on Ader. Several articles appeared in Holland, but in the United States, where so much of his career was based, nothing emerged. His widow was willing to talk about the tragedy, but only the editors of *Avalanche*, who had shown an interest in Ader's work from the beginning, spoke with her. A journalist from Los Angeles, Barry Brennan, who had an office in the same building as Ader's studio, planned to write an article about him, although nothing came to fruition.[26] There are practical reasons for the oversight. Few really knew Ader's art, despite his central role within the Los Angeles conceptual art scene, and by extension that of Amsterdam and other cities linked to it via Art & Project Gallery. It also did not help that Los Angeles in the early to mid-1970s lacked critics with sympathetic outlets to publish their writing, which made it hard for Ader's work to circulate in the broader contemporary art discourse.

The network of ideas in the 1970s had the most profound effect on Ader's reception, in large part because the dominant tendencies could not absorb the ramifications of *In Search of the Miraculous*. For if Ader's last piece is essentially about life, about Ader, then it was out of step with the prevailing winds of a theoretically inflected art criticism. As with the art world, art criticism's focal point around 1976 was New York. The marginal status of Los Angeles in this regard posed obvious challenges, and the migration to New York of such artists as Troy Brauntuch, Jack Goldstein, and David Salle only emphasized the point. That Ader's death occurred during this transformation is an element of chance.[27] It is also a twist of fate that the discovery of the *Ocean Wave* by the *Eduardo Pondal* coincided with the inaugural issue of the journal *October*—the symbolic heralding, in the history of contemporary art, of the death of the author.

The essays that appeared in *October*'s first ten years are emblematic

Figure 42. Bas Jan Ader, *In Search of the Miraculous*. Center spread of the four-page Art & Project Bulletin 89 (1975); on the back page is the score for "A Life on the Ocean Wave." © The Estate of Bas Jan Ader.

of a major shift then occurring in the understanding of art.[28] The journal published criticism that saw itself engaged both aesthetically and politically, commentaries that took as their starting point both structuralist and poststructuralist philosophy.[29] And the incorporation of theory allowed critics to assert their authority in ways that were unprecedented in the recent history of art. A seminal example of the new form of writing is Rosalind Krauss's "Sculpture in the Expanded Field," from 1979. Like much of Krauss's earlier work, the essay excels in its attention to formal details, using structuralism as a way to find in art an internal logic divorced from both the creator and the viewer. She examines the work of sculptors like Richard Serra and Alice Aycock in an attempt to maintain the guidelines of medium specificity while still being accountable to the material reality of art that seemingly has abandoned these systems. But what is most striking about the essay is the agency Krauss recognizes in art objects. She insists that what she observes is a historical phenomenon, a rupture that signals the origins of postmodernism. She resists forms of criticism that are overtly historicist or that attempt to explain formal changes using artistic subjectivity. Instead, what she offers, is "the possibility of looking at historical process from the point of view of logical structure."[30] This move, one that sees the artist fulfilling the predetermined plans of the work of art, places emphasis on the work of art and the critic who extracts meaning from the phenomenon. The artist is now secondary, an almost incidental fact.

Krauss's model of criticism became extraordinarily important. The repudiation of artistic intent, the antagonism toward the fetishization of originality, and the need to think of the work of art as solely a thing in the world drove art writing, particularly the more academic sort, toward seeing art as functioning autonomously. This isolation was for the most part a product of rhetoric, since this kind of criticism, in its dialogic existence, came to be understood as a tool in the fight against the encroachment of late capitalism. It was a weapon to use in an art world where the demand for paintings by white males epitomized (in the eyes of its detractors) a phony avant-garde and a craven capitulation to the market. It is this tension that defines the fraught history of postmodernism in New York. The conflicts between "Pictures" artists like Sherrie Levine and Cindy Sherman and painters like David Salle and Julian Schnabel were promulgated by their advocates. What is telling in the

writing about someone like Sherman, whose subjectivity was always at least indirectly on view in her art, was that little attention was paid to Sherman herself. What mattered was how her photographs embodied the stereotypes of gender disseminated throughout the mass media, and how her work was in theory infinitely reproducible.

During the evolution of postmodernism, Ruppersberg and Van Elk continued to exhibit regularly. Goldstein, having relocated to New York, was one of the central figures of postmodernism, a status cemented by his participation in Douglas Crimp's *Pictures* show at Artists Space in 1977. Ader's art was absent from these developments. There was not a single solo exhibition devoted to him until 1985, and not another until 1988, when the first retrospective of his work took place at the Stedelijk in Amsterdam.[31] There were, from the time of his death, a smattering of group shows in which he was included, but it was not until 1991, fifteen years after *Ocean Wave* was discovered in the North Atlantic, that Ader was again presented in the United States. He had become a peripheral figure. His art faded from discussions, incompatible with an art world caught up with the intricacies of representation and appropriation, cut off from the interests of critics who saw themselves as both cultural commentators and arbiters of taste. In the late 1970s and 1980s Ader's art was nothing less than anachronistic.

The disjunctive relation of Ader's art to the times faded gradually in the 1990s and 2000s. The contestations over postmodernism had begun to wane with the art market crash in the late 1980s and a change in concerns that had artists turning toward identity politics. Issues of race, gender, and sexuality — often glossed over in the 1980s — gained in prominence. Those who were marginalized from normative conceptions of the artist were now becoming highly visible. The 1993 Whitney Biennial was the first major institutional foray into this kind of art, with pieces by Janine Antoni, Robert Gober, and Lorna Simpson, for example, that were decidedly political. Artistic subjectivity could not be seen in any other light, and the legacy of this conflation of art and politics has meant that in the United States the presence of one's identity in a work of art cannot be judged without some consideration of its political ramifications.

A similar phenomenon was occurring almost concurrently in England. There, in work referred to colloquially as Young British Art, artistic subjectivity arose differently than it had in the United States. The

emergence of Tracey Emin and Damien Hirst, for example, marked not only the entrance of formal strategies that had visual shock at their core, but also, according to some commentators, a remarkable ability on the part of individual artists to construct their identity through the media.[32] Given England's rabid tabloid culture, it is not difficult to see how an embalmed great white shark or a tent embroidered with the names of everyone the artist has slept with would generate a stir. On the other hand, the self-conscious manipulation of media outlets in order to construct a celebrity personality facilitated the appearance of a new sense of artistic identity. If in New York the equation of identity and art was necessarily political, what developed in London was the artist's identity in popular culture. This made the art world not much different from Hollywood, where the aura of the film competes with the aura of the actor.[33]

Between the poles of identity and celebrity is art that is participatory in nature, what the French curator Nicolas Bourriaud labeled "relational."[34] Situational in form and often using the institutional setting as a site for social interactions, this new art subverted, it was argued, the reach of a spectacular consumer culture with ephemeral projects that encouraged conviviality and chance occurrences.[35] The greatest example of "micro-utopic" art is Rirkrit Tiravanija's work from the early to mid-1990s. He famously staged exhibitions as communal meals, cooking traditional Thai dishes for all who attended his openings. The novelty of the work lies in the way viewers interact with the artist. The subjectivity of both is stressed, but it is Tiravanija's that matters most. His presence transforms the ordinary into the artistic. What would otherwise be just another meal becomes an experience with an aesthetic dimension, an encounter marked as different from others because of who is doing the cooking. The political in these projects is the resistance to commodification, yet the success of Tiravanija's pieces hinge upon his own celebrity status within the art world. It is a delicate balance between what just a few years earlier were decided oppositions. The contradiction of being at once antagonistic and a central figure in a system, of being radical as well as complicit, is one of the defining characteristics of artistic subjectivity in the contemporary art world.

That appreciation of Ader emerged when it did is no coincidence. Renewed critical interest in Ader's art followed the ascendancy of iden-

tity. The intellectual and discursive conditions of the mid-1990s made it possible to discover in the past elements that seemed contemporary. James Roberts, for example, in a 1994 essay entitled "Bas Jan Ader: The Artist who Fell from Grace with the Sea," sees Ader's work in relation to Young British Art.[36] He finds a connection in the shared power of their imagery and the perceived sense of urgency. Roberts reads Ader's art as both comedic and pathetic, and highlights the romantic aspects of his practice, as did another article that appeared alongside Roberts's. The artist Collier Schorr's "This Side of Paradise" continues Roberts's melancholy analysis, describing how *In Search of the Miraculous* addresses romantic efforts of survival in its purist form. Lurking in these allusions to the early nineteenth century, to the moods portrayed in Casper David Friedrich's paintings, is the idea of failure, something especially attributed to Ader's *Fall* works. For Schorr, Ader's descents differentiate him from the ordinary: "It is his fall, or the possibility of failure, that maintains a safe distance between Ader and the unheroic everyday."[37]

As the heterogeneity and the scale of the global contemporary art world grew in the 1990s and 2000s, the rediscovery of Ader by artists, critics, and curators spoke to the need to designate a historical figure who was considered to be outside of the mainstream and radical in his commitment to art, one who represented a kind of authenticity that was understood to be missing from a contemporary scene in thrall to market forces and entrapped by celebrity.[38] As Isabelle Graw notes, in the work of Ader, as well as that of André Cadere and Lee Lozano, "the commodity character of the [art] object is reduced in favor of the prospects of the reification of the artist-subject."[39] This observation finds its full voice in the writings on Ader that emphasize his romantic qualities and the almost foreordained nature of his death. Comments by the critic Jörg Heiser— "The tragic irony of his final disappearance is that it is the perfect example of the romantic trope of the beloved's death, preferably by drowning"—or the artist Tacita Dean—"More than anyone, he played with this engagement [between the sublime and death]—laid himself open to the possibility of death. Taunted it. Provoked it. Fell for it. Sadly we can only glimpse at the enormity of Bas Jan Ader's feat because he failed"—stress less the virtues of Ader's art and more that of his person.[40] These longing responses, offered as a form of poetic antagonism to a fashion-conscious art world, are not

necessarily wrong in their mythic construction of Ader's subjectivity. Ader's art, especially *In Search of the Miraculous*, made their positions possible. His life was what was left, his agency the reason so many people find his work compelling.

The utter intensity of Ader's practice, his Sisyphean search for concrete truths, the undeniable fact that he died for his art, places him, for many, in an untouchable position. With the recent attention turned on the individual artist — identity politics, celebrity culture, participatory art, artistic agency — it became possible for Ader to be redeemed by those who see in him a kindred spirit. Before it was fashionable or potentially necessary, Ader created art in which life as such communicated. What made him anachronistic at the time of *Ocean Wave*'s recovery has transformed him into a contemporary. In death, he is with the times, so much so that his art radiates life.

20

If there is a work by Ader that matches the mythmaking intensity of *In Search of the Miraculous*, then it is an earlier piece, one that has several iterations: the black-and-white film *I'm Too Sad to Tell You* (1971). Roughly three and a half minutes in length, it shows Ader crying inconsolably. There is no beginning, no end, no reason given for the tears, no signs of relief from an anguish that appears to be unbearable. The camera, fixed in position, crops his face. At times Ader leans forward, almost pressing his features to the surface of the projected image. His tears descend, some noticeably hanging from the cleft of his chin. There is no sound to deepen the sentiment of depicted emotion. Viewers are left to project their feelings upon Ader's representation.

The work originated in 1970. The initial version, which no longer exists in complete form, has Ader outdoors, sitting in front of what appears to be his house. A still image, separate from this film, was imprinted on a postcard. It shows Ader holding his head with his left hand, his eyes shut as he cries. On the back of the card, dated September 13, 1970, is the phrase "I'm too sad to tell you." The same picture was used for a photographic edition, and as with the postcard the title was added to the work, this time on the front, written in the lower right-hand corner with an upward slant. The final film was made in Amsterdam. A documentary photo of the indoor set shows Ader illuminated

Figure 43. Filming *I'm Too Sad to Tell You*, 1971. © The Estate of Bas Jan Ader

by spotlights, sitting with his legs crossed and his hands resting in his lap. His expression is serene, far calmer than the cluttered space would suggest (fig. 43). The unedited version of the film is ten minutes long. It begins quietly, with Ader holding his emotions in check. He builds up slowly, rubbing his eyes to produce tears, trying to bring out a pathos that, as the title suggests, cannot be expressed in words. The final, edited work omits much of this footage, keeping only the most salient moments so that the emotional intensity is at peak from beginning to end. Whether acting or not, Ader evokes in the viewer an unsettling disquiet.[41] Projected on the wall, Ader's larger-than-life head shows suffering literally magnified. It is hard not to be affected by the film, not to feel some empathy, some sense that it really is Ader who offers such raw passion to anyone willing to watch.

The Man of Sorrows has been invoked as a way to understand the piece.[42] The image of Christ showing his wounds, wearing his crown of thorns, seems an easy fit. In an undated note that must be related to *I'm Too Sad to Tell You*, Ader refers to Rogier van der Weyden's famous *Descent from the Cross* (ca. 1435).[43] Ader does not specifically imitate Rogier's impassive Christ, whose limp body subtly points toward the ground. Instead, he captures the anguish of Joseph of Arimathea, who holds Christ's legs, and of the holy woman who weeps into a hand-

Figure 44. Bas Jan Ader, *I'm Too Sad to Tell You*, 1971. © The Estate of Bas Jan Ader.

kerchief.[44] Almost everyone in the painting displays a grief of such depth that their tears become like beads. But if a Christian or theologically inflected read is to be given to the film, one made in the midst of Ader's engagement with the question of free will — an investigation that harkens to his knowledge of Calvin and his teachings — it would seem then that *I'm Too Sad to Tell You* runs counter to Calvin's condemnation of image worship.[45] Calvin's iconoclasm was severe, so committed was he to the word of God. There was no space in his world for representations, no patience for their dissimulations and ability to lead adherents astray from truth. Calvin's connection to *I'm Too Sad to Tell You* is tangential, but it is a link that in a different way reveals one of the main oppositions running through Ader's career: the tension between iconophilia and iconoclasm.

It is a paradox that the iconoclasm inherent to the tragedy of *In Search of the Miraculous* now engenders an iconophilic understanding of Ader's art. Every image in which he is present, like every thing that may allude to his absence, has been charged with a significance that creates an aura surrounding Ader. It is not fanciful to see *I'm Too Sad to Tell You* as a secular icon, a celluloid refashioning of the holy objects and devotional images Calvin thought blasphemous

(fig. 44).[46] In a contemporary art world where religion plays little or no part, where the supposed modernist utopia is taken as an aspiration rooted in the past, there is an emphasis placed on actual experience, on a here-and-now that offers immediate deliverance. The apparent lack of ideological structures does not diminish the need for projecting belief on some sort of system, some set of ideas that gives meaning to existence. If for the moment one kind of aspiration comes in the form of the empowered artist, then *I'm Too Sad to Tell You* is a work to turn to for guidance, for inspiration, for an example of artistic comportment that seems unmistakably meaningful.

What matters in *I'm Too Sad to Tell You* is that it is Ader crying, that it is he who is before viewers. It is not an apparition that is projected on a screen, but Ader's tortured features captured in a chemical emulsion on celluloid. Like the early Christian icons that supposedly bore the impression of Christ's face — depictions fashioned by his divinity, not by human hands — *I'm Too Sad to Tell You* is at once Ader and his representation.[47] It is different from other mechanically reproduced images because of belief, as his presence is the perceived authentic in an inauthentic art world. That one senses his being, wants it to be close, is a condition of the times. How long this feeling will last is difficult to determine. For now, Ader is very much alive.

ACKNOWLEDGMENTS

Any study of Bas Jan Ader begins with Paul Andriesse. This book would have been impossible without his intellectual generosity and willingness to share his archive; for that I am grateful. Erik Ader and Mary Sue Ader Andersen have been a wellspring of information and support from the earliest stages of this project. I cannot thank them enough for all that they have done for me. The insights and reflections of Claire Copley, Tony DeLap, Ger van Elk, Hirokazu Kosaka, William Leavitt, Allen Ruppersberg, Jürgen Wesseler, and Helene Winer were invaluable to my research. Moritz Wesseler made my visit to Bremerhaven memorable. Lidy Visser of the Netherlands Institute of Art History facilitated my access to the Art & Project Gallery's Bas Jan Ader dossier. Jacqueline Rapmund made available for me the Museum Boijmans Van Beuningen collection of Ader photographs and films. Mette Gieskes and her husband, Eric Antokoletz, offered their warm hospitality whenever I visited Holland. Anne Ellegood and Nick Herman allowed me to enjoy their stunning view of the Hollywood Hills when in Los Angeles. Erin Hogan generously provided her support at the beginning of this project. Milica Mitrovich was an excellent research assistant. Suzanne Jansen and Janna Schoenberger ably translated material from the Dutch. Shannon Haskett at Patrick Painter Inc. accommodated my research needs. Elizabeth James and Sarah Hymes of Margo Leavin Gallery, Eva Coster of Grimm Gallery, and Ben Handler of Gagosian Gallery made clearing image rights effortless.

Many of the ideas in this book were first presented in lectures at American University, Our Literal Speed Chicago, the X-Initiative, and the Archives of American Art. I want to thank in particular Christopher Heuer, Matthew Jesse Jackson, Andrew Perchuk, and Cecilia Alemani for the invitations to speak and audience members for their probing questions. Dean Kessmann, Peg Barratt, and my colleagues in the Department of Fine Arts and Art History at George Washington University supported my scholarship in ways I will never forget. My students have been engaged commentators on many of the issues and

themes discussed here. Throughout the entirety of the project I have benefited immensely from my friendship and conversations with Cameron Martin. And although they were not directly involved with this book, it bares the mark of my two greatest art historical influences: Rob Rush and Richard Shiff. My editor, Susan Bielstein, has my gratitude for her steadfast commitment to this project, her sage advice, and for treating me first and foremost as a writer. Thanks are also due to Anthony Burton, Joel Score, Laura Avey, and Matthew Avery, for making my experience with the University of Chicago Press perfect.

I am fortunate to have had excellent criticism of my manuscript when it was in preparation. Two anonymous readers' comments were not only incredibly insightful but in their timing extraordinarily affirming. Suzanne Hudson, whom I collaborated with on several other projects during the writing of the book, gave, as always, poignant, encouraging feedback. Alexander Nagel's suggestions were absolutely spot-on, but I am even more thankful for his continued support of my work — something I wish to thank Jean-Philippe Antoine and Matthew Jesse Jackson for as well. Jeffrey Anderson read every word of the manuscript, and made each one better. For among other things — friendship and mentoring — I am grateful to his keen editorial and literary eye.

It is difficult to know how to thank my parents now that I have a child of my own. Words seem ineffective in conveying my gratitude for all they have done in order to make it possible to write these very lines; nevertheless I will try: thank you. To my brother, thank you for being a wonderful uncle. To Elias, now two years old, thank you for your wide-eyed wonderment that makes me see each day in greater, more immediate detail. And finally, to my wife, Simone, who has been through all of this with me: hearing every idea, discussing every minutia, reading every page. This book is hers as much as it is mine. I would be lost without her, and for this reason — along with my unwavering love — I dedicate this book to her.

NOTES

FALLING

1. Ader was initially unsure what to call the piece. It was only when he was completing the loan agreement forms for the major 1971 exhibition *Sonsbeek buiten de perken* in Arnhem, Holland, that he finally settled on the title. See Doede Hardeman, "The notion of fall and rise were to be explored," in *Bas Jan Ader: Please Don't Leave Me* (Rotterdam: Museum Boijmans van Beuningen, 2005), 152–53.

2. Interview with William Leavitt, Los Angeles, CA, December 7, 2009.

3. Interview with Helene Winer, New York, NY, August 4, 2011.

4. Paul Andriesse, interview with Willoughby Sharp, New York, NY, January 7, 1981, Paul Andriesse Archive (hereafter PAA). Ader acknowledges receiving this call in a letter to Art & Project Gallery, November 14, 1970, Art & Project Gallery Archive, Bas Jan Ader Dossier (hereafter APG; Suzanne Jansen, with the author's assistance, translated the letters in this archive from the Dutch). There was, in the ensuing months, some tension between Ader and Sharp with regard to which work was to be published in *Avalanche*. Bas Jan Ader, letter to Art & Project Gallery, February 17, 1971, APG; Paul Andriesse, *Bas Jan Ader: Artist* (Amsterdam: Stichting Openbaar kunstbezit, 1988), 75.

5. Paul Andriesse, interview with Willoughby Sharp, PAA.

6. Willoughby Sharp, "Rumbles," *Avalanche*, no. 2 (Winter 1971), 2.

7. Paul Andriesse, interview with William Leavitt, November–December 1980, PAA. Ader's interest in the tension between free will and determinism was confirmed in an interview with the author. Interview with William Leavitt, Los Angeles, CA, December 7, 2009.

8. William Leavitt, letter to Paul Andriesse, March 16, 1988, PAA; Andriesse, *Bas Jan Ader*.

9. Both William Leavitt and Mary Sue Ader Andersen describe how Leavitt and Ader ceased being friends around the end of 1972 or the beginning of 1973. Interview with William Leavitt, Los Angeles, CA, December 7, 2009; interview with Mary Sue Ader Andersen, Ventura, CA, December 6, 2009.

10. Andriesse, *Bas Jan Ader*, 72.

11. Andriesse associates these qualities with Ader's *Fall 1, Los Angeles* and *Fall 2, Amsterdam*. Andriesse, *Bas Jan Ader*, 75.

12. In a letter to the organizer of the *Sonsbeek* exhibition in Arnhem, Ader described the nature of his films: "The artist's body as gravity makes itself its master." See Hardeman, "Notion of fall," 153. Ader also gave an interview to Betty van Garrel in which he discussed falling and the tragic. See Van Garrel, "Bas Jan Ader's tragiek schuilt in een pure val," *Haagse Post*, January 5–11, 1972, 48–49.

13. Bas Jan Ader, letter to Art & Project Gallery, December 19, 1970, APG.

14. Van Elk attended Immaculate Heart College, studying with such people as Sister Corita Kent. Interview with Ger van Elk, New York, NY, September 22, 2009; Christophe Cherix, ed., *In and Out of Amsterdam: Travels in Conceptual Art, 1960–1976* (New York: Museum of Modern Art, 2009), 82. The possible influence of Kent on the art of Van Elk and Ader is difficult to determine. Van Elk earned his undergraduate degree in 1963. Ader worked briefly in the college's cafeteria, and may have taken a couple of classes at the school upon arriving in Los Angeles. He was twenty at the time, and soon enrolled at the Otis Art Institute (now the Otis College of Art and Design). Van Elk moved back to Holland after graduation and did graduate work in art history at the University of Groningen. His art took many forms in the years following his return home: from Arte Povera–type sculpture to ephemeral conceptual projects. There is little in these pieces that suggest the influence of Kent, who was primarily a printmaker. The same is true for Ader, who started to make what he considered serious art in 1969. Ader does not mention Kent in letters or his personal notebook. In recent interviews (see above), Van Elk has discussed her importance, which may reflect a contrarian effort to claim a nontraditional artistic origin. What Van Elk now says he found exciting about Kent was not her art per se, but the idea of a nun making progressive, contemporary art.

15. Interview with Mary Sue Ader Andersen, Ventura, CA, December 6, 2009.

16. The move was also prompted by the efforts of a disgruntled neighbor to force Ader and Van Elk out, which included setting fire to their apartment. See Cherix, *In and Out*, 82.

17. See Hardeman, "Notion of fall," 149.

18. Interview with Erik Ader, Usquert, Netherlands, September 16, 2009.

19. What follows is taken, except as noted, from a fairly long reminiscence by the artist John Lees about his times with Ader at Otis. See Lees, letter to Paul Andriesse, July 15, 1988, PAA. Van Elk recalls similar disruptions when he and Ader studied together in Amsterdam.

20. Other instances of Ader's disrupting class included one in which he and Andersen nonchalantly entered a group critique and proceeded to hang two large, blank canvases high upon the wall without saying a word or acknowledging the presence of anyone else in the room.

21. Interview with Erik Ader, Usquert, Netherlands, September 16, 2009.

22. Interview with Mary Sue Ader Andersen, Ventura, CA, December 6, 2009.

23. This work was actually painted by Mary Sue Ader. Paul Andriesse, interview with Erik Ader, 1981, PAA.

24. The document, entitled "Implosions . . . Paintings and Constructions," is reprinted in its entirety in *Bas Jan Ader: Please Don't Leave Me*, 150–51.

25. Ibid., 150.

26. According to Mary Sue Ader Andersen, the work was meant to be an edition

of three. Ader printed only one copy in 1968 because of financial constraints. The edition was completed posthumously in 2003. For more on this issue, see the catalog entry for the work in *Bas Jan Ader: Please Don't Leave Me*, 34.

27. Erik Beenker says that the notes begin as early as 1968. He gives no direct evidence for this, and the notebook page to which he refers is undated. See Beenker, "Bas Jan Ader (1942–1975 missing at sea): The Man Who Wanted to Look beyond the Horizon," in *Bas Jan Ader: Please Don't Leave Me*, 13. His point finds possible corroboration several pages later in the note "The artist is consumer of extreme and absolute comfort," which is quite close to the title of Ader's 1968 work *The Artist as Consumer of Extreme Comfort*. It is not clear, though, if this statement relates contemporaneously to the 1968 work. A later date may be indicated by a note, written during Ader's visit to Sweden in the summer of 1971, describing an unrealized piece: "make a photograph of me next to Swedish end of road, [next to the] begin of water sign" (Bas Jan Ader notebook, PAA). These unrealized works of art, made during the time Ader shot *Farewell to Far Away Friends* (1971), are held in the Bas Jan Ader Archive, Patrick Painter Inc. (hereafter PPIA).

28. PAA; the quote is from *Paradise Lost*, book 3, 98-99.

29. PAA. One clipping from the *Los Angeles Times* is dated May 19, 1973. Another is undated but has part of a story discussing aspects of the Watergate investigation.

30. Van Garrel, "Ader's tragiek schuilt," 48-49.

31. Bas Jan Ader, letter to Art & Project Gallery, January 21, 1972, APG.

32. Bas Jan Ader, letter to Poul ter Hofstede, August 20, 1974. The letter, held in the Groninger Museum exhibition archive (RHC Groninger Archieven, Groningen), has been published in English translation in *Bas Jan Ader: Please Don't Leave Me*, 156.

33. Quoted in Beenker, "Bas Jan Ader," 13-14.

34. The trope of failure has been taken up in, e.g., James Roberts, "Bas Jan Ader: The Artist Who Fell from Grace with the Sea" (32-35), and Collier Schorr, "This Side of Paradise" (35-37), both in *Frieze*, no. 17 (June–August 1994); Jan Tumlir, "Bas Jan Ader: Artist and Time Traveler," in *Bas Jan Ader*, ed. Brad Spence (Irvine, CA: Art Gallery, University of California, Irvine, 1999); Bruce Hainley, "Legend of the Fall: Photographer Bas Jan Ader," *Artforum* 37, no. 7 (March 1999): 90-95; Jörg Heiser, "Emotional Rescue: Romantic Conceptualism," *Frieze*, no. 71 (November–December, 2002), 70-75; Heiser, "Curb Your Romanticism: Bas Jan Ader's Slapstick" (25-28), and Tacita Dean, "And He Fell into the Sea" (29-30), both in *Bas Jan Ader: Please Don't Leave Me*; and Jan Verwoert, *Bas Jan Ader: In Search of the Miraculous* (London: Afterall Books, 2006).

35. Heiser and especially Verwoert provide the notable exceptions. Verwoert convincingly reads Ader's work as a critique of the cultural construction of tragedy.

36. Andriesse, *Bas Jan Ader*, 76.

37. Kasha Linville, "Sonsbeek: Speculations, Impressions," *Artforum* 10, no. 10 (Summer 1971): 56.

38. Letter to Bas Jan Ader from R. W. D. Oxenaar, director of the Rijksmuseum Kröller-Müller-Otterlo, March 25, 1971, PAA.

39. Bas Jan Ader, letter to the Rijksmuseum Kröller-Müller-Otterlo, April 28, 1971, PAA.

40. Interview with Erik Ader, Usquert, Netherlands, September 16, 2009. E-mail correspondence with Erik Ader, July 17, 2012.

41. Paul Andriesse, interview with Carolyn Noren White, 1980 or 1981, PAA.

42. Interview with Erik Ader, Usquert, Netherlands, September 16, 2009.

43. Paul Andriesse, interview with William Leavitt, PAA.

44. Interview with Erik Ader, Usquert, Netherlands, September 16, 2009.

45. John Calvin, *Institutes of the Christian Religion*, ed. John T. MacNeill, trans. Ford Lewis Battles (Louisville, KY: Westminster John Knox Press, 1960), 1:241–53.

46. Augustine, *The Confessions*, trans. Philip Burton (New York: Alfred A. Knopf, 2001); Augustine, *On Free Choice of the Will*, trans. Thomas Williams (Indianapolis: Hackett Publishing, 1993).

47. Calvin, *Institutes*, 297–99.

48. Commentators have broadly alluded to this in recent years.

49. Interview with Erik Ader, Usquert, Netherlands, September 16, 2009.

50. Ibid.

51. Ader talks about Camus in his interview with Van Garrel, "Ader's tragiek schuilt," 48–49; Andriesse, *Bas Jan Ader*, 75.

52. Albert Camus, *The Myth of Sisyphus and Other Essays*, trans. Justin O'Brien (New York: Vintage International, 1991), 3.

53. Ibid., 27.

54. Ibid., 40.

55. Ibid., 54.

56. Ibid., 57.

57. Hannah Arendt, *The Life of the Mind*, vol. 1, *Thinking*, and vol. 2, *Willing* (New York: Harcourt Brace Jovanovich, 1978).

58. Ibid., 2:217.

59. Ibid. Arendt was not yet satisfied with this answer. It was too open-ended, insufficient to explain why one makes one choice instead of another, or how this equates to freedom, a freedom to decide a course of actions. But she saw a way out of this impasse through an analysis of judgment. Fate, tragically, did not allow her to complete what she willed; a week after writing that all are doomed to be free, she passed away suddenly, the victim of a heart attack.

REPRESENTING

1. For a discussion of *Landslide*, especially from the point of view of Leavitt, see Erik Bluhm, "Minimalism's Rubble: On William Leavitt's and Bas Jan Ader's *Landslide*," *artUS* 10 (October–November 2005): 14–17.

2. Andriesse, *Bas Jan Ader*, 72

3. The best discussion of the relation between the art of Ader and Burden is Christopher Müller's exhibition catalog, *Bas Jan Ader: Filme, Fotografien, Projektionen, Videos und Zeichnungen aus den Jahren 1967–1975* (Köln: Verlag der Buchhandlung Walther König, 2000).

4. Interview with Claire Copley, New York, NY, June 28, 2009.

5. Corinna Ferrari, "Chris Burden," *Domus*, no. 549 (August 1975), 50.

6. Peter Plagens, "He Got Shot — For His Art," *New York Times* (September 2, 1973), D1, D3; Frazer Ward, "Watching Chris Burden's *Shoot*," *October*, no. 95 (Winter 2001), 114–30.

7. Plagens, "He Got Shot," D3.

8. On the issue of masochism, see Kathy O'Dell, *Contract with the Skin: Masochism, Performance Art, and the 1970's* (Minneapolis: University of Minnesota Press, 1998); Ward makes the allusion to Vietnam and the violence portrayed on television one of the central points of his argument in his essay "Watching Chris Burden's *Shoot*."

9. Ward's primary argument regarding *Shoot* concerns the tension between the public and the private and how a private event has public consequences, especially in terms of a public made complicit in an event that could have had a fatal outcome.

10. Tom Wolfe, "The Me Decade and the Third Great Awakening," in *Mauve Gloves & Madmen, Clutter & Vine* (1976; New York: Bantam, 1999), 117–54. See also Andreas Killen, *1973 Nervous Breakdown: Watergate, Warhol, and the Birth of Post-Sixties America* (New York: Bloomsbury, 2006).

11. Both notes in PAA.

12. Paul Andriesse suggests that Ader liked Mondrian because of "his search for harmony through a rigorous reduction of visual means." Andriesse, *Bas Jan Ader: Artist* (Amsterdam: Stichting Openbaar kunstbezit, 1988), 77.

13. Harry Cooper, "Mondrian, Hegel, Boogie," *October*, no. 84 (Spring 1998), 138. See also Yve-Alain Bois, "The De Stijl Idea," in *Painting as Model* (Cambridge, MA: MIT Press, 1990), 101–21.

14. Piet Mondrian, "Neo-Plasticism: The General Principle of Plastic Equivalence," in *The New Art — The New Life: The Collected Writings of Piet Mondrian*, ed. and trans. Harry Holtzman and Martin S. James (New York: Da Capo Press, 1993), 137.

15. Mary Sue Ader said in an interview from 1976 that "[Ader] often referred to Mondrian's ideas about neo-classicism, and the colors red, yellow, blue, black, and white. He felt very much like being identified as an individual instead of part of a movement." Liza Bear and Willoughby Sharp, "A Telephone Conversation with Mary Sue Ader," *Avalanche* (Summer 1976), 27.

16. The show ran from April 4 to April 24. Kosaka did not take part because he felt what he was doing at the time — mainly ephemeral performances — was not art in the sense that those exhibiting understood it. Interview with Hirokazu Kosaka, Los Angeles, CA, August 17, 2011.

17. Interview with Helene Winer, New York, NY, July 1, 2009.

18. Allen Ruppersberg recalls how his copy of the catalog for *When Attitudes Become Form*, a show he was included in, was essential reading for his peers. Interview with Allen Ruppersberg, New York, NY, September, 25, 2009.

19. Peter Plagens, *Sunshine Muse: Art on the West Coast, 1945–1970* (1974; Berkeley: University of California Press, 1999), 153.

20. See his negative review of Lucy Lippard's exhibition *557, 087*, held in Seattle, Washington, in September 1969. Peter Plagens, "557,087," *Artforum* 8, no. 3 (November 1969): 64–66.

21. Plagens, *Sunshine Muse*, 161; Willoughby Sharp, "Willoughby Sharp Interviews John Coplans," *Arts Magazine* 44, no. 8 (Summer 1970): 39–41.

22. Elizabeth C. Baker, "Los Angeles, 1971," *ARTnews* 70, no. 5 (September 1971): 27–28. See also Peter Plagens, "Los Angeles: The Ecology of Evil," *Artforum* 11, no. 4 (December 1972): 67–76.

23. Helene Winer, "The Los Angeles Look Today," *Studio International* 183, no. 937 (October 1971): 127.

24. For a recent discussion of 1960s Los Angeles art and its relation to Hollywood see Alexandra Schwartz, *Ed Ruscha's Los Angeles* (Cambridge: The MIT Press, 2010).

25. Kim Levin, "Narrative Landscape on the Continental Shelf: Notes on Southern California," *Arts Magazine* 51, no. 2 (October 1976): 95.

26. For a detailed account of the network of conceptual artists and dealers, particularly in Europe in the late 1960s and 1970s, see Sophie Richard, *Unconcealed: The International Network of Conceptual Artists 1967–1977 Dealers, Exhibitions, and Public Collections*, ed. Lynda Morris (London: Ridinghouse, 2009). The recent exhibition *In & Out of Amsterdam: Travels in Conceptual Art, 1960–1976* addressed this issue as well.

27. See Rudi Fuchs, "On Semantics, Ger van Elk, Structure and the Difficult Terms," in *Ger van Elk*, ed. E. de Wilde and Rini Dippel (Amsterdam: Stedelijk Museum, 1974), 49–72.

28. The piece exists as a single photo as well as a triptych. There is some controversy regarding the dating of this work, Paul Andriesse suggesting it was from 1969 or 1970, as the work was found on the same reel as *Please Don't Leave Me* (1969) and *All of My Clothes* (1970). It could be that Ader made the work in 1969 or 1970 and only printed it in 1971. See the discussion in *Bas Jan Ader: Please Don't Leave Me* (Rotterdam: Museum Boijmans van Beuningen, 2005), 58–60.

29. Interview with Mary Sue Ader Andersen, Ventura, CA, December 6, 2009.

30. Robert A. Wright, "At a California Hospital, 'Everything Came Down,'" *New York Times* (February 10, 1971), 1, 30.

31. Interview with Ger van Elk, New York, NY, September 24, 2009.

32. Richard Hertz, ed., *Jack Goldstein and the CalArts Mafia* (Ojai, CA: Minneoloa Press, 2003), 23.

33. Stoerchle never showed with Art & Project Gallery. His brief career was

marked by more failures than successes. He showed sporadically in Los Angeles, and in 1972 moved to New York with the hopes of furthering his career. Few opportunities came his way, and he left New York, eventually settling in New Mexico, where his ideas became progressively more spiritual and New Agey. For more on Stoerchle, see Glenn Philips, "Untitled Critical Project: Wolfgang Stoerchle's Brief Career," in *It Happened at Pomona: Art at the Edge of Los Angeles, 1969-1973*, ed. Rebecca McGrew (Pomona, CA: Pomona College Museum of Art Montgomery Art Center, 2011), 53-72.

34. Telephone interview with Hirokazu Kosaka, July 2, 2009.

35. Hertz, *Jack Goldstein*, 50.

36. Helene Winer, "Introduction," in *Bas Jan Ader, Ger van Elk, William Leavitt* (Claremont, CA: Pomona College Gallery, 1972), n.p.

37. Interview with Helene Winer, New York, NY, July 1, 2009.

38. William Wilson, "Photo-Sculpture Show at Otis," *Los Angeles Times* (February 14, 1972), F8.

39. Peter Plagens, "Los Angeles," *Artforum* 9, no. 1 (September 1970): 81-82. Leavitt's show was compared to Dieter Rot's (his spelling at the time) famous exhibition *Staple Cheese, A Race*, also at Eugenia Butler. Plagens was equally dismissive of both shows.

40. Interview with William Leavitt, Los Angeles, CA, December 7, 2009.

41. Leavitt gives this narrative in a brief two-paragraph statement that accompanied the image of his work in the catalog *Bas Jan Ader, Ger van Elk, William Leavitt*.

42. Bas Jan Ader, letter to Art & Project Gallery, January 21, 1972, APG.

43. Lawrence Elliott, "The Boy Who Plunged Over Niagara," *Reader's Digest* (March 1972), 119-23. What follows is a summary of the story.

44. Robert Barry, for example, felt this with regard to the use of language in order to document various projects that were not visible.

45. The show ran for the last two weeks of June 1972.

46. Jürgen Wesseler's indomitable spirit led him to make contact with galleries throughout Europe, even knocking on the door of Joseph Beuys's house to ask if Beuys would be interested in showing with them. He eventually did, as did Blinky Palermo (upon Beuys's recommendation), Gerhard Richter, Van Elk, Ruppersberg, Leavitt, Goldstein, and a host of other prominent American and European artists.

47. Bas Jan Ader, letter to Jürgen Wesseler, Spring 1972, Kabinett für Aktuelle Kunst Archive (hereafter KAKA).

48. Interview with Jürgen Wesseler, Bremerhaven, Germany, September 18, 2009.

49. The April 1973 performance of *The Boy Who Fell Over Niagara Falls*, part of the exhibition *1, 2, or 4 Day Exhibits and Evening Performances* at Gallery A-402 on the campus of CalArts, was documented in a video. Ader showed this video documen-

tation in a show with Leavitt at the Mezzanine Art Gallery at the Nova Scotia College of Art and Design, also in April 1973.

TRADING

1. Tom Burke, "Princess Leda's Castle in the Air," *Esquire* 73, no. 3 (March 1970): 104.

2. Jon Margolis, "Our Country 'Tis of Thee, Land of Ecology . . ." *Esquire* 73, no. 3 (March 1970): 177. See also John McPhee, *Conversations with the Archdruid* (New York: Farrar, Straus, and Giroux, 1971); Kevin Starr, *Golden Dreams: California in the Age of Abundance, 1950–1963* (Oxford: Oxford University Press, 2009), 259–60; Mike Davis, *Ecology of Fear: Los Angeles and the Imagination of Disaster* (New York: Vintage, 1999).

3. John Gregory Dunne, "Eureka!" in *Quintana & Friends* (New York: E. P. Dutton, 1978), 243–62.

4. Umberto Eco, "Travels in Hyperreality [1975]," in *Travels in Hyperreality* trans. William Weaver (New York: Harcourt Brace Jovanovich, 1986), 41–48. Eco sees this phenomenon taking place, in particular, at Disneyland.

5. Joan Didion, "In Hollywood," in *The White Album* (1979; New York: Farrar, Straus and Giroux, 1990), 162.

6. Cees Nooteboom, "Autopia," in *Writing Los Angeles: A Literary Anthology*, ed. David L. Ulin (New York: Library of America, 2002), 576.

7. Bas Jan Ader, letter to Art & Project Gallery, January 21, 1972, APG.

8. Bas Jan Ader, "But to Beginning at the Beginning," PAA, translated from the Dutch by Janna Schoenberger.

9. Bas Jan Ader, letter to Art & Project Gallery, October 29, 1972, APG.

10. The view, particularly prevalent in exhibition catalogs, that Ader's work on the commodities market foreshadows his attempt to sail across the Atlantic Ocean in the summer of 1975, assumes that both activities are dangerous beyond reason and that Ader entered into them with little preparation or understanding of the inherent risks.

11. See L. Dee Belveal, *Commodity Speculation—With Profits In Mind* (Wilmette, IL: Commodities Press, 1967), 1–9; Richard J. Teweles et. al., *The Commodity Futures Trading Guide: The Science and the Art of Sound Commodity Trading* (New York: McGraw-Hill Book Company, 1969), 4–6.

12. Interview with Mary Sue Ader Andersen, Ventura, CA, December 6, 2009.

13. Interview with Mary Sue Ader Andersen, Los Angeles, CA, February 22, 2012. The notebook was destroyed in a car fire in the summer of 1973.

14. Interview with Mary Sue Ader Andersen, Ventura, CA, December 6, 2009.

15. Paul Andriesse, interview with Richards Jarden, New York, NY, January 7, 1980, PAA.

16. Paul Andriesse, interview with Claire Copley, New York, NY, December 29, 1980, PAA.

17. Interview with Mary Sue Ader Andersen, Ventura, CA, December 6, 2009. Helene Winer also recalled Ader talking about this project as an artwork. Interview with Helene Winer, New York, NY, August 4, 2011.

18. Ader would often set a work aside only to come back to it at a later date. Paul Andriesse, interview with Erik Ader, 1981, PAA.

19. Paul Andriesse Interview with Ger van Elk, September 8, 1981, PAA; Paul Andriesse, *Bas Jan Ader: Artist* (Amsterdam: Stichting Openbaar kunstbezit, 1988), 79.

20. *Bas Jan Ader, William Leavitt*, Mezzanine Art Gallery, Nova Scotia College of Art and Design, Halifax, April 1–7, 1973.

21. *Robert Barry* (Luzern: Kunstmuseum Luzern, 1974): n.p.

22. I want to thank Anne Collins Goodyear for bringing this connection to my attention.

23. For a discussion of Duchamp's use of the Martingale system and its broader implications, see David Joselit, "Marcel Duchamp's *Monte Carlo Bond* Machine," *October*, no. 59 (Winter 1992), 8–26.

24. Marcel Duchamp, letter to Jacques Doucet, January 16, 1925, cited in André Gervais, "Connections: Of Art and Arrhe," in *The Definitively Unfinished Marcel Duchamp*, ed. Thierry de Duve (Halifax: Nova Scotia College of Art and Design, 1991), 407.

25. See Dalia Judovitz, *Unpacking Duchamp: Art in Transit* (Berkeley: University of California Press, 1995): 178–85.

26. Richard Hertz, ed., *Jack Goldstein and the CalArts Mafia* (Ojai, CA: Minneoloa Press, 2003), 50.

27. Benjamin Buchloh, "Conceptual Art 1962–1969: From the Aesthetic of Administration to the Critique of Institutions," *October*, no. 55 (Winter 1990), 105–43; Ian Burn, "The 1960s: Crisis and Aftermath," in *Dialogue: Writing in Art History* (North Sydney, NSW: Allen & Unwin, 1991), 101–19.

28. See Julia Bryan Wilson, *Art Workers: Radical Practice in the Vietnam Era* (Berkeley: University of California Press, 2009), 1–39.

29. Like many of his peers, Ader opposed the war. He participated in a number of protests, and around 1967 the US Immigration and Naturalization Service pressured him to apply for American citizenship, ostensibly to make him eligible for the draft. Ader's political activities waned after 1968, as he was deeply affected by the assassinations of Martin Luther King Jr. and Robert Kennedy. He supposedly felt hopeless with regard to political action and focused his energies instead on art (interview with Mary Sue Ader Andersen, Ventura, CA, December 6, 2009). It is obviously possible to read Ader's early *Fall* works as allusions to Vietnam, although this is more of a speculative interpretation than a claim supported by facts. None of Ader's art directly deals with Vietnam, nor do his sparse writings or his various correspondences from 1970 onward. None of his immediate peers made art about the war, and, importantly, the critical recep-

tion of Ader's and his peers' art fails to mention what was transpiring in Southeast Asia.

30. Joseph Kosuth, "Footnote to Poetry [unpublished 1969]," in *Art after Philosophy and After: Collected Writings, 1966–1990*, ed. Gabriele Guerico (Cambridge: MIT Press, 1991), 36.

31. Cindy Nemser, "An Interview with Vito Acconci," *Arts Magazine* 45, no. 6 (March 1971): 20.

32. Allan Kaprow, "The Education of the Un-Artist, Part 1," in *Essays on the Blurring of Art and Life*, ed. Jeff Kelley (California: University of California Press, 1993), 102.

33. Daniel Buren, "Standpoints," *Studio International* 181, no. 932 (April 1971): 185.

34. John Anthony Thwaites, "Kassel-in the Air?" *Art and Artists* 7, no. 6 (September 1972): 23.

35. René Denizot, "Exposition of an Exhibition: A Backward Look at Documenta 5," *Studio International* 185, no. 953 (March 1973): 99.

36. Jan van den Marck, "Venice & Kassel: The Old and the New Politics," *Art in America* 60, no. 6 (November–December 1972): 137.

37. H.A., "Elementare Erfahrungen," *Bremer Nachrichten* (June 28, 1972); interview with Mary Sue Ader Andersen, Ventura, CA, December 6, 2009.

38. Paul Andriesse, interview with Ger van Elk, September 8, 1981, PAA.

39. "Interview with Frédéric Paul," in *Allen Ruppersberg: You and Me, or The Art of Give and Take*, ed. Constance Lewallen (Zurich: JRP Ringier, 2009), 107.

40. "Interview with Frédéric Paul," 107.

41. Interview with Allen Ruppersberg, New York, NY, September 25, 2009. The police closed *Al's Café* for not having a proper liquor license. William Wilson, "Rooms with Environmental Art," *Los Angeles Times* (May 30, 1971), N47; interview with Allen Ruppersberg, El Segundo, CA, August 17, 2011.

42. Allen Ruppersberg, *Al's Grand Hotel* (brochure, 1971).

43. Helen Winer, *Allen Ruppersberg* (Claremont: Pomona College Gallery/ Montgomery Art Center, 1972), n.p.

44. Ruppersberg decided to sell the constituent parts of *Al's Grand Hotel* in order to recoup some of his investment in the project.

45. "Interview with Frédéric Paul," 107.

46. Interview with Allen Ruppersberg, El Segundo, CA, August 17, 2011.

47. Baker, 36.

48. Ruppersberg sees the work coming out of the tradition of both Fluxus and Kaprow's Happenings. He is also adamant that neither *Al's Café* nor *Al's Grand Hotel* were performances of any sort. Interview with Allen Ruppersberg, El Segundo, CA, August 17, 2011.

49. Winer, *Allen Ruppersberg*.

50. Interview with Allen Ruppersberg, El Segundo, CA, August 17, 2011.

51. "Interview with Frédéric Paul," 108.

52. Ger van Elk, "Dear Basjan," in Andriesse, *Bas Jan Ader*, 69; interview with Claire Copley, New York, NY, June 29, 2009.

53. Bas Jan Ader, letter to Art & Project Gallery, January 21, 1972, APG.

54. Interview with Claire Copley, New York, NY, June 29, 2009. Gilbert & George were also a part of a group show at Mt. San Antonio College in 1973. Both Ader and Leavitt once taught there.

55. Gordon Burn, "Gilbert & George: Interview with Gordon Burn [1974]," in *The Words of Gilbert & George: With Portraits of the Artists from 1968-1997* ed. Robert Violette (London: Violette Editions, 1997): 68–70.

56. Germano Celant, "Gilbert & George," *Domus* 508 no. 3 (March 1972): 50.

57. Barbara Reise, "Presenting Gilbert & George, The Living Sculptures," *Artnews* 70, no. 7 (November 1971): 62–65.

58. They professed no literary talent and admitted, without embarrassment, that they read little. Anne Seymour, "Gilbert & George: Interview with Anne Seymour 1971," in *The Words of Gilbert & George: With Portraits of the Artists from 1968-1997*, ed. Robert Violette (London: Violette Editions, 1997), 48.

59. Gilbert & George, *To Be with Art Is All We Ask* (London, 1970), n.p.

60. Carter Ratcliff, "The Art and Artlessness of Gilbert and George," *Arts Magazine* 50, no. 5 (January 1976): 57 (emphasis in original).

61. Andriesse, *Bas Jan Ader*, 88.

62. An undated, unpublished note from Ader's papers, probably from 1974 or 1975 (PAA), describes the piece as the first stage of a three-part work. The note mentions not only *In Search of the Miraculous (One Night in Los Angeles)* but also a transAtlantic sail and another night walk in Amsterdam.

63. I want to think Alexander Nagel for this observation. It is also mentioned often in the Ader literature that the title of this piece comes from the famous P. D. Ouspensky book *In Search of the Miraculous*. There's little evidence that Ader read the book, although he was probably familiar with it.

64. Thomas Crow discusses the importance of the song to the work in "The Art of the Fugitive in 1970s Los Angeles: Runaway Self-Consciousness," in *Under the Black Sun: California Art 1974-1981*, ed. Lisa Gabrielle Mark and Paul Schimmel (Los Angeles: Museum of Contemporary Art; Munich: DelMonico Books/Prestel, 2011), 46–47.

65. Shots that had him walking utilized the old trick of taking a step backward in order to make it look as if he was moving forward. Interview with Mary Sue Ader Andersen, Ventura, CA, December 6, 2009.

66. "Interview with Frédéric Paul," 108. It is important to note that by this time Ader had lived in Los Angeles for ten years, essentially his entire adult life.

67. Bas Jan Ader, undated notes, PAA. In these notes Ader mentions that the works could possibly be made as either film or video. It is the potential use of video that makes it plausible to date these notes to around 1973 or 1974. Ader gained access to this technology once he started teaching at University of California, Irvine, in the fall of 1973 and did make a video in 1974.

68. Interview with Jürgen Wesseler, Bremerhaven, Germany, September 18, 2009.

69. Over the years commentators have connected Ader with the artist Christopher D'Arcangelo, who, like Ader, had a brief career. The two have been linked, most famously by Thomas Crow in his essay "Unwritten Histories of Conceptual Art: Against Visual Culture," both because of their poetic and ephemeral practices and because of their deaths (D'Arcangelo committed suicide in 1979 at the age of twenty-four). Thomas Crow, *Modern Art in the Common Culture* (New Haven: Yale University Press, 1996), 212–42. The association was further cemented by Christopher Williams's powerful photographic installation *Bouquet for Bas Jan Ader and Christopher D'Archangelo* (1991). Ader and D'Arcangelo did not know one another. Ader never went to New York, where D'Arcangelo lived, and D'Arcangelo commenced making art around the time Ader was lost at sea. Nonetheless, some connections can be made in relation to the issue of privacy. D'Arcangelo did not make objects. His art revolved around interventions in institutional spaces, including, most famously, the removal of his presence — from announcements, exhibition literature, etc. — as his contribution to a group show at Artists Space in 1978. D'Arcangelo's practice was far more political than Ader's, whose involvement with the futures market was only obliquely a critique of art's commodity status. D'Arcangelo thought of the artist as a laborer, often foregrounding this issue in his few works.

SAILING

1. Paul Andriesse, interview with James Turrell, January 5, 1981, PAA.

2. Phone interview with Tony DeLap, January 22, 2009.

3. Bas Jan Ader, letter to Art & Project Gallery, March 22, 1974, APG.

4. Bas Jan Ader, letter to Art & Project Gallery, August 20, 1974, APG; Paul Andriesse, interview with Carolyn Noren White, 1980 or 1981, PAA.

5. Ger van Elk, "Dear Basjan," in Paul Andriesse, *Bas Jan Ader: Artist* (Amsterdam: Stichting Openbaar kunstbezit, 1988), 68.

6. Paul Andriesse, interview with Jane Reynolds, December 30, 1981, PAA.

7. Ibid.; Bas Jan Ader, letter to Art & Project Gallery, August 20, 1974, APG.

8. Bas Jan Ader, undated note (likely 1974), PAA. The plan was to present one or two works an episode by such artists as Weiner, Van Elk, Ruppersberg, Jan Dibbets, and William Wegman. Ader would situate the pieces historically and within the context of the particular artist's practice, and after viewing the pieces would answer questions from a presumably live audience.

9. Bas Jan Ader, letter to Art & Project Gallery, postmarked June 5, 1975, APG.

10. Bas Jan Ader, letter to Art & Project Gallery, August 20, 1974, APG.

11. Mary Sue Ader wrote a letter to Paul Andriesse and Erik Ader, while they were working on the Ader catalogue raisonné, stating that *Primary Time* and *Un-*

titled (Flower Work) were not meant to be exhibited. Andriesse, interview with Erik Ader, 1981, PAA.

12. Paul Andriesse, interview with Tom Jancour, 1980 or 1981, PAA.

13. Paul Andriesse, interview with Jane Reynolds, December 30, 1981, PAA.

14. Interview with Erik Ader, Usquert, Netherlands, September 16, 2009.

15. The account of Ader's eleven-month sail to Los Angeles aboard the *Felicidad*, unless otherwise noted, is summarized from Neil Tucker Birkhead's unpublished manuscript, "A Sketch of the Voyage Yacht *Felicidad*: From Gibraltar to Los Angeles," PAA.

16. Interview with Mary Sue Ader Andersen, Ventura, CA, December 6, 2009.

17. Interview with Mary Sue Ader Andersen, Ventura, CA, December 6, 2009.

18. Phone interview with Tony DeLap, January 22, 2009.

19. Sir Francis Chichester, *Gipsy Moth Circles the World* (New York: Coward-McCann, 1968).

20. For a history of this race, see Peter Nichols, *A Voyage for Madmen* (New York: HarperCollins Publishers, 2001).

21. Robin Knox-Johnston, *A World of My Own: The First Ever Non-Stop Solo Round the World Voyage* (1969; London: Adlard Coles Nautical, 2004); Bernard Moitessier, *The Long Way*, trans. William Rodarmor (1971; Dobbs Ferry, NY: Sheridan House, 1995).

22. See Kenichi Horie, *Kodoku: Sailing Alone across the Pacific*, trans. Takuichi Ito and Kaoru Ogimi (Rutland, VT: Tuttle, 1964).

23. See Hugo Vihlen, *April Fool, or, How I Sailed from Casablanca to Florida in a Six-Foot Boat* (Chicago: Follett, 1971); UPI, "American in 6-Foot Boat Crosses the Atlantic in 84 Days," *New York Times* (June 22, 1968), 1, 65.

24. For brief accounts of Riding's and Willis's sails, see William H. Longyard, *A Speck on the Sea: Epic Voyages in the Most Improbable Vessels* (New York: International Marine, 2003), 270, 251–53.

25. Mary Sue Ader made reference to Ader's interest in breaking Manry's record for the fastest sail in the smallest vessel across the North Atlantic. See Liza Bear and Willoughby Sharp, "A Telephone Conversation with Mary Sue Ader," *Avalanche* (Summer 1976), 26–27.

26. See Robert Manry, *Tinkerbelle* (New York: Harper & Row, 1965); Alexander Dumbadze, "Of Man and Nature," in *Cameron Martin: Analogue* (Brooklyn: GHava{Press}, 2009), 129–35.

27. Carolyn Noren White, who had a long-standing affair with Ader beginning around 1973, describes his imagining himself as an artist who wore a tie while driving a Mercedes. Paul Andriesse, interview with Carolyn Noren White, 1980 or 1981, PAA; Andriesse interview with Tom Jancour, 1980 or 1981, PAA.

28. Manry, *Tinkerbelle*, 67.

29. Bas Jan Ader, letter to Jürgen Wesseler, November 22, 1973, KAKA.

30. Anthony de Kerdrel, letter to Bas Jan Ader, April 30, 1973, PAA; de Kerdrel, letter to Paul Andriesse, March 17 [probably early 1980s], PAA.

31. Bas Jan Ader, letter to Art & Project Gallery, August 20, 1974, APG.

32. Bas Jan Ader, letter to Jürgen Wesseler, November 22, 1973, KAKA.

33. Anthony de Kerdrel, letter to Bas Jan Ader, December 7, 1973, PAA.

34. Bas Jan Ader, telegram to Jürgen Wesseler, December 1973, KAKA.

35. Françoise Lambert, letter to Bas Jan Ader, January 9, 1974, PAA.

36. Bas Jan Ader, letter to Art & Project Gallery, August 20, 1974, APG.

37. Bas Jan Ader, letter to Jürgen Wesseler, August 20, 1974, KAKA.

38. Bas Jan Ader, letter to Jürgen Wesseler, October 1974, KAKA.

39. Paul Andriesse, interview with Claire Copley, 1980, PAA; Andriesse, interview with Erik Ader, 1981, PAA. Ader also had exchanges with Ida Gianelli, who ran the Saman Gallery in Genoa (Gianelli, letter to Bas Jan Ader, January 15, 1975, PAA).

40. Paul Andriesse, interview with Claire Copley, New York, NY, December 29, 1980, PAA; interview with Claire Copley, New York, NY, June 29, 2009.

41. Interview with Claire Copley, New York, NY, June 29, 2009.

42. Paul Andriesse, interview with Claire Copley, New York, NY, December 29, 1980, PAA.

43. Ibid.

44. Henry J. Seldis and William Wilson, "A Critical Guide to the Galleries," *Los Angeles Times* (May 2, 1975), F8.

45. Bas Jan Ader, letter to Art & Project Gallery, March 3, 1975, APG.

46. Bas Jan Ader, letter to Art & Project Gallery, postmarked June 5, 1975, APG.

47. Bear and Sharp, "Telephone Conversation," 26.

48. "Guppy 13: A Mini Sailer for a Mini Car," *Trailer Boats* (August 1974).

49. E-mail correspondence with Erik Ader, January 12, 2009.

50. Bas Jan Ader, letter to Art & Project Gallery, postmarked June 5, 1975, APG.

51. Phone interview with Tony DeLap, January 22, 2009.

52. Paul Andriesse, interview with Claire Copley, New York, NY, December 29, 1980, PAA.

53. Paul Andriesse, interview with Jane Reynolds, December 30, 1981, PAA.

54. Paul Andriesse, interview with Claire Copley, New York, NY, December 29, 1980, PAA.

55. Interview with Ger van Elk, New York, NY, September 22, 2009.

56. Interview with Mary Sue Ader Andersen, Ventura, CA, December 6, 2009.

57. E-mail correspondence with Erik Ader, January 12, 2009.

58. Ibid.

59. Bas Jan Ader, letter to Ida Gianelli, July 7, 1975 (incorrectly dated by Ader as June 7, 1975), APG. Ader also mentioned in the letter that he probably will not be able to visit her because he needs to return to Los Angeles in October in order to teach.

60. Bas Jan Ader and Mary Sue Ader, postcard to Jürgen Wesseler, July 8, 1975

(incorrectly dated June 8, 1975), KAKA; Bas Jan Ader and Mary Sue Ader, postcard to Art & Project Gallery, APG.

61. Interview with Mary Sue Ader Andersen, Ventura, CA, December 6, 2009.

DYING

1. The United States Coast Guard had no knowledge of Ader's whereabouts either. Liza Bear and Willoughby Sharp, "A Telephone Conversation with Mary Sue Ader," *Avalanche* (Summer 1976), 26.

2. It seems that Ader had worked things out with the Groninger Museum, after expressing concern in a letter to Art & Project Gallery about a month before he departed.

3. This account is a summation of the Spanish judicial system's discovery file, which contains affidavits, official legal documents, letters, interviews, and newspaper articles. The documents have been assembled and translated in Marion van Wijk and Koos Dalstar, *In Search of the Miraculous: Bas Jan Ader Discovery File 143/76* (Rotterdam: Veenman Publishers, 2007).

4. Mary Sue Ader, letter to Art & Project Gallery, June 4, 1976, APG.

5. E-mail correspondence with Erik Ader, January 12, 2009; interview with Erik Ader, Usquert, Netherlands, September 17, 2009; Erik Beenker, "Bas Jan Ader (1942–1975 missing at sea): The Man Who Wanted to Look Beyond the Horizon," in *Bas Jan Ader: Please Don't Leave Me* (Rotterdam: Museum Boijmans van Beuningen, 2005), 11.

6. Phone interview with Tony DeLap, January 22, 2009.

7. Mary Sue Ader Andersen recalls Ader telling James Turrell that it would be interesting if he came back after three years. Interview with Mary Sue Ader Andersen, Ventura, CA, August 16, 2011.

8. Nicholas Tomalin and Ron Hall, *The Strange Last Voyage of Donald Crowhurst*, intro. Janathan Raban (1970; Camden, ME: International Marine/McGraw-Hill, 1995).

9. Bear and Sharp, "Telephone Conversation," 27.

10. Mary Sue Ader, letter to Art & Project Gallery, June 4, 1976, APG. Ader and his mother were quite close, but it seems, at least according to Ader, that she was unsettled by his art, finding its subject matter difficult to reconcile. Art & Project, letter to Bas Jan Ader, April 10, 1973, APG; Bas Jan Ader, letter to Art & Project Gallery, April 24, 1973, APG.

11. The poem is quoted from Beenker, "Bas Jan Ader," 11–12.

12. Interview with Allen Ruppersberg, New York, NY, September 25, 2009.

13. Thomas Crow makes a very compelling argument along this line in terms of disappearance being a central concern of Los Angeles artists. See Crow, "Disappearing Act: Art In and Out of Pomona," in *It Happened at Pomona: Art at the Edge of Los Angeles, 1969–1973*, ed. Rebecca McGrew (Pomona, CA: Pomona College Museum of Art Montgomery Art Center, 2011), 35–52. For a discussion of the issue of agency

in regard to Jack Goldstein's early art, see Alexander Dumbadze, "Of Passivity and Agency: Jack Goldstein," in *Jack Goldstein x 10,000*, ed. Philipp Kaiser (Newport Beach, CA: Orange County Museum of Art; Munich: Prestel Publishers, 2012), 12–25.

14. Kosaka did not like Goldstein's sculptures but did admire his films. Phone interview with Hirokazu Kosaka, July 2, 2009.

15. Richard Hertz, ed., *Jack Goldstein and the CalArts Mafia* (Ojai, CA: Minneoloa Press, 2003), 65.

16. Ruppersberg shot the piece in the studio Goldstein and Kosaka shared, with Goldstein present. Interview with Allen Ruppersberg, El Segundo, CA, August 17, 2011.

17. Howard Singerman makes the interesting observation that "suicide is always influential in Ruppersberg's works; not only because it interprets the events that lead up to it, but because it is the subject and, as in *To Tell the Truth*, the end of all important arguments." Singerman, "Allen Ruppersberg: Drawn from Life," in *Allen Ruppersberg: The Secret of Life and Death*, vol. 1, 1969–1984, ed. Julia Brown (Los Angeles: Museum of Contemporary Art, 1985), 26.

18. Robert Horvitz, "Chris Burden," *Artforum* 14, no. 9 (May 1976): 24–25.

19. A piece from the tail end of 1971, entitled *Disappearing*, in which for a period of three days no one knew where Burden was, suggests what was to come with *White Light/White Heat*. Another work, *B.C. Mexico* (1973), had Burden paddle a sea kayak to a remote beach in Baja California. Over the course of eleven days he was alone, surviving in 120-degree heat without shelter and only the water he carried aboard his small craft. His absence was a major part of the work, the diary he kept while away another, which he read to an audience upon his return. Still, it does not speak to the element of deprived presence that imbues *White Light/White Heat*. In *B.C. Mexico* and other works from the time, Burden's presence was either noticeable or not.

20. Paul Andriesse, interview with James Turrell, January 5, 1981, PAA. Ader and Turrell also spoke, at times, about Arthur Cravan, the hero of the surrealists and Dadaists, who was never seen again after setting off in a fishing boat from the southern Mexican city of Salina Cruz in 1918. Ader liked the mystery of Cravan's disappearance, but it was not something, according to Turrell, that he wanted to emulate.

21. Bear and Sharp, "Telephone Conversation," 26.

22. Jacques Derrida, "Signature, Event, Context," in *Margins of Philosophy*, trans. Alan Bass (Chicago: University of Chicago Press, 1982), 307–30. The essay was originally presented as a lecture in 1971 at a conference in Montreal, which is important since at the core of his discussion was the relation between presence and absence.

23. Ibid., 311–21.

24. Ibid., 321–27. There is an exception to Derrida's observations: one's individual signature, a unique graphic intervention tied specifically to one's being.

25. Hertz, *Jack Goldstein*, 23.

26. Bear and Sharp, "Telephone Conversation," 27.

27. Ader, however, was thinking of spending more time in Holland in part to help his brother look after their mother. Interview with Erik Ader, Usquert, Netherlands, September 16, 2009.

28. Not all, of course, transpired in its pages; other venues, like *Art in America*, gave space to a type of writing that was more theoretical in its orientation.

29. On the political engagement of this kind of art criticism, see Miwon Kwon, "The Return of the Real: An Interview with Hal Foster," *Flash Art* 29, no. 187 (March–April 1996): 62–63.

30. Rosalind Krauss, "Sculpture in the Expanded Field," *October*, no. 8 (Spring 1979), 44.

31. The 1985 show was at Art & Project Gallery. The 1988 retrospective was organized by Paul Andriesse.

32. Julian Stallabrass, *High Art Lite: British Art in the 1990s* (London: Verso, 1999), 17–48, 127–69.

33. Any contemporary discussion of aura is indebted to Walter Benjamin, who made a distinction between aura and false aura, the latter associated with celebrities and dictators. This distinction seems historically specific to Benjamin's time, for it is difficult to say in a culture that takes mechanical reproduction to such intense levels that the aura once attributed to religious relics, for example, does not also reside in things with few discernible referents. To a large extent, the aura of certain individuals is the closest thing contemporary culture has to the divine. For the most complete discussion of celebrity culture in the contemporary art world, see Isabelle Graw, *High Price: Art Between the Market and Celebrity Culture*, trans. Nicholas Grindell (Berlin: Sternberg Press, 2009).

34. Nicolas Bourriaud, *Relational Aesthetics* (Dijon: La presses réel, 1998).

35. The strongest critique of these claims can be found in Claire Bishop, "Antagonism and Relational Aesthetics," *October*, no. 110 (Fall 2004), 51–79.

36. James Roberts, "Bas Jan Ader: The Artist Who Fell from Grace with the Sea," *Frieze*, no. 17 (June–August 1994), 32.

37. Collier Schorr, "This Side of Paradise," *Frieze*, no. 17 (June–August 1994), 37.

38. Between 1999 and 2007 there was at least one solo show a year dedicated to Ader. In 2010 alone there were two major museum shows.

39. Graw, *High Price*, 83.

40. Jörg Heiser, "Emotional Rescue: Romantic Conceptualism," *Frieze*, no. 71 (November–December, 2002), 73; Tacita Dean, "And He Fell into the Sea," in *Bas Jan Ader: Please Don't Leave Me*, 30.

41. I want to thank Alexander Nagel for reminding me that depicted emotions generate real feelings.

42. Beenker, "Bas Jan Ader," 13.

43. Bas Jan Ader, undated note, PAA.

44. There is a debate regarding the identity of the holy woman, with some suggesting that she is Mary Cleophus. See Lorne Campbell, "The New Pictorial Lan-

guage of Rogier van der Weyden," in *Rogier van der Weyden: 1400-1464, Master of Passions*, ed. Lorne Campbell and Jan Van der Stock (Zwolle: Waanders Publishers, 2009), 32–61.

45. John Calvin, *Institutes of the Christian Religion*, ed. John T. MacNeill, trans. Ford Lewis Battles (Louisville, KY: Westminster John Knox Press, 1960), 1:99–116.

46. Ibid., 105.

47. For a discussion of early Christian icons and their relation to photography, see Hans Belting, *Likeness and Presence: A History of the Image before the Era of Art*, trans. Edmund Jephcott (Chicago: University of Chicago Press, 1994), 53.

INDEX

Page numbers in italics indicate figures.

linked to, 81; Gilbert & George's life indistinguishable from, 92–93; nature and boundaries of, 70, 85; participatory and situational in, 150; post-1975 transitions in understandings of, 145, 148–52; reorientation of (function, appearance, interaction), 7, 142, 143–45; unlimited freedom of, 44–45. See also art world; and specific media

Art & Project Gallery (Amsterdam): as Ader's dealers, 8, 56; Ader's first show at, 66–68, 69; Barry's Closed Gallery piece at, 80; Gilbert & George's exhibits at, 91; In Search of the Miraculous image on bulletin of, 144–45, 146–47; Los Angeles artists' connections to, 61; pre-sailing postcard for, 123; as Van Elk's dealers, 56. See also van Beijeren, Geert; van Ravesteijn, Adriaan

Arte Povera (exhibition), 56

"Art for All" concept, 92–93

Artist as Consumer of Extreme Comfort, The (Ader), 13, 160–61n26

Artist Game (computer work, Ader), 106

artists: art as defined by, 85; dissent of vs. capitulation to authority, 85–86; identity politics of, 149–51; labor ideas and, 82–83; sidelined by art object and critic, 148–49

Artists Space (New York), 149

art world: Ader's view of art dealers, 77; agency of art objects in, 148–49; art criticism's claim to meaning making in, 148–49; art defined and aestheticized by museums and galleries in, 85–86; art objects fetishized in, 143–44; disinterested in contemporary works, 54–55; problematic relation of art to contemporary market, 83–85

Asher, Michael, 116

Augustine (saint), 26–27, 30–31

Austin, J. L., 143

authenticity: Ader's aspiration to, 6–7; Derrida's view of, 142–43

Avalanche (periodical): Ader interview in, 4–5, 42, 159n4; I'm Too Sad to Tell You reproduction in, 76; Mary Sue Ader interview in, 145

Aycock, Alice, 148

Bakker, Peter, 32

Baldessari, John, 82, 135

Banham, Reyner, 74, 97

Barry, Robert, 78–80, 165n44

Bear, Liza, 132

Beenker, Erik, 161n27

Beeren, Wim, 23, 86

Beijeren, Geert van. See van Beijeren, Geert

Bell, Larry, 55

Benjamin, Walter, 175n33

Beuys, Joseph, 92, 165n46

Birkhead, Neil Tucker, 107–9, 108, 171n15

Bonnard, Pierre, 62–63, 63

book format projects, 12–13, 14–15

Bourriaud, Nicolas, 150

Boy Who Fell Over Niagara Falls, The (Ader): in context of other works, 8, 78, 135–36; description of, 66–68; Gilbert & George compared with, 93; photograph of, 67; possibilities opened by, 140; reviews of, 86; showings of, 66, 69–70, 70, 77, 106; videotaping of, 165–66n49; viewers separated from, 77–78

Bradbury Building (Los Angeles), 9

Brauntuch, Troy, 145

Bremerhaven (West Germany). See Kabinett für Aktuelle Kunst

Brennan, Barry, 145

British Coast Guard, 129

Winer, Helene (*continued*)
 scene, 4; on Ruppersberg, 88–89, 90; shows curated by, 54, 62
Winschoten (Netherlands), Ader born in, 24–25
Women's House project (Los Angeles), 84
Woodward, Deane, 67–68
Woodward, Frank, 67

Woodward, Roger, 67–68
wordplay, pleasures of, 17–18
World War II, childhood in, 24–25
writing as medium, 142–44, 174n24. *See also under* Ader, Bas Jan
Wudl, Tom, 61

Young British Art, 149–51